Intimate Creativity

Intimate Creativity

Partners in Love and Art

Irving and Suzanne Sarnoff

THE UNIVERSITY OF WISCONSIN PRESS

The University of Wisconsin Press
1930 Monroe Street
Madison, Wisconsin 53711

www.wisc.edu/wisconsinpress/
3 Henrietta Street
London WC2E 8LU, England

1 3 5 4 2

Printed in the United States of America

Library of Congress Cataloging-in-Publication Data
Sarnoff, Irving, 1922–
Intimate creativity : partners in love and art / Irving and Suzanne Sarnoff.
pp. cm.
Includes bibliographical references and index.
ISBN 0-299-18050-6 (cloth : alk. paper)
ISBN 0-299-18054-9 (pbk. : alk. paper)
1. Creation (Literary, artistic, etc.). 2. Man-woman relationships.
3. Intimacy (Psychology). 4. Love. I. Sarnoff, Suzanne. II. Title.
BF411.S27 2002
153.3'5 — dc21 2002002340

*To all the couples
who are striving to make intimate creativity
a reality in their lives*

Contents

Illustrations

Acknowledgments

We are most indebted to the partners in love and art who agreed to be interviewed by us. They spoke to us from the head and the heart, disclosing the essences of their personal and artistic partnerships with exceptional honesty, clarity, and insight. Indeed, what they had to say constitutes the core of our work.

Dan Cameron, senior curator of the New Museum of Contemporary Art, kindly gave us a lengthy consultation before we began this project. His enthusiastic response to our plans reinforced our belief in the value of studying intimate creativity among collaborative couples in the visual arts. And his knowledge of people in the art world led us to some of the teams featured in our study.

Erika Goldman, an accomplished editor now affiliated with W. H. Freeman, provided us with constructive feedback on early drafts of our opening chapters. Her positive comments about our writing and ideas were very encouraging.

For helping us to contact couples represented by their galleries and obtain biographical information about them, we want to thank Tom Zollner of T'zart; Nick Sheidy of Sonnabend; Sarah Douglas of Jack Shainman; Emily Graham of Ronald Feldman Fine Arts; Diane Michalowski of Mimi Ferzt; and Stephan Basilico of Basilico Fine Arts.

Most of the photographs in this book were provided by the partners whom we interviewed. We are grateful for the effort they put forth in supplying this material. Getting pictures of other couples proved to be quite a daunting task. Fortunately, the following individuals came to our aid: David Gill, senior lecturer at Swansea University, for Ricketts and Shannon; Jennifer Keane of Ronald Feldman Fine Arts for Helen and Newton Harrison;

Nick Sheidy of the Sonnabend Gallery for Anne and Patrick Poirier; Liz Fischbach at LALouver Gallery and Anita Duquette of the Whitney Museum for Edward and Nancy Kienholz; and Anu Vikram for Claes Oldenburg and Coosje van Bruggen. We also extend thanks to the following organizations: Stiftung Hans Arp und Sophie Taeuber-Arp in Rolandseck, Germany; Tate Enterprises Ltd. in London; and Art Resource in New York.

We benefited from the keen observations and unfailing emotional support of two couples who are friends of ours: Joan and Edwin Schur and Alice and Joel Schick. The Schicks were also exceedingly generous with their technical expertise, and Joel provided all the assistance necessary to prepare the photographs for transmission to the publisher. Finally, we want to thank our children and grandchildren for their understanding and appreciation of our own practice of intimate creativity.

Intimate Creativity

Introduction

Exploring Intimate Creativity

After being married for many years, we gradually made the transition from separate careers to a fulltime co-career as authors and college teachers. Although we attained many personal, relational, and professional benefits from working together, our enthusiasm was often dampened by the dissension that arose between us as we attempted to find a common voice in our writing and lecturing. In the end, however, we learned that these conflicts are to be neither avoided nor denied. Rather, by promptly facing and resolving them, we intensified our intimacy and the effectiveness of our collaboration.

Since becoming a team, we have focused our writing and research on two of the basic sources of human realization: love and creativity. The fruitfulness of our experience inspired us to learn more about how other couples integrate these two wellsprings of fulfillment. What rewards do they derive, what difficulties do they encounter, and how do they surmount those problems?

Essentially, we wanted to clarify the specific ways in which a couple's involvement as lovers affects their joint creativity and, at the same time, how their creative work influences the quality of their loving relationship. To represent this simultaneous process, we have coined the phrase *intimate creativity*.

∽o∾

Loving couples have made their presence known as collaborators in many areas of creativity. Gracie Allen and George Burns once flourished as superstars of radio comedy. On the stage, Alfred Lunt and Lynn Fontaine were a legendary acting team. Judith Malina co-founded the Living Theater with her husband, Julian Beck; after he died, she continued to develop it with her subsequent mate, Hanon Reznikov.

Millions of people have enjoyed the comfort and beauty of the Eames chair, created by the prodigious couple Charles and Ray Eames. Co-creators in industrial design, architecture, and experimental filmmaking, they "are considered by many to be among the most, if not the most, important American designers of the twentieth century."[1] Billy Tsien and Todd Williams, a husband and wife architectural team, were cited in *Newsweek* as prominent people of 1997 for making "a big splash with luminous, neo-modern buildings, like San Diego's Neurosciences Institute."[2] Leo and Diane Dillon, another marital pair, have twice won the Caldecott Medal for their outstanding illustrations of children's books.

In modern dance, Bill T. Jones and Arnie Zane started their own distinguished troupe, which Bill has maintained in the aftermath of Arnie's death. Eiko and Koma, a Japanese wife and husband duo, highly respected as choreographer/dancers, have broadened their scope by performing as a living sculpture at the Whitney Museum in New York.

James Ivory and Ismail Merchant, personal and professional partners since 1960, have created over thirty-five feature films. Other notable couples in filmmaking include Belinda and Philip Haas as well as Nancy Savoca and Richard Guay. In popular music, Alan and Marilyn Bergman, a team of lyricists since 1960, wrote the words for some of Frank Sinatra's biggest hits. And in popular fiction, Judith Barnard and Michael Fain write their novels as a team and publish them under a pseudonym that combines their first names, Judy Michael.

Three couples reached the pinnacle of their specialties in science, winning the Nobel Prize for collaborative research. Marie

and Pierre Curie were honored in 1903 for their work in physics. Subsequently, in 1935, their daughter, Irene, and her husband, Frederick, who linked his name to hers as Joliot-Curie, were awarded the Nobel in chemistry. Carl and Gerty Cori received the award in 1947 for physiology and medicine.

∽∾∾

Co-career couples in the visual arts have also been acclaimed for the esthetic inventiveness and appeal of their creations. In fact, we decided that lovers who work together as artists would be most appropriate for an exploratory study of intimate creativity. After all, they have dared to go beyond the constraints of personal egoism to collaborate in a field of creative endeavor that has been supremely individualistic since the dawn of the Renaissance. "Of all the premises on which modern art is built, one of the most unshakable, surely, is the idea of the artist as rugged individualist, the singular genius working in isolation, the visionary driven by intensely personal perceptions, compulsions, and, perhaps, demons."[3]

Even today, people picture the artist as someone who is irresistibly impelled to express his or her rare abundance of talent. Given the intense and continual self-absorption stimulated by this creative drive, artists are presumed to give their individual work priority over everything else they do in life—including their participation in a loving relationship.

The partners we interviewed contradict this conventional image. Regardless of their sexual orientation, the commitment they have made to love one another is inextricably intertwined with a pledge to blend their individual talents. Forgoing separate artistic careers, they pour their energies into their joint creations and identify themselves professionally as a team. Their unwavering unity of purpose generates a powerful charge of synergy, reinforcing their artistic and relational growth.

Such partners in love and art provide a natural laboratory for acquiring new insights into the dynamics of intimate creativity and the psychological parameters of loving relationships. While

gaining professional legitimacy, these pairs have withstood the divisive forces imposed on all couples by the competitive thrust and hierarchical structure of work in contemporary society. Thus, they also show it is possible to break through the obstacles that induce most people to maintain a separation between loving and working.

These couples prove that Yeats's classic poem "The Choice"—often cited as the lyrical summation of an irrefutable truth—is based on a false dichotomy. "The intellect of man is forced to choose," he wrote, "Perfection of the life, or of the work."[4] According to this formula, a person seriously dedicated to developing his or her creative gifts must sacrifice the possibility of attaining equal growth in any other area of living. By contrast, the innovative partners featured in this book demonstrate that they can perfect their capacities for love and creativity within the scope of the same relationship.

In this respect they differ from lovers who work independently in the same creative discipline: Elizabeth Barrett Browning and Robert Browning in poetry, for example, or, in painting, Frida Kahlo and Diego Rivera, Jackson Pollack and Lee Krasner. Although these partners may have had a strong influence on each other's creativity, they pursued separate careers and were known professionally for their individual work.[5]

On the other hand, there are collaborative pairs of artists who identify themselves professionally as a team, such as the Starn brothers or Komar and Melamid. But these people are not involved with each other in a holistic relationship of love that encompasses both affection and sex.

Through their sexual contact, partners in love and art experience a breadth of physical familiarity and a depth of emotional expression known only by couples in a committed relationship of love. Having displayed their beauty and blemishes, power and frailties, they accept one another's assets and liabilities. Each can sense when the other is serene or upset, elated or depressed, involved or detached.

Besides, the ideas and images they communicate emerge from the deepest recesses of each one's unconscious. So they know one another at every level of being and have an incomparable

opportunity for reciprocal evaluation. The completeness of this intimacy enables partners in love and art to bring a unique blend of passionate intensity and mutual understanding to all their interactions.

In this book we focus exclusively on couples who fully integrate their loving relationship with creative collaboration. Combining a new dimension in artistic creativity with the way they live in the world as lovers, these partners merge their minds and bodies together in an amalgam that has never before been the subject of serious psychological study.

∾∘∾

Taking account of our combined expertise, professional interests, and limited financial resources, we designed a qualitative study based on interviews with a small but select sample of co-career couples in art. We aimed to establish an initial base of psychological knowledge about how such partners function in the most significant aspects of their shared lives.

Many facets of individual creativity have been studied by psychologists and reported in numerous books and journals. Scholars have also investigated creative teamwork among pairs and groups of people who collaborate on a project. But we could find no psychological research focused entirely on loving couples who identify themselves as a collaborative team in visual art—or in any other sphere of symbolic creativity. Similarly, a substantial literature on the psychology of close relationships considers how lovers interact to their mutual benefit or distress, but none of these investigations center on partners in love and creative work.

We refer to relevant concepts and empirical data from both of those psychological specialties, integrating this material with our own ideas and findings to yield an entirely new and coherent account of the dynamics and outcome of a previously ignored—yet psychologically powerful—process. Particularly timely, our exploration of this phenomenon dovetails with an emerging trend in research on positive psychology, which—in contrast to the

traditional concentration on psychopathology—seeks to uncover and reinforce the constructive potentials of human behavior.[6]

To launch our research and give it thematic focus, we drew on key concepts from our *Love-Centered Marriage in a Self-Centered World*.[7] In that book we articulate the fact that every loving relationship is a two-person creation that partners can go on creating for a lifetime by fulfilling the four basic promises inherent in the giving and receiving of love: unity, interdependence, equality, and sexual pleasure.

Most couples, of course, separate their private sharing of love—the ongoing creation of their relationship—from their different spheres of individual work. But partners in intimate creativity combine the manner in which they relate as a couple with their collaboration in making works of art. They continue to create their loving relationship as they jointly create their artistic products. For them, relating is creating and creating is relating. This simultaneity affects their ability to fulfill the four promises of love and their artistic potentials.

Accordingly, we constructed an open-ended questionnaire to uncover the connection between relating and creating.[8] Many of the fundamental issues we explored are paraphrased in questions like: How do these partners meld their innermost thoughts, feelings, and perceptions? How do they agree on what to create, and how do they go about doing it? How do they divide the artistic labor? What impact does their collaboration have on their sexual satisfaction, and, conversely, how do their sexual relations affect their creativity? What personal growth and creative benefits do they derive from working together?

Since our own experience has taught us that intimate creativity is by no means free of conflict and frustration, other questions dealt with the problematic interplay of unity and autonomy, cooperation and competition, open communication and dishonesty or withdrawal, trust and distrust, equality and power differentials, erotic pleasure and immersion in work.

We also wanted to know how these partners resolve their relational and artistic disagreements. Do they have trouble coping

with the roles and responsibilities of their daily lives? What are their attitudes toward procreation and parenting? How do they weather the stormy periods of creative block? What stresses are involved in exhibiting and marketing their co-creations? How do they react to success and failure—individually and as a pair?

We used this questionnaire as a basis for conducting in-depth interviews face-to-face, with both members of every pair interacting with us and each other. We asked every couple the same set of questions. The fact that we are also partners in love and creative work helped us to establish excellent rapport with all the couples. We were able to empathize with their range of experiences and follow up spontaneously on issues unexpectedly raised by the format of our questions.

Every pair permitted us to tape record the interviews. All the couples knew we would quote them by name and use their material to illustrate the ideas and topics we would be covering. Considering their lack of anonymity, they were remarkably forthcoming in their disclosures.

We did not attempt to obtain a random and representative sample of current partners in love and art. Nor did we strive to interview individuals who had once been in such partnerships but had broken up. Comparing intact couples, like those described here, with broken couples might make for an interesting study in its own right. But our positive emphasis for this initial effort led us to concentrate on pairs who were harmonious, productive, and succeeding in the art world.

∽◦∾

Finding couples to interview was an intriguing process. We were aware of the best-known teams, but in tracking down other couples, we often felt like detectives. Scanning the listings of professional artists in the *Art Diary* and the annual August editions of *Art in America*, we kept our eyes open for clues that might indicate the work of a couple—duos with the same surname, or names connected with an ampersand or a plus sign. We also

checked ads in art journals and exhibit notices in publications like the *New Yorker,* the *Village Voice,* and the *New York Times.* Spotting a likely pair, we immediately telephoned the gallery or museum listed to find out whether or not the partners were in a loving relationship.

Intrigued by the originality of our project, curators and other employees were happy to give us press kits, articles, or catalogues. Many offered suggestions about other likely pairs. Eventually, we located a diverse sample—including a gay and a lesbian couple— who agreed to be interviewed. Each pair met the criteria of our exploration: a mutually committed relationship of love; a record of productivity in their particular genre; and favorable recognition by experts and critics. They differ widely in age, fame, and the number of years they have been living together and working collaboratively.

The participants represent every artistic genre—painting, sculpture, photography, mixed media installations, public and environmental art, performance art. Their work has been exhibited and reviewed in America and abroad. Many have received prizes and commissions for public installations; they are mentioned in articles and books and represented in private collections.

ເ∾○∾ວ

Christo and Jeanne-Claude, both born on the same day in 1935, have been a team since they met in Paris over forty years ago. He is from Bulgaria; she is French. They are internationally renowned for their monumental public projects in countries throughout the world: their temporary wrappings of the Reichstag in Berlin, the Pont Neuf in Paris, and miles of the Australian coastline; the installation of twenty-four and a half miles of the *Running Fence* in California; and the simultaneous planting of thousands of blue umbrellas in Japan along with yellow ones in an inland valley in Southern California.

The couple has secured a lasting place in the history of twentieth-century art as pioneers of the conceptual movement.

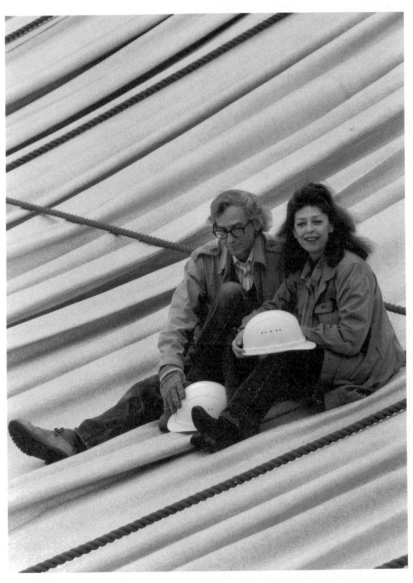

Christo and Jeanne-Claude on the roof of the *Wrapped Reichstag*, June 1995.
© Sylvia Volz.

The realization of their huge works entails a complex and ingenious mix of skills that both bring to their partnership. Encompassing the traditional disciplines of drawing, painting, sculpture, and architecture, their combined creativity incorporates aspects of physics and engineering as well as expertise in business management and high finance. Free from dependence on galleries, institutions, or corporations, they have created a self-reliant method of raising the funds needed to support themselves and underwrite their very expensive artistic projects. Their collaboration also involves public education, persuasion of reluctant officials and landowners, and effective use of the media to promote their work.

∽o∾

Elizabeth Diller and Ricardo Scofidio have been collaborating since 1979, shortly after they met at Cooper Union, where she was his student. Elizabeth was born in Poland in 1954; Ricardo, a native New Yorker, was born in 1935. Leaders of the current trend to integrate the visual arts, performing art, and architecture, they are involved in thematically driven experimental projects, including temporary and permanent site-specific installations, multimedia theater, semiotics, and the electronic media.

Their work has been exhibited at the Museum of Modern Art (MoMA) in New York as well as in galleries and museums in Europe and Japan. They were co-curators and designers of *The American Lawn: Surface of Everyday Life,* a conceptual and visual installation held at the Canadian Center for Architecture in Montreal. Their theater piece *Jet Lag,* which used video imaging and computer animation, was performed as part of the grand opening for the Massachusetts Museum of Contemporary Art (Mass MoCA) and won an Obie award.

In 1999 Diller and Scofidio were the first pair of architect/ artists to receive a prestigious MacArthur "genius" award. Their works in progress include a major installation on Lake Neuchatel for the Swiss Expo of 2002 and a commission to design the Institute for Contemporary Art (ICA) on Boston Harbor, the first art museum to be built in that city in almost a hundred years.

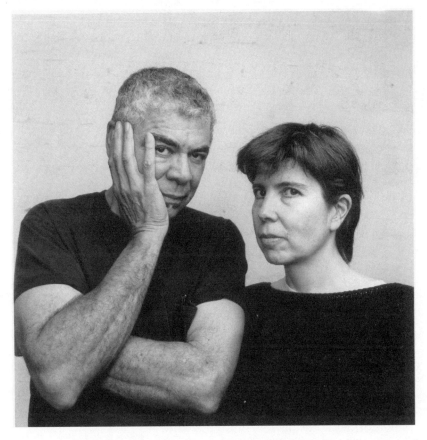

Elizabeth Diller and Ricardo Scofidio. Photo by Mark La Rosa; courtesy of the artists.

Kristin Jones and Andrew Ginzel have been working together since they met in 1981. She was born in Washington, D.C., in 1956, and he was born in Chicago in 1954. Most of their projects stem from commissions to create permanent or temporary site-specific installations in public spaces. Overseas, they have done major works in Italy, Switzerland, and India. In the United States, their installations have appeared at the 1996 Olympic Arts Festival in Atlanta, P.S. 1 Contemporary Art Center, the

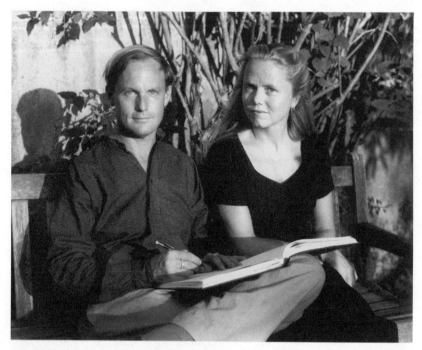

Kristin Jones and Andrew Ginzel. Courtesy of the artists.

New Museum of Contemporary Art, and City Hall Park in New York.

Combining a wide variety of materials, their evocative work conveys the extremely delicate balance between order and chaos, stability and instability. Their creations challenge our perception of current reality and memory, expressing the complexities of mortality and time. In 1999 the couple completed the ArtWall, a permanent sixty- by one hundred-foot installation that adorns the facade of a massive building on the south side of Union Square. This work was sponsored by the Public Art Fund/ Municipal Art Society of New York and the real estate company that developed the building. One hundred well-known artists had been invited to submit designs for this project. After winning the competition, Jones and Ginzel created *Metronome*, the most prominent public art commission in New York City. While it functions as an enormous clock, the artists view it less

Bill and Mary Buchen. Courtesy of the artists.

as a timepiece than as a piece about time—a meditation on how we define it and how it defines us.

∽o∾

Bill and Mary Buchen began their collaboration in 1972, soon after meeting at the University of Minnesota. Bill was born in 1949 and Mary in 1948. Originally they created and performed on musical instruments; they now design and construct visually arresting sculptures that transmit sound. Permanent installations of their "sonic architecture" stand in outdoor sites, such as school playgrounds and public parks, in various parts of the United States. They have also created many pieces for science and children's museums.

Their recent projects include installations for eight Light Rail Stations and system-wide enhancements in San Francisco, as well as play and environmental sculptures for Hudson River Park in New York City. The interactive nature and public accessibility of their creations bring people together in a literal harmony as they

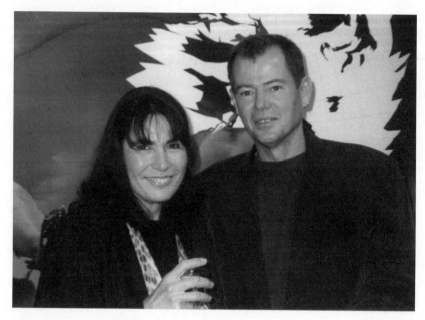

Lilla LoCurto and Bill Outcault. Courtesy of the artists.

speak into or drum on the sculptures, activating the full sensory potentials of those works.

∽०∾

Lilla LoCurto and Bill Outcault were both born in 1949, Lilla in Venezuela and Bill in New Jersey. They met at Southern Illinois University, where they received their master of fine arts (MFA) degrees. Although married in 1979, they didn't start to collaborate until 1991. Combining her figurative and social approach with his nonreferential abstract style, they use video and computer technology in mixed-media installations that focus on body and gender politics.

Represented by a gallery in New York, their work has been exhibited at Harvard University's Carpenter Center, Indiana State University, and several galleries in California, as well as in London and Barcelona. Recently, working with scientists in a laboratory at the Massachusetts Institute of Technology (MIT), they have recorded and mapped on the computer limb-by-limb

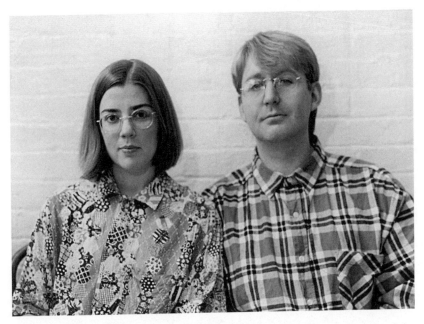

Andrea Robbins and Max Becher. Photo by Tanya Braganti; courtesy of the artists.

scans of their own bodies. The configuration, color, and density of these images are digitally manipulated to create distorted and provocative representations of the human body. This project was shown in a major exhibition at the MIT List Visual Arts Center. Since that show, they have also worked with scientists at Johns Hopkins University.

∽o∾

Andrea Robbins and Max Becher, a husband and wife team of photographers, have been collaborating since they met in 1984 as students at Cooper Union. Andrea was born in Boston in 1963 and Max in Dusseldorf, Germany, in 1964. Their pictures include social commentary, often focusing on the dislocation of cultures and places by colonialism or racism. One series documents the aftereffects of German rule in Namibia before World War I; another depicts an area of Havana with architecture reminiscent of

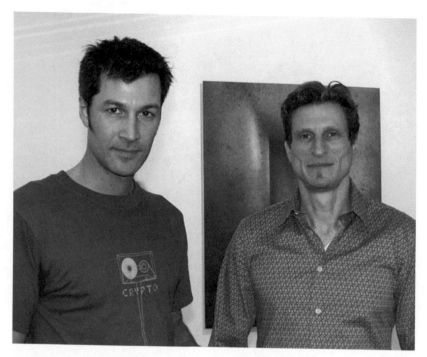

Anthony Aziz and Sammy Cucher. Courtesy of the artists.

New York's Wall Street district—illustrating the expansion of the United States into Cuba.

Capturing the essence of a particular place, the couple conveys empathy for the people and conditions they portray. For example, their project on the concentration camp at Dachau subtly recalls all of its horrors through the unadorned objectivity of the images. Exhibited in Europe and America, their photographs are in such leading collections as the Guggenheim Museum in New York, the San Francisco Museum of Modern Art, and the Los Angeles County Museum of Art.

∽∾

Anthony Aziz and Sammy Cucher met as graduate students at the San Francisco Art Institute in 1990. Anthony, an American, was born in 1961; Sammy, a Venezuelan, was born in 1958. Shortly

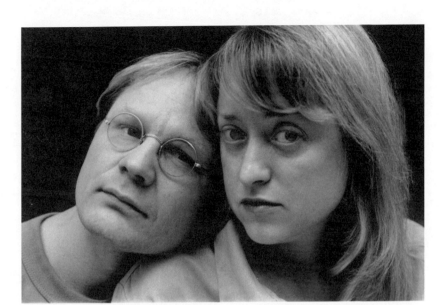

Suzanne Scherer and Pavel Ouporov. Photo by Luba Proger; courtesy of the artists.

after meeting, they became lovers, and by 1991 they had cemented their creative collaboration. In digitized photography and sculptured installations, they dramatically capture the increasingly dehumanizing impact of technology on our lives.

Their work has been shown in galleries in America and abroad, as well as in the New Museum of Contemporary Art, the Kemper Museum in Kansas City, the MIT List Visual Arts Center, and the Rijksmuseum Twenthe in the Netherlands. In 1995 a major piece was included in the Venice Biennale. Their latest series, *Interiors,* represents a lyrical and poetic departure from their previous images. Synthesizing human flesh and architectural space, it offers a new perspective on the body's interior, exploring human emotion and mortality.

∽o∾

Suzanne Scherer and Pavel Ouporov met when she came from New York in 1989 to continue her graduate studies at the Surikov

State Art Institute in Moscow, where he was a student. An American born in 1964, Suzanne was the recipient of a Visual Arts Grant from the International Research and Exchanges Board in conjunction with the Ministry of Culture and Academy of Arts in Russia. Pavel, a Russian, was born in 1966. Quickly forging a loving relationship, they became a team and learned each other's language by working in tandem on their paintings. Married in 1991, the couple took up residence in New York.

Their work is a blend of delicate composition with exquisite draftsmanship. Dealing with existential themes, their paintings often incorporate archeological elements derived from nature and the environment. Represented by galleries in New York, their work has also been shown in the Lancaster Museum of Art in Pennsylvania, the Binghamton University Art Museum, the Ekaterinburg State Museum of Fine Art in Russia, and several Moscow art galleries. Work from their most recent series, *Dream Ikons*, was included in a major exhibition commemorating the discoveries of Sigmund Freud. This event, called *Dreamworks 1999–2000*, was held at the Equitable Art Gallery in New York City. One of the couple's paintings was featured on the Public Broadcasting System (PBS) television program about that show.

∽ం∾

Katleen Sterck and Terry Rozo met in 1989 at a women's motorcycle rally, where Terry was doing a photography shoot. Katleen was born in Brussels, Belgium, in 1964; and Terry, a New Yorker, was born in 1952. They began to collaborate immediately. In 1992 they rented a place on Cape Cod, where their work evolved from autobiographical portraits to a study of the figure in nature. Influenced by the daily cycles of low and high tide, sunrise and sunset, they portrayed themselves in the misty light of the seashore. By repeatedly manipulating the negatives, using a novel technique they devised themselves, they produced ethereal images with an impressionistic, painterly quality. Those pictures have been exhibited in galleries in New York, Seattle, Brussels, and Provincetown. Representing a major departure in content and technique,

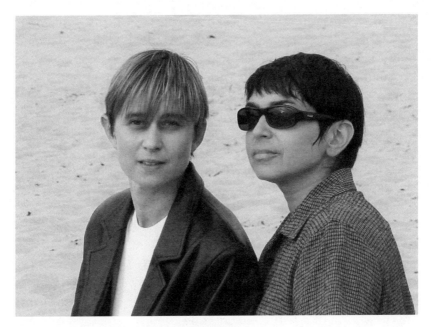

Katleen Sterck and Terry Rozo. Self-portrait © Sterck and Rozo, 2001; courtesy of the artists.

their recent work is characterized by clear depictions of forms from nature. With exact images of the objects positioned side by side in each quadrant of the picture, these photographs create a kaleidoscopic effect.

∽o∾

In addition to our structured interviews, we had the opportunity to meet and converse briefly with the British couple Gilbert and George when they were in New York for the opening of a new show. Gilbert was born in Italy in 1943; George was born in England in 1942. They met in art school and had their first exhibit at a London gallery in 1968. Since then, they have achieved world renown for their dramatic works in photomontage. Their groundbreaking techniques—the glowing luminosity of their colors and their enormous prints, which they fit together in segments bordered by black grids—have influenced many other artists. They

have also had a profound effect on performance art. The historian and curator David Sylvester has described their work as an important addition to the long English tradition of eccentric visionary art represented by William Blake, Francis Bacon, and Stanley Spencer.[9]

∽o∾

To trace the evolution of partnerships in love and art, and to set the topic of intimate creativity in historical perspective, we mined biographies, professional journals, exhibition catalogues, press releases, newspapers, popular magazines, and the Internet for pertinent information about the lives and works of other collaborative couples—past and present. Beginning with the glorification of creative individualism in the Renaissance, we discuss the economic, political, and social forces that led up to and ushered in this new form of artistic collaboration.

Instead of devoting a separate chapter to each of the couples interviewed, we organized our material by topic, quoting what our interviewees had to say about each issue. Throughout the book, we illustrate the constructive patterns of communication and conflict resolution they utilize, spelling out how they interact to maximize the rewards and minimize the costs of intimate creativity.

Little by little, each pair comes to life in a vivid portrait of their particular relationship and accomplishments. In the epilogue, we summarize our findings and draw out the implications for other couples. Reflecting on how partners in love and art combine their energies and cope with their problems can be useful to any pair of lovers looking for ways to enhance their relational and personal growth—no matter how they earn a living.

1

Relating and Creating

Loving and creating arise from the same basic core of yearning for the ultimate in human fulfillment. Both are experienced as a gratifying change from desire to consummation, from an imagined possibility to an accomplished reality. In going through this transformation, people derive tremendous enjoyment from releasing their pent-up tensions and expressing the constructive energies they have stored up within themselves just by being alive.

Love is so vital to our sense of well-being that we equate it with the central organ of existence—the heart. When we love and are loved in return, we say our hearts are overflowing with joy. When sorely troubled by our love-life, we describe the anguish as heartache and heartbreak. Even newborn babies need affection and sensual fondling to thrive, and love-starved adults can become depressed or physically ill.[1]

Lovers crave union with every facet of their beings. They want to devote as much attention and care to each other as to themselves, and they desire to give and receive erotic pleasure. In fulfilling this innate need to express the affectionate and sexual wholeness of love, partners offer the best of themselves to one another and share the heights of emotional and physical satisfaction.

Everyone is also born with the "instincts for exploring, for enjoying novelty and risk—the curiosity that leads to creativity," as Mihaly Csikszentmihalyi has pointed out.[2] "Creativity is a central

source of meaning in our lives," this expert on the psychology of creative behavior believes. "Most of the things that are interesting, important, and human are the results of creativity." It is our capacity for language, concept formation, learning, and creative expression that distinguishes us from all other animals. The process of creativity is so intriguing because "when we are involved in it, we feel that we are living more fully than during the rest of life. The excitement of the artist at the easel or the scientist in the lab comes close to the ideal fulfillment we all hope to get . . . and so rarely do." And the benefits extend to others: "The results of creativity enrich the culture and so they indirectly improve the quality of all our lives."[3]

The great majority of artists produce their work as solitary creators, conforming to the individualistic approach that still dominates the world of art in western society. Undoubtedly, the process of individual creativity yields its own psychological rewards. Bringing original ideas and esthetically pleasing objects into the world can be extremely gratifying. The same may be said about giving free rein to one's own imagination—without having to stop, consider, discuss, and incorporate offerings from another person. In addition, what an individual communicates and produces gives something of his or her innermost self to others, providing them with enjoyment and enlightenment. Others' positive reactions, in turn, bolster the artist's self-confidence and faith in being inventive.

It is impossible, however, for anyone to give and receive love without relating to someone else. Love can be fulfilled only by participating in a relationship with a real partner. On this point Alexander Lowen, a pioneering practitioner of bioenergetic psychotherapy, remarks: "Love as a psychological experience is an abstraction . . . an anticipation that has not found its realization. It has the same quality as a hope, a wish, or a dream." And he concludes, "The appreciation of love as a psychological phenomenon must not blind one to the necessity of its fulfillment in action."[4]

Similarly, in his classic *I and Thou*, the eminent philosopher Martin Buber explains that the potential to relate lovingly cannot

be actualized in social isolation; it is brought out by two people in their direct encounters. Buber believes this capacity for relating is the finest and most unusual of all human potentials for creativity.[5]

Yet most lovers do not perceive one another as co-creators of their relationship. Nor are they aware that they themselves determine all aspects of this interpersonal creation. It is commonplace to hear people refer to their intimate connection as "it"—as if their relationship were some alien object imposed on them by an unfathomable and capricious source beyond their control, a "thing" they had no part in creating and have no further personal responsibility for directing. Such partners may say, "It is working," or "It isn't working," or "Hopefully, it will work out," when they are actually talking about the quality and outcome of their own creation.

A Loving Relationship Is a Collaborative Creation

Two people begin to create a loving relationship from the moment they experience a transporting click of attraction, a feeling of being involuntarily drawn to one another. To cultivate the emotional and erotic wholeness of their nascent love, however, they have to use their volition to make a myriad of agreements about how to express it. Some of these agreements are verbal, like arranging to go on dates or discussing where and how to spend their time together. But even more of their agreements are non-verbal, made simultaneously by both partners through facial expressions and gestures.

Because their communication is often very rapid, they may feel caught up in a process that bypasses their volition. Nevertheless, both are deciding what to do and comment upon, what to ignore and remain silent about. All of this decision making is jointly creative, since it brings into being experiences and expectations that had never existed before, either within or between these two people.

Building up a mental picture of the thoughts and feelings they are communicating, partners develop the same configuration of

meaning about what is happening between them. Of course, both retain their own self-images. But now each also has a mental image of the other and of the two of them interacting together. And they carry this complex picture around in their heads—even when they are apart.

Both lovers grow increasingly cognizant of being partners in a psychological entity that did not exist when they first met. Eventually, they openly acknowledge the newly constructed connection between them. Now, instead of seeing themselves as just a "me" and a "you," they also see themselves as a "we." This common conception of their "we-ness"—along with the matrix of their agreements—constitutes the essence of the relationship the two of them are creating together.

Stephan Fry, the English actor who plays the part of Oscar Wilde in the film *Wilde*, describes the energizing effect of the feeling of "we-ness" very well. "I realized . . . that fulfillment lay partly in work, but didn't lay entirely in it. That I would be more fulfilled if I found love and companionship." After finding a boyfriend, he also discovered, delightedly, that he had become half of a couple: "I love this thing. . . . You're talking about a film and you say, 'Yes, we saw that, we saw it in so-and-so.' And I haven't used that 'we' for—well, ever, really."[6]

A loving relationship is more than the mere summation of each person's input. Through the interpenetration of each one's consciousness, lovers meld their individual contributions into a novel and unique conception that neither could create or enact without the other—just as nobody can converse, make love, or conceive a child without the involvement of someone else. This collective creativity enlivens a couple, multiplying their energy and pleasure in being together.

Romancing the Integration of Love and Creativity

Before uniting their lives in a loving relationship, people tend to see themselves as heroes or heroines in their own minds, formulating favorable images of what they will achieve over time. These

mental projections give unattached individuals an ongoing impetus to strive for the accomplishment of their personal goals. But after creating their "we," lovers are mutually inspired to compose a common dream or romance—a vision of how they want to live in the world as a couple. What social values do they stand for? How do they hope to express those values through the kind of work they do? What are their priorities? How will they balance personal achievement with the cultivation of their loving relationship?

Unlike a painting or a scientific report, however, a relationship is intangible. It is not a palpable organism, as are the individuals who construct it. Nor is it an inanimate thing that can be set apart and readily observed. Consequently, committed lovers become highly motivated to create a perceptible product that symbolizes the fruitfulness of their intangible merger: having and rearing a child, building or decorating a home, sharing a hobby, or starting a business together. All of these creative accomplishments serve as an external focus for the nurturing inclinations they feel toward one another and become an integral part of their romance.

A couple's romance is not a trivial or misleading illusion that interferes with their ability to accept reality. Instead, it gives them a vital and unified sense of purpose for a future that they can work toward enthusiastically. It augments their individual reservoirs of energy when they are together as well as when they are apart. And it provides a permanent repository of exhilarating memories that they can draw upon for encouragement. Ellen Berscheid, an expert on the psychology of emotion, speculates that "perhaps it is only people who can continue to dream dreams that include their partner who can stay emotionally alive within a relationship."[7]

Ethel Person, a noted psychoanalyst and author, has observed that many adults entertain "the dream . . . to find a love relationship which is also the locus of creative collaborative work."[8] Perhaps those who entertain this fantasy hunger for the chance to open up fully to someone who will listen with genuine interest. They may imagine that doing creative work with a lover would allow them to be as honest and trusting as humanly possible. Despite all the duplicity required to function successfully in today's economy—or because of it—many people feel imprisoned behind

a false front they are aching to shed. They often yearn to "let it all hang out" and still be accepted by a partner.

Such individuals may sense the delicious freedom involved in creative collaboration—the chance to set their own standards, work at their own pace, and spend long periods of time together in the privacy of their own space. Clearly, those who nurture this alluring—but unrealized—dream of being immersed in a bubble of undivided intimacy are stirred by the same longings that the pairs in this book are putting into vibrant reality.

∽◦∾

Christo and Jeanne-Claude are glowingly wrapped around each other. The passionate and infectious warmth of their mutual affection exhilarated us throughout our interview. They were instantly smitten by one another when he came, as a penniless artist and refugee from Bulgaria, to Jeanne-Claude's well-to-do home in Paris to paint a portrait of her mother in 1958. Because of the difference in social status, her parents vehemently objected to their involvement. Unable to purge each other from their deepest desires, she defied her parents' prohibitions and married Christo, incurring their wrath and rejection for several years.

Once they gave themselves to each other, nothing could divide them. As Christo said to us, "The love is the most important thing." Jeanne-Claude certainly felt the same way. "I was physically crazy about him." Amazingly, she was exactly his age, born in Casablanca on the very same day, June 13, 1935, that he came into the world in far-off Gabrovo, Bulgaria. This coincidence fueled their romantic fantasy about having been destined for one another. Jokingly but fondly, they often refer to themselves as twins. Since being joined, they have blended their talents and energies to face life as a team.

Anthony Aziz and Sammy Cucher also felt an immediate rapport, a harmony of outlook and sensibility. Sammy had come to the San Francisco Art Institute to begin his graduate studies. He was very impressed by an exhibit of Anthony's work and asked a friend to introduce them. Anthony had just completed his master's

degree and was planning to move to New York, but he decided to remain in San Francisco so that he and Sammy could continue to develop a personal relationship and explore the possibility of working together. After about one year, they decided to collaborate.

In contrast to their art, which comments on the dehumanizing impact of technology, their relationship is buoyant with expressions of mutual care and concern. As Anthony exclaimed in his first telephone conversation with us, "Working together is so romantic." In our interview, he affirmed that he felt privileged to find a lover with whom he could collaborate so intimately. Elaborating on these sentiments, Sammy said that their satisfaction after completing a body of work "brings out feelings of love for each other and enhances the notion of accomplishing something—not only as artists but also as a couple."

In doing our study, we discovered that all of the co-career couples have made a romance out of successfully combining love and artistic creativity. Co-authors and co-stars of their own love story, they make their dreams come true in the real world. As a result, they feel mutually empowered and validated.

Intimate Creativity as a Pathway to Relational and Creative Growth

A couple's profound commitment to intimate creativity continually requires each partner to interact with the other. They could not create a steady stream of work unless they also created the interpersonal skills necessary to sustain their harmony and productivity. This simultaneous process of relational and artistic creativity is the principal means by which these partners fulfill the four basic promises that are intrinsic to every loving relationship.

Unity

In becoming a couple, people go through a major psychological change. Formerly, as unattached individuals, they coped with life and the world on their own. Now, linked by the common creation

of their loving relationship, they liberate one another from the confining boundaries of a solitary existence. Both of them build on the foundation of their unity by honestly sharing their separate thoughts and feelings, hopes and apprehensions, quirks and eccentricities. As the relevant empirical research reveals, "the more that people self-disclose to each other, the more progress is made in their relationship and the better the quality of that relationship."[9]

Lovers also become more united every time they agree on what they want to do as a couple. Some of these agreements are quite easy to reach—for example, deciding to participate in a recreation or pastime that both regard as enjoyable. Other decisions may evoke sharp differences that take a lot of time and effort to resolve: whether or not to become parents, how many children to have, and how to rear them. Nevertheless, when a couple unequivocally agrees to cooperate in pursuing any particular plan of action, they become more unified.

Having agreed to unite in every facet of their lives, partners in love and art are extremely dedicated to the welfare of the relationship that encompasses both of them. Voluntarily subduing their self-centered and competitive inclinations, they cooperate to ensure their effectiveness as a loving couple and as a professional team. Commenting on the various activities she and Christo share, Jeanne-Claude said, "He doesn't do it for me and I don't do it for him. We do it for us."

Elizabeth Diller and Ricardo Scofidio amplified this viewpoint: "We're so completely intertwined, sometimes, we don't know where one begins and the other ends." Ricardo told us, "There's an enormous amount of pleasure in putting your thoughts together. Otherwise, it's a very lonely process." Elizabeth added, "How do you know it's good or bad? By talking about it, the idea is outside your own body and head. It becomes an object that you can look at and point to and discuss. If we couldn't talk about our work together, it would reduce the pleasure of doing it."

Kristin Jones and Andrew Ginzel are thankful for the warmth and security they have developed by functioning as "part of a unity." Both emphasized the need to "forget about your ego . . . just give it up." It doesn't matter to them who does what. The

concepts they exchange during their endless conversations are totally interwoven.

Neither Kristin nor Andrew can imagine working separately. Nor would they like to be in a relationship where both partners are artists pursuing individual careers. They think such an arrangement would arouse too much competition between them. And they are extremely sorry for spouses who have to work long hours in different jobs, "just having one meal a day together."

Lilla LoCurto and Bill Outcault also feel that working together is "less lonely and easier." When they got married in 1979, they contemplated the possibility of collaborating. But as graduate students in art at the University of Southern Illinois, they were warned by colleagues that it would be "the kiss of death" for both of them. Although they had always helped one another with their individual work, each regarded the final outcome as a personal achievement.

In 1991 they finally decided to collaborate on a project. By fusing the social slant of Lilla's previous work with Bill's nonreferential abstract style, they went through an unexpected transformation. "We had no ego . . . we were working for the piece . . . not for ourselves." Since that liberating experience, they have always collaborated "because we don't see any other way. We do much better as a team. We're so one."

Andrea Robbins and Max Becher voiced a similar attitude. "It's exciting and comforting when we click into each other. There's a magic in the cooperation. We put our trust in that magic." Both of them are convinced that their collaboration has made them "more of a couple." As Andrea asked at the end of our interview, "Why would you want to put in with a bunch of strangers and give twenty years to a company with people you feel half-hearted about and leave the person you care most about every day?"

Interdependence

Clearly, nobody can satisfy the need to love and be loved on one's own. A person can secure this satisfaction only through a

relationship with someone else. At this elemental level, lovers must trust each other to behave in ways that are gratifying to both of them. They also have a need to rely on one another for assistance in meeting the multitude of responsibilities they confront in their daily lives.

In order to remain a viable couple, partners depend on each other and accept the importance of being dependable for one another. Both of them are prepared to offer whatever emotional, physical, and economic support is necessary to safeguard their mutual well-being. By becoming trusting and trustworthy, lovers simultaneously cultivate their personal competence and their confidence in themselves as a reliable team.

In combining their individual lives and talents, partners in intimate creativity are called upon to be unquestionably reliable in coming through for one another. Terry Rozo said it was "love at first sight" for her and Katleen Sterck. Becoming inseparable, they decided to collaborate and apply for a grant. Shortly afterward, Terry had a serious motorcycle accident that required two years of recuperation. Katleen helped Terry to get around in a wheelchair and did everything else necessary to aid in her recovery. Awed by Katleen's devotion, some people said, "If it were me, I wouldn't deal with it." Terry confirmed that many couples would have broken up in such a situation, but she and Katleen stuck by each other and got even closer.

Being creators and subjects of many of their pictures gives their relationship a plenitude of interdependence. "I feel I'm doing what I'm meant to do with the person I'm meant to do it with," Terry said. Katleen echoed her statement: "You feel blessed when you can share something you like with someone else that you like."

Christo and Jeanne-Claude find it is much easier to face obstacles as a couple. "We may do a lot of crying when things go wrong," she conceded, "but we can't both cry at the same time. So, when one feels weak, the other is strong for both of us—and vice versa."

When Suzanne Scherer met Pavel Ouporov in Moscow, she didn't know much Russian, and he could hardly speak English. They communicated by showing each other their sketches. Soon,

with "absolute trust," they were literally laying their hands on the same canvas. Since then, they have relied on each other to apply their best efforts to their common endeavors.

Suzanne said, "Working together is a need, just as we need to paint." As she reported, her mother chides them about not being able to breathe without each other, commenting, "When Suzanne inhales, Pavel exhales."

According to this couple, other artists envy their ability to be mutually supportive. For Aziz and Cucher, having a built-in "support system" helps to "keep each other on track" and sustain a sense of clarity about their work. As Bill Buchen remarked, "When it's tough, two people are pulling the cart. When it's good, it's double the fun. . . . You've always got a friend."

This readiness to "be there for each other" can keep any couple from wallowing in despondency when their efforts fail or fall short of the outcome they had envisioned. Many of the co-career couples in art have been unable to obtain commissions to implement proposals they worked very hard to design. Yet those disappointments did not undermine their basic morale or their ability to move forward with other creative projects.

Equality

Loving relationships function as microscopic units within the organizational framework of an entire society. In America, this overarching structure is characterized by invidious distinctions imposed on groupings of people based primarily on their class, race, gender, and sexual orientation. Long before meeting one another, lovers are exposed to these societal inequities—and to the prejudices that reinforce them.

In heterosexual pairings, sexism is a prevalent form of injustice. Even without consciously malicious intent, men may attempt to exploit or belittle their female partners. And those women, while suffering from such treatment, may submit to it because of their own internalization of self-abasing stereotypes.

Similarly, in same-sex relationships, both partners may have absorbed feelings of inferiority in comparison with the majority

status of heterosexuals. Mimicking the superiority that society typically accords to heterosexuals, one homosexual partner may consistently try to dominate the other: For example, a gay lover may seek to exert the power attributed to "macho" males, and a lesbian lover may do the same by acting as a "butch" woman.

All these denigrating attitudes and power-plays prevent partners from spontaneously expressing the entire spectrum of their emotions with each other. Relational inequality not only stimulates festering resentment between lovers but also limits their ability to experience the fullness of their humanity.

Nevertheless, partners in a loving relationship have the best incentive to become as genuinely equal as any pair of individuals can possibly be. The more they shed the stereotypical attitudes and behaviors that interfere with the holistic sharing of their love, the better they will feel about themselves and one another. These improvements motivate a couple to persist in dredging up the remnants of inequality and making the relational changes necessary to eliminate them.

By fulfilling this promise of equality, both partners actualize personal potentials they once felt too inhibited to display because those traits and abilities were unjustly assigned to either males or females. Both are free to utilize the inclinations and sensitivities they share in common with all human beings — regardless of gender — to enrich their relationship.

The heterosexual partners in our study have taken the egalitarian goal of feminism to its ultimate realization, discarding the conventional roles that keep women subordinate to men. They equalize the responsibilities of making and marketing their art — showing that a woman can team up with a man, match him in talent, and receive the same amount of credit for the work they conceive and implement together.

Robbins and Becher have a very flexible arrangement for sharing all the roles connected with managing their day-to-day lives and doing their photography. While Sterck and Rozo divide the household tasks, both of them do every aspect of their creative work together. On the other hand, LoCurto and Outcault totally share the chores of cooking, cleaning, and shopping, but

they divide the labor involved in their professional work to take advantage of their separate skills and abilities.

Classmates advised this couple to avoid collaboration, reasoning that Lilla, as a woman, would have less power than Bill in their relationship. Yet many of the pieces they have done since becoming a team show their common commitment to gender equality. They told us that a man who viewed one of their installations was astonished to learn that it was done by a male/female duo; "I thought this was the work of a pissed-off woman!" he admitted.

An identical relationship of equality exists in the same-sex couples we interviewed. Whether gay or lesbian, these pairs are unabashedly out of the closet, openly living and working together as beloved peers. They share a degree of mutual respect that is as deep and authentic as any of their heterosexual counterparts, and they refrain from attempting to dominate or control each other.

Striving to connect with everyone's basic humanity through their work, Aziz and Cucher refuse to be stereotyped as homosexual artists—just as none of the male/female couples are regarded as heterosexual artists. Likewise, Sterck and Rozo do not think of themselves as two women or a lesbian couple—"It just seems natural to be together." Still, they are happy to be considered a good role model by the gay community.

The work of Gilbert and George portrays the stark physicality of being human. Although they use themselves in their photomontages to create large, in-your-face images, they aim to shock viewers into serious self-contemplation. "When people look at our pictures they don't question our sexuality—they are not looking at us, they are searching for themselves."[10]

Sexual Pleasure

Obviously, lovers decide to get together—and stay together—because of the special quality of the experiences they share only when interacting with each other. Expressing an affection they feel toward no one else, they revel in its incomparable depth of intimacy. When they also make erotic contact, partners combine the sexual and affectionate components of their love. Through

this holistic sharing, they enter the most exquisitely pleasurable state of being two people can create for one another.

In making love, people employ the most primitive modality of sensation: the sense of touch. Through the magic of their tactile contact, they transport each other into a deliciously altered state of consciousness that begins at arousal, becomes intensified during foreplay, and peaks in the release of a sexual climax. Riding the orgasmic waves of mental oblivion, lovers rid themselves of their daily preoccupations along with their usual psychological and physical restraints.

Some of the partners we interviewed extolled the benefits of sexual fulfillment for their relational well-being and the effectiveness of their work. For Bill and Mary Buchen, the sexual pleasure they share not only makes collaboration much more enjoyable but also enhances the quality of their creativity. Besides, the emotional and physical closeness of their erotic contact helps them to dissipate tensions that arise from their work.

On the other hand, many of the couples in our study said that when their creative work is going well, it has a positive effect on their feelings for one another and on their sexual relations. After solving a creative problem, they may become erotically "turned on." For Christo and Jeanne-Claude as well as Gilbert and George, completing a work of art induces a powerful rush of climactic pleasure.

The Fear of Loving

No matter how turned on and psychologically compatible they are, no pair of lovers can merge so completely—in body and mind—without making themselves extremely vulnerable. In their unconditional commitment to love one another, partners risk their happiness, emotional security, physical safety, and material well-being—indeed, everything they have, are, and hope to be.

The decision to "play for keeps" with one person is especially daunting when everyone knows that half of today's marriages end in divorce. Besides, whether one is heterosexual or homosexual,

the anticipation of being with a lover "until death do us part" also hammers home the existential dread of being unable to live forever.

Ironically, in the very process of fulfilling each promise of love, partners arouse a corresponding fear. As they strengthen their unity, both may react with alarm: Will they be so engulfed by their union as to lose their sense of personal identity? Are they endangering themselves by honestly revealing their deepest, innermost thoughts and feelings? To tame the fear of merging too closely, lovers resort to such modes of withdrawal as avoiding each other's company or being uncommunicative when together. Instead of cooperating, they may be competitive and quarrel vehemently without apparent justification.

As they increase their interdependence, both partners may be troubled about growing so dependent on one another that they will be unable to do anything on their own. They may also balk at remaining consistently trustworthy and reliable. Will they have the stamina to keep on giving of themselves unstintingly? Pervaded by such fears, partners become distrustful. Suspicious and detached, they limit the development of their joint dependability.

Despite their affirmation of relational equality, each partner may worry about being exploited by the other. Is their division of labor really fair? Is one trying to exert too much power in their relationship? Disturbed by these unexpressed tensions, lovers may undermine whatever agreements they have made for an equitable sharing of the responsibilities they have taken on as a couple.

Finally, a couple may limit their sexual pleasure because they are afraid of steeping themselves so thoroughly in the bliss of lovemaking that they lose their motivation to handle the demands of economic and social reality. What if they regressed into the mindlessness of infancy? In addition, their contortions, grimaces, and ecstatic cries may set off the threat of losing control and appearing too animalistic. Reacting defensively to these fears, partners either avoid erotic contact or inhibit the spontaneity of their responses when they do make love.

∽o∾

Of course, people become lovers in spite of all these apprehensions. Inevitably, however, mutual defensiveness detracts from the amount of "quality time" partners spend with each other. Couples differ with regard to the kind and degree of fear they can tolerate. Some have such a low boiling point that they immediately lapse into silence or argumentation when they feel threatened by a particular aspect of their intimacy.

In a great many cases, partners reach a point beyond which they are afraid to go. Although they may remain in their relationship, they stagnate in a state of chronic alienation. Others may be so overwhelmed by the fear they unleash in loving each other that they break up as a means of guaranteeing their personal survival.

From our study, it appears that sexual pleasure may be the one promise that is especially threatening to partners in love and art. They tend to attribute their neglect of sexual relations to strenuous and fatiguing work. Yet these exertions, rather than being the cause of their erotic privation, may be their defensive means of avoiding immersion in the pleasure of lovemaking.

But all the couples we interviewed impressed us with their evident ability to withstand the fears associated with the other promises of love. Indeed, both partners cherish the psychological closeness resulting from intimate creativity. They freely share whatever is on their minds, rely on each other's input, and contribute equally to the successful results of their collaboration.

As with love, the fear of loving comes upon partners involuntarily. But just as people use their volition in deciding how to show feelings of love, they have the same capacity to decide how to deal with fear. They can never completely eliminate the eruption of their fear of loving or their defenses against it. But as the partners in our study demonstrate, couples can choose to tip the balance of their relationship in favor of love over fear.

The Fear of Creating

As gratifying as it can be, doing creative work also arouses everyone's fear. People are afraid they will be unable to meet the

challenge of translating their images into worthwhile concepts or products. The thrilling bolt of excitement when an idea pops into their heads is accompanied by a corresponding concern about whether or not to trust its seemingly powerful promise.

With the pleasure of developing the possibilities latent in the original inspiration, people also encounter blocks and hang-ups, painful periods of incubation, and the ambiguity of wondering when or whether a creative breakthrough will occur. During these times, it is only natural for a person to ask: "Am I really capable of bringing it off? Have I taken on too big a challenge?" Even Einstein "was often depressed, sometimes in despair" while waiting for the insights needed to complete his theory of relativity.[11]

Finally buoyed by a solution to a particular problem, a person may feel reassured and freed from bottled-up tension. But this idyllic state is soon interrupted by worries. What is the best way to implement one's plans? How will the work be received by experts in one's domain of creativity? How can one mobilize the energy and zest to come up with ideas for the next project and grapple with its inherent difficulties? As Rollo May has written, people have to muster "the courage to create" in spite of all their fears of inadequacy, failure, and rejection.[12]

The Fear Imbedded in Intimate Creativity

To create something individually, a person has to be attuned only to whatever is going on within his or her own mind. In a collaborative work composed by two people, each partner has to take the other's needs, desires, and ideas into consideration. This kind of interaction requires an unfettered flow of communication and a constant willingness to attain consensus.

On top of the fear that creativity arouses in everyone, members of an artistic team can be upset by the prospect of subordinating their own originality to fit in with that of their partner. They may be similarly put off by the thought of losing their distinctive skills and styles.

But the deepest dread that can strike a person working in a dyad is the apprehension that one's collaborator might die. If that

happened, would he or she be able to mount a successful solitary career? The loss of someone who was not only a professional partner but also a friend is truly a calamity, but in most cases it does not also deprive the survivor of the one person with whom he or she shared a committed relationship of love.

For partners in intimate creativity, however, the demise of one leaves the other without a co-career and without a lover. Having staked everything they value most in life—their vital need for love and their chosen mode of artistic expression—these partners take on a level of psychological risk absent from any other form of creative collaboration.

Given the intrinsic fears of loving and creating—as well the additional anxieties evoked by intimate creativity—it is understandable that so many artists shy away from doing creative work with a lover. Indeed, whenever we mentioned the subject of this book at social gatherings, some people immediately reacted with alarm: "We can't imagine how those couples do it. We're so hooked on doing our own thing. Both of us need our space. My God, we'd always be fighting like cats and dogs if we ever tried that!"

Coping with the Fear of Intimate Creativity

Of course, partners have to reconcile differences in opinions and overcome blocks in the flow of their joint artistry. As Mary Buchen said laughingly, "We're not known as the 'Bickermans' for nothing." Other couples were just as candid, acknowledging that they fight and scream while attempting to resolve their artistic disagreements. But instead of regarding such battles as a symptom of incompatibility, these partners accept regular dissension as normal and predictable. To reach mutually agreeable compromises, they exchange task-oriented criticism and refrain from destroying each other's creative confidence or the productivity of their partnership. By cooperating in the solution of their artistic problems, both lovers develop their capacities for empathy, patience, and compassion.

Actually, partners in love and art eagerly strive for the uplift they get from sharing their creative energies. They generate a

dynamo of inventive synergy by acting on and reacting to the personal inspiration each communicates to the other. At the same time, they reinforce their solidarity and give one another the validation needed to tolerate the harrowing ambiguities of plumbing their creative depths.

LoCurto and Outcault stress how important it is for artists to talk to someone about what they are doing. "When you're alone, you can be telling yourself lies, working on a piece for months and it turns out to be junk. Lots of artists run amok."

Vera John-Steiner, a scholar of creative thinking has said, "Artists often face loneliness, poverty, and doubts about their ability. . . . Creative work requires a trust in oneself that is virtually impossible to sustain alone. Support is critical, as the very acts of imaginative daring contribute to self doubt."[13]

By taking each other into account, Robbins and Becher keep themselves from going "as crazy" as they would if they worked individually. Collaboration has made them more efficient in setting priorities, giving them a longer view of what they are working toward. Calmer and less troubled by fears, they can accomplish more with greater confidence and enthusiasm.

In this respect, David Sylvester believes Gilbert and George have used their collaboration to an incredible advantage. Their creativity flourishes because they are able to renew themselves by hitting ideas off one another and providing mutual criticism, something that most people find too difficult.[14]

Yet Gilbert confided to us how much fear he and George stir up in themselves through their art. The inimitable quality of their pictures is the direct portrayal of themselves as central figures in the themes they express. In some of their works, they appear stark naked, showing all their anatomical parts. Recently, they have even included artistic representations of their own excrement and bodily fluids. Naturally, they worry that their work might reveal too much about their inner lives, or that viewers will be overly disturbed or even horrified by the images and ideas they depict.

In an interview about their now infamous 1995 exhibit of *The Naked Shit Pictures* in London, George is quoted as saying, "Imagine showing yourself like this, absolutely naked and utterly

vulnerable to the world. Not funny. None of our works are. We are terrified of the world. We're in the pictures, a constant measure, a constant presence, looking at the world staring at us in the face. . . . A world where walls are sprayed with obscenities and pavements are caked with filth. . . . We represent unpalatable truths or reality in what some people think of as unpalatable ways. We don't condone."[15]

Gilbert and George told us that they endure this stressful exposure by giving each other unending emotional support. That is a major benefit of their collaboration. "It is as though, joined in a relationship that is closer than most marriages, they are freer to act on their impulses than most artists. Having each other, they don't have to think about what the real audience out there will think of them. They can experience anything and turn it into art," writes Sanford Schwartz.[16]

∽◦∾

All of the couples believe that the products of their collaboration are different from and much better than anything either one could have done alone. When she and Andrew Ginzel work together, Kristin Jones mused, "Something special is in the air." They thoroughly enjoy the suspense stemming from the unknown of their combined creativity.

Likewise, partners express great enthusiasm for their total togetherness. As Suzanne Scherer said, "We're together twenty-four hours a day . . . day and night. We couldn't do it any other way." In describing the extent of his involvement in collaborative work with Lilla LoCurto, Bill Outcault remarked, "It's what we get up in the morning and do and go to bed at night thinking about."

Diller and Scofidio jokingly refer to their time together as "dog years"—one year in a dog's life is equivalent to seven years for a human. Estimating the amount of time they spend together and how much they accomplish in a year, they conclude that it is probably equal to seven years of an ordinary couple's life.

All the pairs agree that they are much more productive as a team than they would be as artists working alone. For Sammy

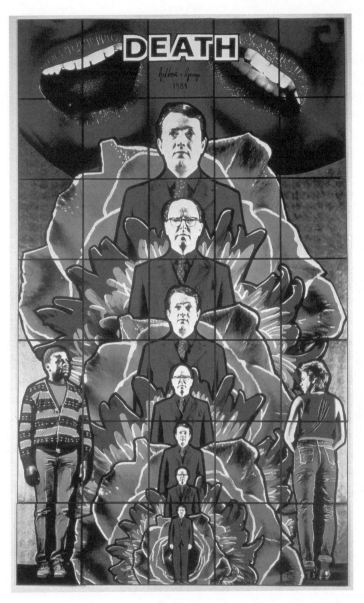

Death Hope Life Fear by Gilbert and George, 1984, the Tate Gallery, London, Great Britain. © Tate Gallery, London / Art Resource, New York; used by permission.

Cucher, the synergy brought about by his relationship with Anthony Aziz has "exponentially multiplied" their accomplishments. This opinion is seconded by Sterck and Rozo: "If we didn't have each other, we wouldn't be this far along." Scherer and Ouporov told us that a well-known artist examined their portfolio, marveled at the quantity of their output, and asked how old they were. At the time, Pavel was thirty and Suzanne was thirty-two. Hearing their ages, he retorted: "That's it—thirty plus thirty-two, that's sixty-two. O.K., that makes sense!"

∽०∾

Consistently, we found that co-creative couples incur no professional disadvantage. On the contrary, regardless of their age or when they started to collaborate, all of them make the same assessment—attributing their artistic achievements to the benefits of working together.

Each partner in these couples is gifted, resourceful, and keenly intelligent. Every one of them could easily fit the traditional view of the artist as an extraordinary individual. As a brilliant "genie," each has the power to make many of his or her own creative wishes come true. Instead, both partners have opted to blend whatever they have to offer one another, completely dedicating their individual lives to the welfare of their multifaceted relationship. In the process, they virtually create a new being—an invisible "geni-*us*"—whose powers of fulfillment in love and art far exceed whatever each "genie" in the pair could experience or do separately.

2

Transcending the Culture of Individualism

Co-career couples in art have agreed to cross the psychological line that leads most couples to put their love life and creative work into separate compartments. By rejecting this compartmentalization, they are implicitly making a powerful political statement. For them, the interpersonal—not the personal—is the political.

Most partners do not view the fact of their collaboration as a deliberate effort to advance a particular ideology. Yet all of them are engaged in a lifelong challenge to remain professionally and economically viable in a society that glorifies the creative output of individuals. To appreciate the cultural forces with which these couples must still contend, it is necessary to understand the historical evolution of intimate creativity in art.

Artistic collaboration between partners in a loving relationship is a comparatively recent development, but group collaboration is a very old method of making art. In the Dark and Middle Ages, as Christianity took root and flowered in Europe, illuminated manuscripts, stained glass windows, statuary, and soaring cathedrals were produced by many gifted people working together anonymously on the same project. Seeing themselves as members of the same spiritual community, these creative artists felt that

they were uniting their talents to glorify the loving Creator of all human beings.

During the Renaissance, the elevation of individual above collective creativity was reinforced by the simultaneous rise of capitalism, with its emphasis on material acquisition and economic competitiveness. Artistic success was redefined, from being a nameless contributor to a spiritual team to the attainment of public recognition for creating works of art—along with the ability to make money from them. Indeed, the Renaissance gave birth to the cultural novelty of singling out and glorifying particular artists, setting them above and apart from all others as worthy of dazzling rewards in terms of celebrity, riches, and esthetic influence.

In commenting on the rise of artistic egoism during this period, one historian writes:

> Here and now man aspires to bring to bloom his seeded powers and cherishes less a blessed immortality than an imperishable name acquired . . . by artistic and literary pre-eminence. . . . Surely, here we have a contrast to the prevailing anonymity of medieval donors and craftsmen who vied with one another to honor the Blessed Virgin without carving their names into the pediments. . . . The sculptors, painters, and poets first commenced to talk of their "creations." . . . All of the modern vocabulary of creative art, creative writing, creative painting stems thus from the Renaissance. The Middle Ages would have regarded such terminology as arrogant, if not indeed well-nigh blasphemous. Did not Thomas Aquinas say, "God alone can create, because creation is the bringing of something out of nothing, and that no man can ever do."[1]

This presumption, this desire to make something visually arresting out of nothing but a blank wall or a block of stone, motivated many gifted individuals to unleash the full range of their creative capacities. The magnificent results of some of these efforts, like Michelangelo's ceiling in the Sistine Chapel, could be seen as a creation intended to rival any done by a superhuman hand. It took him four years to complete the fresco, even with the assistance of

outstanding craftsmen, and he spent much of that time painting from a supine position on a scaffold suspended more than sixty feet above the floor.[2]

Of course, no amount of ambitious striving can, by itself, produce a moving, original, and lasting work of art. That requires a special degree of talent. But by legitimizing the connection between ambition and artistry, the Renaissance set the stage for making the solitary individual—not collaboration between individuals—the fount of creativity.

Italian princes of state like the Medici, financiers who used their wealth to gain political control over Florence, became great patrons of art to aggrandize themselves and their domains. Linked to the papacy by familial relationships, the Medici often employed the same artists to adorn the palaces and urban piazzas under their rule. In the following centuries, it became similarly fashionable for affluent members of the rising bourgeoisie, like merchants and burgomasters in Holland, to employ artists with the prominence and talent of a Rembrandt to flatter and immortalize them in portraiture.

In the Baroque period, illustrious artists exploited groups of unnamed employees for their own economic and professional advancement. Rembrandt's assistants flawlessly imitated his palette and brush strokes: "Thus, the one artist who has always been thought of as unique, as a particularly subjective kind of genius, seems to have been engaged in a form of corporate art making."[3] Rubens similarly used anonymous artists to help in producing his huge and numerous paintings. Andy Warhol's Factory, which he set up in New York in the 1960s, was a direct descendant of such entrepreneurial and self-glorifying ateliers.

In the late eighteenth century, when capitalism became the economic base for political democracy in America and Europe, individualism was elevated to the status of a sacred and universal truth. In the words of Thomas Jefferson, all persons—not just those in the aristocratic and mercantile elite—had God-given rights to "life, liberty, and the pursuit of happiness." By divine decree the individual—viewed as a self-contained unit apart from all others—was held up to be the means and measure of a successful existence.

In the secular arena of daily living, success in the pursuit of happiness had already been firmly defined in terms of progress in attaining the self-aggrandizing values of wealth, prestige, and power. Each individual was implicitly enjoined to apply his or her life and liberty toward endless competition with everyone else for those worldly rewards.

The philosophical and societal coalescence of this individualistic orientation greatly reinforced the allure of the Renaissance model for an artistic career. Requiring an ever-increasing specialization and division of labor, the ongoing industrial revolution provided artists with their own particular niche in the economy. By the end of the nineteenth century, they had become a distinct category of self-employed entrepreneurs. Catering to the middle as well as the upper classes, they sold their works privately or in galleries, as is commonplace today.

In giving visual form to what they see in looking inside or outside themselves, artists discover and release feelings and sensations welling up from each one's unconscious. Reciprocally, in viewing these creations, other people are induced to re-create, within themselves, an analogous experience of insight and catharsis. Public reactions consonant with an artist's experience in creating a work complete a cycle of mutual validation between artists and viewers.

This symbiotic relationship became more widespread as the number of artists grew along with the entry of more and more people into factories and offices. The freedom to derive the psychological benefits of creativity and yet survive economically—albeit minimally—was a magnet for artists. On the other hand, many people in routine jobs felt an acute need for the vicarious sense of creativity a work of art could give them.

In their role as producers of objectified originality, artists were expected to be idiosyncratic nonconformists, and lay people accorded the artist much greater leeway in departing from social conventions than they would ever give to themselves. For their part, artists began to incorporate this expectation into their own personalities and behavior:

[M]any artists celebrated or suffered their individuality as a central aspect of their art: Paul Gauguin self-consciously assumed it in his updated versions of the Romantic hero in South Sea Islands dress, and Vincent Van Gogh was a manifestation and victim of it. So great was the need for this type of individual that when some of Vincent's letters to his brother Theo were published . . . people clamored to see the paintings, to recognize this severely alienated but true individual, and to collect work by him. The fetishizing of Van Gogh's paintings as direct indicators of his personality is highly ironic, for it points to the fact that individuality in the modern era has been achieved only at great expense.[4]

The Dada Revolt against Artistic Individualism

The culture of creative and economic individualism seemed unalterably entrenched until early in the twentieth century, when a leading artist challenged it. Giving voice to his deep-seated repugnance toward the use of art as a vehicle for personal vanity, Jean Arp wrote: "The illusionist sculptures of the Greeks, the illusionist paintings of the Renaissance, led man to overestimate his nature, to separation and discord. The hands of our brothers became our enemies instead of serving us like our own hands. In the place of anonymity there arose renown and the masterpiece. Wisdom died."[5]

While Arp was writing these words, the death of wisdom was also being gruesomely enacted on the battlefields of World War I. Like Arp, other artists viewed the proper aim of art to be the illumination and edification of life itself. They were horrified by the obscene slaughter unleashed by the war; and by their recognition that it had been promoted by greed for corporate profits:

> The outbreak of the war had an immediate impact on the young avant-garde artists. . . . For those who were able to escape conscription, neutral Switzerland offered sanctuary. It was here, in Zurich, that Dada was born as a direct literary and artistic response to the carnage and upheaval in Europe.[6]

Arp was one of the founders of this movement. "In Zurich, in 1915," he reported,

> disgusted by the butchery of World War I, we devoted ourselves to the Fine Arts. Despite the remote booming of artillery, we sang, painted, pasted, and wrote poetry with all our might and main. We were seeking an elementary art to cure man of the frenzy of the times and a new order to restore the balance between heaven and hell.[7]

This utopian program was patently impossible for a small band of artists to implement. Still, as Arp notes, they threw themselves into it with missionary zeal. Within their limited milieu, Dada artists began to practice what they preached. Although they had launched their careers as solitary creators, many of them turned to collaborative work as a means of rebelling against the capitalist tradition of competitive individualism. In groups of two or more, they also departed from the artistic conventions of their time — experimenting with nonrepresentational styles and conveying politically radical messages. In their social ideals, the Dadaists appeared to revive — in secular terms — the unselfish and collective work that characterized the creation of religious art before the Renaissance.

Another strong wave of collaborative work arose during the same era among the Constructivists in Russia following the Revolution of 1917. Those Russian artists could scarcely have been expected to foresee the dictatorial restrictions that Soviet regimes would impose on creative expression. Rather, they were caught up in the excitement of celebrating, through the novelty of their own stylistic departures from the past, the establishment of a society that promised justice and plenty for everyone.

The Evolution of Co-career Couples in Art

No one can determine when, where, or under what circumstances lovers began to collaborate in making art. For all anyone knows, such pairs may have worked together diligently and fruitfully

throughout the centuries without exhibiting their creations in public. But the history of art, like the history of other areas of creative endeavor, can pay homage only to people whose work has been observed and judged by experts as a significant contribution to their field.

By this standard, some European couples—even before the outbreak of World War I and the Russian Revolution—had started to lay the foundation for combining a loving relationship with collaboration in artistry.

Charles Ricketts and Charles Shannon: The Valeists

Meeting in 1882 at the Lambeth Art School in London, Charles Ricketts and Charles Shannon "formed a loving relationship which lasted throughout their lives."[8] They shared a repugnance for the materialism of the growing industrial society, preferring the dreamy sensuality of the neoclassical Aesthetic movement, which was then very fashionable in England. But aside from their common values and tastes in art, what brought and held them together was the depth of their affection for one another.

Ricketts and Shannon began living together as students and, in 1888, moved into the house that Whistler had occupied in The Vale, Chelsea, a section of London favored by artists. In this commodious setting, they rented workshops to other artistic aspirants and, beginning in 1889, not only published their own magazines but also "designed books and often collaborated on illustrations as well as doing their own painting."[9] Oscar Wilde, most of whose books they designed, fondly referred to them as "The Valeists."

"Wilde felt at home in the Vale. 'I'm taking you to the one house in London where you will never be bored,' he once told a friend."[10] Wilde had in mind the stimulating social ambiance Ricketts and Shannon fostered in their home, where brilliant artistic and literary figures—including Yeats and Shaw—came to visit and take part in their weekly salons.

Along with their collaborations, The Valeists pursued separate careers. Shannon, while continuing to produce lithographs and drawings, concentrated on painting. Ricketts, while never

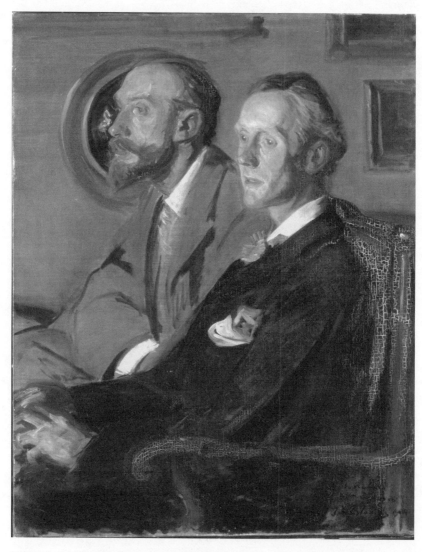

Painting of Charles Shannon (right) and Charles Ricketts (left) by Jacques-
Emile Blanche, 1904, the Tate Gallery, London, Great Britain. N04907/101.
© Tate Gallery, London / Art Resource, New York; used by permission.

abandoning painting, focused on lithographs and drawings. He also took over the business of publishing and producing books, including the management of the Vale Press, which he and Shannon had established in 1896 for the publication of scholarly works.

While hanging a large painting at an exhibit, Shannon fell from a ladder and struck his head on the marble floor. He eventually made a physical recovery, but not a mental one. Ricketts was so distraught that he didn't undress or go to bed for four days and nights after the accident. Subsequently, he sold some of their own art collection to raise money for Shannon's care. Paradoxically, Ricketts would die in 1931, while Shannon lived for six more years.

The very fact that this couple acknowledged joint authorship of the works of art they created as a team constitutes a notable step toward legitimizing artistic collaboration by partners in love. But it was not until 1979, almost a century after they met, that the two men were paired in a gallery exhibition subtitled *An Aesthetic Partnership*, which identified "both their shared artistic life and the spiritual and emotional quality of their relationship."[11]

Robert and Sonia Delaunay: The Synergy of Simultaneity

In 1907 Robert Delaunay, a young French painter, briefly met Sonia Terk in Paris, where she had come from Russia in 1905 to study art. When they met again in 1908, they quickly began an ardent relationship. Sonia was already pregnant when the couple married in 1910:

> They were approximately of the same age . . . of similar interests, energies, and passions, temperamentally different and for that reason enormously compatible and supportive . . . continually reviewing each other's work and providing each other with critical illumination and strength. . . . Founded upon honor and respect . . . the collaboration of the Delaunays was to prove one of the most genuine and unfailing in the history of art.[12]

Their son was born in 1911. Over the next few years, Sonia and Robert were extremely prolific. This is the period when "the two

artists, in collaborative development, made the break with descriptive art and gave themselves wholly to abstraction."[13]

In their work, the Delaunays wanted to represent the scintillating pace of life in their Parisian milieu and the rapid technological changes occurring in the city. Enthralled by the multihued halos of light emanating from the electric lamps that replaced the old-fashioned gaslights, they jointly originated a technique for

> integrating sensations of movement and immobility on a two-dimensional surface. Using strident juxtapositions of color, they evoked volume and depth . . . without recognizable subject matter. . . . They called the results simultaneity . . . and its principles would dominate the work of both for the remainder of their lives.[14]

The concept of simultaneity "incorporated virtual motion and suggested the reconciliation in art of that which is irreconcilable in nature: that two things, apparently dissonant and contrary, can not only be present together but in fact complement, enhance, enrich each other by their dissimilarity."[15]

Reflecting these ideas in painting, Robert went beyond his "deconstructive" phase—fragmenting, in cubist style, the powerful structural forms of cathedrals and the Eiffel Tower—to delve into "the examination of moonlight and ultimately of light itself."[16] From this study, he began his "constructive" phase, doing a series of paintings that are a pure abstraction of form, color, and light.

For Sonia, simultaneity led to a series of paintings that captured the layering effect of the circular colored surfaces produced by the lamplight. She then brought their new artistic vocabulary into the design of more functional products, such as women's clothing, fabrics, interior decor, and even automobiles. The vast body of her work centered on these areas, although she continued to paint throughout her life.

Some historians claim that she turned away from painting to avoid interfering or competing with Robert's career. Others say she was searching for a way to create a greater sense of movement, which could certainly be made manifest when a woman walked

around wearing the colorful, abstract patterns of the dresses and coats she created. Like a number of avant-garde artists of her time, Sonia rebelled against the hierarchical premises contained in the traditional definition of fine art. She believed that the basic principles of painting need not be restricted to that static form alone, but could be just as legitimately applied to the decorative arts, which reach a much larger audience.

Sonia incorporated the principles of simultaneity in designs and illustrations for books of poems by Blaise Cendrars and Guillaume Apollinaire, who often visited the Delaunays' home and attended the intellectual salons for which the couple was known. She and Robert also collaborated on a book project, "an album of orange and indigo blue sheets designed for a poem of Apollinaire's inspired by Robert's painting *Windows*. The project provided a powerful impetus toward their subsequent experiments with verbal and visual combinations."[17]

In 1918 the Delaunays were commissioned by Serge Diaghilev, whom they had met while living in Spain during World War I, to collaborate on the costumes and sets for the ballet of *Cleopatre*. This project established their reputation as a pair of exceptionally innovative designers.

The Russian Revolution deprived Sonia of the income she had been receiving from her parents, and she decided to commercialize her creations to make up for that loss. Returning to Paris in 1921, the Delaunays soon became part of the Dada movement there. Sonia established a very successful boutique, while Robert made displays for presentations of her work and managed the business.

The Delaunays collaborated with several colleagues in producing murals to decorate the Palais de l'Air and the Palais des Chemins de Fer at the 1937 Paris Exposition. Shortly after that, Robert became ill and died of cancer in 1941 in southern France, where they had gone at the outbreak of World War II. Although Robert and Sonia had many exhibits of their separate work, their productions were never shown together until 1987—after both of them were deceased—at a major exhibition in the Musee d'Art Moderne de la Ville de Paris.

The word the couple coined for their esthetic invention—*simultaneity*—can also be applied to the relational means by which they derived it. Together, they simultaneously thought out, talked out, and painted out their seminal concept. Then they agreed to tap into it as a common—and evidently inexhaustible—source of energy for their individual creations. The historian Whitney Chadwick has aptly described the unfolding of the Delaunays' creative life as a pattern "rich in loops and circles—like the prisms and discs of [their] painting—loops which sometimes parallel each other, sometimes intersect, only to swirl away again, always returning to a central point."[18]

Jean Arp and Sophie Taeuber Arp: Sharing Souls, Joining Hands

In Switzerland, the Arps made the next big advance in the evolution of co-career couples in art. Sophie met Jean in 1915, when she came to the gallery in Zurich where some of his works were on exhibit. Although they did not marry until 1922, they "fell in love with each other at first sight" and started working together just a few days later.[19] They became ardent soul mates, sharing the aspiration to express in art the spiritual transcendence they sought for themselves and wished for everyone. They were "motivated by Romantic hopes for utopia and communion. Working together as partners marked only a step toward a rejuvenated society."[20]

Jean Arp and Sophie Taeuber participated with others in Dada collaborations and, in bringing artistic collaboration and a loving relationship together, surpassed even their close friends the Delaunays. Jean and Sophie took the revolutionary step of doing a lot of hands-on work on the same pieces and represented their relational unity in the content of some of their joint creations. "They admired collaboration because it required suppression of the individual ego and devotion to a selfless ideal."[21]

Their groundbreaking relationship spanned almost twenty-eight years, punctuated by intervals of intense collaboration when they gave each other inspiration, technical help, praise, and criticism. They called their joint products *duos* or *duets*. "The impulse for an idea was transmitted in a continuous, wavelike motion

Jean Arp and Sophie Taeuber, Arosa, Switzerland, 1918. Courtesy of Stiftung Hans Arp und Sophie Taeuber-Arp e.V., Rolandseck.

from one to the other. Each had freedom, but could harvest abundantly from the other. They were considered a harmonious couple, completing each other ideally."[22] Jean's playful, inventive manner contrasted with Sophie's more rational and conscientious nature. He led her to become more aware and trusting of her creative abilities. She provided him with an attention to practical issues that counteracted his impracticality in both life and art.

They became a team in diverse media—painting, sculpture, drawing, embroidery, and collage—and experimented with combinations of different media. But of all the things they made together, a wooden piece called *Marital Sculpture* highlights their historic fusion of love and creativity. "The playful title is significant in itself," one art historian observed,

> for it designates art and marriage in such a way as to make them inseparable. The single head, no doubt embedding their unified minds, can be construed as an homage to their union. Not only does the title designate a work of art produced by a couple but it suggests that the marriage of true minds or skilled fingers has sufficed all by itself to give birth to the sculpture. And since the artifact represents marital union, it functions simultaneously as object and subject.[23]

Although Jean had already attracted widespread professional respect prior to meeting Sophie, he warmly welcomed her artistic input from the outset of their relationship. He admired the luminous colors and simple forms she used in her abstract compositions. She and he were equally essential in coping with every aspect of the life they shared: She held a steady job for many years to earn a living for both of them and, being an architect as well as an artist, designed the house in which they lived.

Along with their collaboration, Sophie and Jean had continued to work separately and maintain separate identities as artists. But like the Delaunays, they perceived their individual work as stemming from the seeds of content and form they had devised together in widening the scope of abstract art. As a couple, they have been praised for representing a seamless merger between the sexes. "By their dovetailed togetherness, the duodrawings

convey . . . an idyllic androgyny."[24] Proof of their artistic unity is the inability of experts to ascribe specific authorship to many of their creations.

Nevertheless, like the Delaunays, the Arps never identified themselves fully as a professional team. Perhaps they were more imbued with aspirations to individual recognition than their utopian ideology allowed them to admit. Sophie's untimely death in 1943 certainly prevented their eventual development as a complete co-career couple, but they demonstrated that artistic collaboration between lovers can be a boon to intimacy and creativity.

Postwar Individualism

The onset of World War II seems to have discouraged collaboration between artists. Perhaps its destructiveness and dislocation led everyone, even lovers, to become more preoccupied with sheer survival than with pooling their energies to enhance their creativity and relationships. Artists and nonartists alike became concerned about repairing their lives and securing their futures.

Among all the Allied nations, this physical and emotional recuperation was easiest for America, since the war was not waged on its own territory. Europe paid a much larger price — not only in lives and property, but also in morale and creative sparkle. By the time Sonia Delaunay returned to Paris after the defeat of Germany:

> The whole cultural climate of Paris had changed. Instead of the light-hearted, cocky anarchy of Dada and the Freudian fantasies of Surrealism, there was the rather dour Existentialism of Jean-Paul Sartre and his band. . . . While there was important intellectual activity, the sense of ferment and the release of gaudy bubbles was gone; there were no Scott Fitzgeralds living off champagne and dancing the night away. And most significant of all, Paris was no longer the art centre of the world; New York had taken over that role during the course of the war.[25]

But even in postwar New York, artists turned severely inward and away from creative collaboration. This tendency became

glaringly conspicuous among the abstract expressionists of the 1950s. Like the existentialist writers in France, the abstract expressionists saw their art as an attempt to articulate the sense of standing before a void. They "used martial metaphors to describe the act of painting, words like engagement, struggle, victory and defeat" to connote their artistic combat with the nagging torment of inner emptiness.[26]

In ideological contrast to the Dadaists, who united in an organized effort to spread artistic and social commonality, the abstract expressionists "were joined only by a common allegiance to individually intuited knowledge. They established a new standard of individuality . . . as a divinely inspired gift but an incredibly difficult burden that frequently resulted in periods of extreme depression, bouts with alcoholism, and suicide."[27]

The Resurgence of Artistic Collaboration

The reawakening of creative collaboration began at a time "of intense social idealism and nostalgic desire for the social integration of the artist." As in the early part of the twentieth century:

> [A]gain in the late 1960s and early 1970s, [artists] longed for a radical restructuring of art itself and sought ways to communicate more directly with audiences outside the art world. They hoped to liberate art from the constraints of commerce and aestheticism and make [it] a vital force in the world.[28]

This artistic upheaval was attuned to the vigorous social struggles for liberation from racism, sexism, homophobia, and militarism. The movements for civil rights, peace, gender equality, and gay and lesbian liberation could not fail to affect the attitudes of artists toward their work—and toward one another. Many of them were uplifted by the struggle for a more just, cooperative, and peaceful society, for a world in which compassion and generosity would replace ruthless competition and self-centeredness. And the love-consciousness extolled in the mores and music of the counterculture emphasized the supreme value

of people relating lovingly to one another in every sphere of daily life.

Meanwhile, more and more artists began to depart from modernist orthodoxy. Hard-edge painting, minimalist sculpture, and conceptual art vied for attention with body and performance art and films. These innovations opened up fresh vehicles for artistic expression and collaboration in live performances, "happenings," multimedia constructions, installations in public places, and linkages to electronic and every other kind of modern technology. Groups of people began to collaborate as artists/activists, effectively employing the developing media to create and disseminate the esthetic embodiments of their social messages.

There were setbacks in the 1980s:

> The tentative steps taken in the 1970s toward a more democratic climate were completely reversed by a renewed emphasis on market-driven concerns as the commodity status of the art object, the cult of the individual artist, the prestige of collecting, public-relations packaging, and media manipulation were elevated to new heights. Male painters dominated the scene until the late 1980s (some acquired stardom and enormous wealth virtually overnight), and the backlash against feminism was echoed in the art world, where the gains of the 1970s seemed suddenly to vanish.[29]

This reactionary upsurge did not stop progressive activists from collaborating, however. The Guerrilla Girls, a group launched in 1985 and still thriving, mounted very effective graphic protests against galleries that excluded women artists from representation. During this period, in fact, an increasing number of artists "addressed many of the same issues as political activists and advocacy groups on the left, including the nuclear crisis; imperialism; . . . the environment; homelessness and gentrification; racial, ethnic, and sexual politics; . . . and the AIDS crisis. Interestingly, the AIDS crisis of the 1980s politicized the art world in much the same way feminism did in the 1970s."[30] Gran Fury, a group who worked together from 1988 to 1992, produced viscerally moving posters to advocate greater public involvement in fighting this scourge.

Like these groups of activists, some partners in intimate creativity began to use their artistry for the explicit purpose of conveying their social values. Worried about the prospects for human survival, Helen and Newton Harrison teamed up in the late 1960s to document the human impact on the environment. Their art communicates the urgent need for the preservation and regeneration of the planet's delicate ecological systems.

Married in 1953 at an early age, they didn't start their co-career until later in their lives. Still, their work represents a total synthesis of their separate skills and sensibilities. As a member of the art faculty at the University of California at San Diego, Newton was trained as a painter and sculptor. Helen had a separate career in education and sociology before collaborating artistically with him. The couple shared a teaching position for several years before retiring from academic life.

According to Robert Hobbs, the Harrisons combine the goals of cooperation and nurturance with the ecological concept of listening to the needs of the environment:

> They have evolved a mythic/poetic/scientific art. . . . [They] ask for a new understanding of the need to collaborate with Nature, and they help to manifest this need directly . . . by collaborating with each other. In this manner the subject matter reinforces the means by which the art is created and both become part of its plea for integration.[31]

Carole Conde and Karl Beveridge, a Canadian couple who lived in New York during the 1960s and 1970s, also experimented with ways to make their art a direct form of social action. Using banners, cartoons, photographs, and posters, they viewed their creations as media for criticizing the existing society and helping to usher in a more just socioeconomic system. On their return to Canada, they worked as a team to involve members of various trade unions in the collective creation of art. Much of what the couple does emphasizes the promotion of greater acceptance and equality for women in the workforce: "They bring to their projects a sensitivity to gender issues that reflects their own experiences and struggles to work together as artists. As such, their external

collaborations with unions mirror an internal commitment to the collective process of questioning and discussion in their own art."[32]

Complete Co-careers in Art: Pioneering Couples

Two couples who began their careers in the late 1950s are still very much alive, productive, and celebrated in the contemporary world of art. Although their professional collaborations evolved differently, both pairs have always displayed a similar degree of commitment to their loving relationship and their joint creativity.

Bernd and Hilla Becher: Picturing a Passing Era

As far as we could determine, Bernd and Hilla Becher, both from Germany, were the first couple of recognized artistic merit to work together on a full-time basis and to identify themselves exclusively as a professional team from the outset of their relationship. Their photographs have been exhibited in leading galleries around the world and are part of the permanent collections in a number of museums, including the Guggenheim and MoMA in New York.

The Bechers began their co-career in 1959, soon after they met in Dusseldorf. Born in 1931, Bernd had studied painting and lithography in Stuttgart and typography at the Acadamie of Arts in Dusseldorf. Hilla, also born in 1931, was trained in photography in Potsdam and had been an aerial photographer in Hamburg before moving to Dusseldorf. They were married in 1961 and had one child, Max, who would become the partner of Andrea Robbins.

Hilla and Bernd's merger can be regarded as a forerunner of the egalitarian relationships we found among all the couples we interviewed for this book. Moreover, their collaboration began long before the cause of gender equality was vigorously advanced by the women's movement of the 1970s.

Patiently and systematically, they have recorded a passing era of industrialization with unadorned black-and-white photos of

silos, grain elevators, blast furnaces, and water tanks throughout Europe and North America. In displaying their work, they typically group together several pictures of buildings with the same or similar design to bring out the basic structural pattern of the images for the viewer to compare. "Together they developed a documentary approach to photographing their industrial surroundings that introduced new kinds of social, cultural and aesthetic questions about the increasing destruction of many late nineteenth century buildings."[33]

By 1977 the Bechers had established a department of photography at the Dusseldorf Kunsthochschule, where both taught. Since then, they "have become the best-known and most influential photographers in Germany."[34] Thomas Struth, Thomas Ruff, Axel Hutte, and Andreas Gursky are all prominent alumni of what has been called the "Becherschule."[35]

When the students felt ready for an evaluation of their work, they brought it to the Bechers' house, "a crumbling former paper mill in the suburb of Kaiserwerth. Most of the house had been turned into darkroom areas and work spaces, and you could smell developer when you came in the door. Hilla was a warm personality and a great cook, and Bernd had a library of photography books that the students could always borrow ('or steal,' as he put it)."[36]

Andreas Gursky, acclaimed for the 2001 exhibit of his monumental photographs at MoMA, recalls, "What was important to me about the Bechers was to see how they lived. . . . It was so different from my parents. . . . Everything in the house was for photography." Gursky developed his own style, but during his six years of study with the Bechers, he "internalized the discipline and high seriousness of their approach."[37]

The Bechers have made an important contribution to the development of conceptual art. With the dedication of archivists, they have preserved the achievement of anonymous architects who built in a common style:

> This quality of anonymity, of cataloguing types rather than emphasizing individual production, is a modus operandi for the

work and themselves. The subject matter reinforces the matter-of-fact, low-key interest in work and the submerging of artistic ego. . . . [They are] two individuals who are attempting to forge a new concept of a collaborative self.[38]

Christo and Jeanne-Claude: Wrapped around Each Other

A collective powerhouse, Christo and Jeanne-Claude have been described as "extremely well-matched in their tenacity and appetite for hard work."[39] We witnessed an impressive display of their combined energy when Jeanne-Claude greeted us in the dark stairwell of their eighteenth-century loft building in Soho with a walkie-talkie in hand. She quickly buzzed Christo in the fifth-floor studio to signal our arrival. By the time we were ready to enter the modernized gallery space on the first floor, he had dashed down the four steep flights of steps to join us. Interacting with the two of them was like confronting a force of nature.

Christo grew up in a financially comfortable and cultured family whose security was shattered when the Communists took over Bulgaria following World War II. His father, a western-educated scientist, was harassed and hounded, the chemical factory he owned was nationalized, and he was imprisoned as a "saboteur." Christo's mother, to whom the artist was very close, had once been secretary general of the Academy of Fine Arts in Sophia.

Deciding early in his life to become an artist, Christo began his formal training at that academy in 1953. By 1956, he found the political and esthetic dictates of the authoritarian regime intolerable. "Bulgaria was the most ardently Stalinist nation in the Communist bloc, the isolated hinterland of Europe, and Christo knew that if he was ever to see the work by Matisse or Picasso . . . outside the covers of a book, he would have to go west. His dream was of Paris."[40] Withdrawing from the academy before completing the full course, he fled from Bulgaria, first to Prague and then to Vienna, where he remained for one year to study art. Moving on to Paris, he supported himself by painting portraits of families and children. This income permitted him to do his "real art,"

which consisted of small-scale installations and wrappings of small objects.

Jeanne-Claude was born into a wealthy and influential French family. Her father, an army general, accompanied DeGaulle in the liberation of Paris. Her mother was a comtesse. Although she had a baccalaureate in Latin and philosophy from the University of Tunis, Jeanne-Claude was living the pampered life of an aristocrat when Christo came to her home to paint a portrait of her mother. "I was riding horses and playing tennis," she recalled, with a wince that emphasized how bored she had been.

Her boredom was banished by her instant attraction to Christo, who was just as smitten by her. Her parents' hostility toward their relationship made Jeanne-Claude desperate, and she tried to placate them and "exorcise" Christo from her thoughts by impulsively marrying a man eleven years her senior from her own class and cultural background. She described him sardonically as "the perfect husband," a man with a good economic situation who played tennis and bridge and rode horses. Christo was deeply hurt.

It did not take Jeanne-Claude long to realize she had made a terrible mistake. Within a few weeks, she had locked her husband out of her apartment and resumed her love affair with Christo. She terminated her loveless marriage and wedded Christo.

They decided to face the future as a team. With Jeanne-Claude at the wheel, they drove all over Europe, bringing exhibits to various galleries. They were so poor they often had to sleep in their car. After their son was born, they took him along on these stressful trips.

It was once assumed that esthetic decisions were Christo's alone. Although he does all the drawings and preliminary sketches, Jeanne-Claude has always contributed her own ideas to everything they do. Together they handle the complicated financial and organizational arrangements essential to plan and complete each project. In addition, both are regarded as masters of communication. They were the first artists to include *human* impact statements along with the environmental reports they submit.

The first time we saw them, they were lecturing as a team at the Fulcrum Gallery in New York in the fall of 1996. Christo

proudly mentioned that Jeanne-Claude had initiated the idea for the *Surrounded Islands* in Biscayne Bay, Florida, considered one of their most attractive projects. Later, in our interview, they admitted that when she disagrees with Christo over how something should be designed or executed, they might scream and argue over who knows better. But when they consult their engineer, Jeanne-Claude gleefully informed us, it often turns out that she was right.

Although she had no formal training in art, Christo and Jeanne-Claude see themselves as totally equal and indispensable co-creators. No matter how they divide the labor, both regard the *actual implementation* of a work—finally putting it in place in its intended setting—as the essence of their art. In this respect they differ from those conceptual artists who consider the rendition of a plan for an installation as the completed work of art. "We want to see it happen," say Christo and Jeanne-Claude. Regardless of the diverse interpretations of critics and historians, the couple feel that their creations are expressions of love, joy, and beauty— bringing pleasure to both of them and, hopefully, to others. None of their ideas could come to fruition if they didn't work together to solve the problems that arise in the process of bringing their "babies"—as she so endearingly calls them—into the world.

While their creative projects have usually been attributed solely to Christo, many people have underscored Jeanne-Claude's crucial contributions:

> The single most important person in the Christo entourage next to Christo himself is his wife. . . . In fact he would be lost without her. . . . It is Jeanne-Claude who keeps everything moving. Whether it is raising money for projects, deferring the public and the press if [Christo] is otherwise engrossed, or getting people, materials and food to the right place at the right time— Jeanne-Claude is the one who manages the operation with an iron fist in a velvet glove. . . . [She] is a necessary, integral part of every aspect of Christo's art and his life as an artist. She is at [his] side at public hearings and lobbying sessions, she contributes to the decisions for each project. . . . She is a brilliant, motivated woman who works tirelessly to achieve the impossible. And she succeeds. . . . She can miraculously be in ten places at one time,

and she has the uncanny ability to persuade everyone else to be in ten places at one time too. She can also be witty, charming and the best friend you could hope to have around when problems arise.[41]

One of the workers on *Surrounded Islands* gave a down-to-earth description of their collaboration:

Christo's a guy that you talk to him and he will listen. . . . It's good to work for a guy like that. He's a very emotional guy to work with, very expressive. Jeanne-Claude she's very demanding. She wants her thing done right, and I agree with her, you know. But that's what makes the thing so beautiful because both of them have an attitude that what Jeanne-Claude doesn't have Christo does. Or what Christo doesn't have Jeanne-Claude does. I think they make a beautiful team the way they are.[42]

3

Embracing a Collective Identity

Nobody is born with an identity preformed—only with the potential for constructing one. Children slowly form a concept of themselves from bits of information derived from introspection and their social surroundings—especially parental caretakers and peers. Growing in cognitive sophistication, they add many new elements to their self-image: their gender; race and ethnicity; physical characteristics and attractiveness; and convictions about their abilities and personality, including their intelligence, assertiveness, and athletic and vocational talent.

The attainment of biological maturity presents teenagers with a plethora of fresh material to absorb and incorporate into their concepts of self. Preoccupied with the task of cutting loose from childlike attachments to parents, adolescents struggle to consolidate their sexual orientation and assume complete responsibility for all aspects of their lives. During this period, they also make crucial decisions about the kind of education that will permit them to utilize their particular talents and become economically self-sufficient.

Once in the workforce, young adults begin to concentrate the development of their personal identities around their jobs or careers. Eventually, however, the innate need to love and be loved

becomes imperative. No matter how well they are doing vocationally, most adults feel impelled to find someone with whom they can create a loving relationship.

But uniting with someone in love entails a *reversal* of the long process of separation and individuation that precedes the attainment of adulthood. A committed relationship of love involves a voluntary and unconditional attachment to another person—an intimate merger with a depth and scope unprecedented in an individual's past relationships with parents, siblings, and peers. It is not easy to make such a fundamental shift from the individualistic thrust of one's earlier development. People fear they will lose or dangerously diminish the precious sense of self they worked so hard to construct. "As Paul Simon's lyrics from the song 'Slip-Slidin' Away' succinctly convey, 'Dolores, I live in fear. My love for you is so overpowering, I'm afraid that I will disappear.'"[1]

Yet the matchless gratification of their interpenetration in mind and body motivates lovers to put aside such qualms. In creating the "we" that designates them as a couple, they do not lose their individual identities. Instead, they expand the boundaries of their separate selves to include one another in a new collective identity. From then on, this "we" or "us" is the conceptual shorthand they use to symbolize the entirety of their relationship. Now, while retaining their personal concepts of self, both partners also define themselves by membership in their interpersonal union.

A couple's collective identity is not located solely inside the perimeter of either partner's separate being. Rather, each one perceives it as existing within—and enacted between—both of them. Serving several crucial functions, their collective identity provides partners with a common concept for defining themselves to one another. It gives them the same ongoing goal for uniting their energies. Presenting themselves as a couple in public, they offer other people a coherent means of relating to them as a pair.

Seeing themselves as members of the same "we" makes each lover feel stronger as a "me." The loosening of ego boundaries

between them "is *enjoyed* as feelings of selflessness and oneness with the beloved, virtually losing one's self into the bond and fulfillment of romantic intimacy. This flow of feeling, surrender to a powerful force and excitement of risk makes the lover feel alive in ways he or she has not previously experienced."[2] Paradoxically, therefore, partners create the optimal conditions for continuing to grow ever stronger as individuals by *intensifying* their intimate connection—rather than by *differentiating* themselves from each other.

While interacting, lovers are constantly making new agreements and decisions about how they want to relate to one another and live in the world. Just as they previously added new elements to their personal self-images, they continue to create an evolving portrait of their relationship. As their needs and desires change, couples eliminate from their collective identity features that have ceased to be gratifying. They formulate new goals and objectives that promise to be more consonant with their growing abilities and desire for greater intimacy.

> For example, on getting married . . . we saw ourselves as talented members of a well-matched and happy pair. We had no doubt about how close we wanted to be nor how much we enjoyed each other's company—in and out of bed. So our hopes for the future included the idea of having a great deal of time to be together. . . .
>
> However, our definition of creativity, at that time, was extremely individualistic: still tied to seeking acclaim for the products of our personal uniqueness. So, in our most outrageous fantasies we portrayed ourselves as the "Renaissance Man and Woman," each striving for one's own greater glory.
>
> Since we had not yet clarified our position about the preeminence of our relationship, we frequently lapsed into tipping the balance of our values in the direction of individual egoism. Still, whenever we felt the noxious effects of that imbalance, we did try to right ourselves again by putting more weight on the side of love. . . .
>
> Eventually, we stopped our waffling and chose conclusively in favor of loving, but not until we had developed sufficient awareness of the importance and power of our *relationship*.

With that insight, we made a fundamental change in our common dream, adding our present concept of working together and dropping our previous fantasies of personal striving. Now we fully utilize our separate talents in jointly producing our lectures and our writing, and the more we unite through our *interpersonal* creativity, the more we bring out our individual capacities for self-expression and improve the quality of our collective production.[3]

Of course, no couple can devote the same amount of time and energy to every activity that reflects a part of their collective identity. Instead, lovers establish priorities among their shared allegiances; and they act in concert on those values. Devoted to nurturing their children, one couple may identify themselves primarily as parents. Another may favor a common spiritual practice over anything else they do together, upholding their identity as members of a particular religion. Others may be just as fervently dedicated to political action, defining their identification in terms of a position on the spectrum from left to right.

Like us, some partners in a loving relationship do not pursue separate careers. They choose to become partners in work as well. As we found in our previous research on marital relationships, many of these couples are functioning successfully in retail businesses, manufacturing, computer consultation, and a variety of other fields. All of them have made vocational collaboration a guiding element in their collective identity. They demonstrate that spending most of their time interacting with one another—albeit through the medium of whatever work they do—is at the top of their individual and collective priorities.

As an affirmation of their priorities, co-career couples in art make intimate creativity the centerpiece of their collective identity. They integrate their private identity as a loving couple with their public identification as a professional team. But this integration does not occur automatically. Like co-career couples in other fields, each pair of artists makes it happen by deciding how they want to meld their abilities and present themselves to society. As Sammy Cucher said, "Each couple builds their relationship on

what they accomplish together. My parents did it through their children. For Anthony and me, each project we do becomes another part of the foundation for this build-up."

For Aziz and Cucher, and the majority of the couples we interviewed, the decision to be partners in love and art posed few, if any, problems within or between them. Amazingly, from the outset of their relationships, these partners shared an intuitive conviction about their ability to do creative work together. They quickly harmonized their artistic collaboration with their public representation as a professional team. Some partners, however, experienced difficulties, for various lengths of time, in defining their collective identity as artists and bringing the reality of their collaboration to public notice.

Quick and Seamless Bonding in Love and Art

Gilbert and George

What makes Gilbert and George truly unique is how thoroughly they have obliterated their individual differences and re-created themselves as a single entity. In this transformation they perceive no demarcation between their personal existence and their joint artistry.

Gilbert had come from Italy to St. Martin's School of Art in London, where he met George, a native Englishman. They soon united in a loving relationship and an artistic career. After leaving St. Martin's, they settled into a rundown house in the East End of London, which they have refurbished over the years.

Very early in their co-career, Gilbert and George displayed themselves as a living work of art in their *Singing Sculptures*. "Dressed in their now famous suits, their faces painted with metallic paint and wearing gloves they mimed along to . . . 'Underneath the Arches.'"[4] This seven-hour marathon yielded a pivotal harvest of publicity and had a powerful effect on the subsequent development of performance art. By turning themselves into virtually inanimate objects, it has been said, they made a

more complex sculpture than any other could be—a sculpture that has not only a surface but also a soul.

Our only opportunity to meet with them occurred in the Sonnabend Gallery in Soho at the May 1997 opening of their show *The Fundamental Pictures*. Exceptionally reclusive, they had declined our written invitation to participate in a full-scale interview. We found them seated in a room off the main exhibit space. Gilbert showed some signs of fatigue; George exuded the composure of an unflappable country vicar. Although they hadn't expected to speak with us, they were cordial when we introduced ourselves.

George, who stood up to shake hands, explained their reluctance to be interviewed in the terms we had described to them: a couple who collaborates in creating art. He informed us that they do not collaborate—they are a work of art. Evidently, we had made a semantic error in our letter. When we pressed him to elaborate, he said that they work together to create a unified work of art—that is their life.

Gilbert and George are proud of their long, loving relationship. The affection and trust passing between them were as spontaneous and sincere as any we encountered in our interviews with other couples. Both beamed with satisfaction as George told us they were still happily together after thirty years—even though many of their instructors and colleagues at St. Martin's had predicted that their relationship would not last and they would fail professionally. Leading historians now regard them as the "Godfathers of contemporary British art."[5]

Anne and Patrick Poirier

Anne and Patrick were both students at the Ecole Nationale Superior des Arts Decoratifs in Paris from 1963 to 1966. They trace the origins of their co-career to their travels in Cambodia and Italy during the 1960s. Discovering their common fascination with archeology and the fragility of civilizations, they began to center their artistry on the ethereal theme of memory's loss and preservation. "We believe that . . . hate and violence between

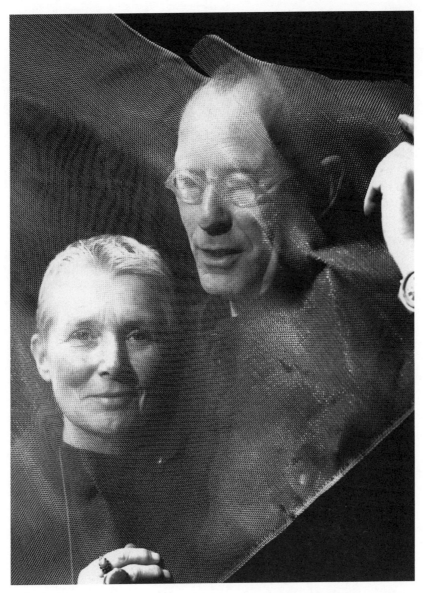

Anne and Patrick Poirier. Photo by Vincent Knapp; courtesy of the artists.

peoples, intolerance in all its terrible forms, all begin with ignorance and the voluntary destruction of Memory; . . . that in the contemporary world, the destruction of both Cultural memory and Nature have quickened; and that we must, with all the modest means at our disposal, oppose the generalized amnesia and destruction."[6]

When at a particular site, the Poiriers are moved by exactly the same things. They often go off alone to look at the ruins, but when they meet again to talk over their notes and observations, "always, we have the same impressions — separately, but together."[7]

Working together "came naturally," Anne was quoted as saying in *ARTnews,* "because Patrick and I had not worked a great deal separately." Although they were involuntarily captivated by each other when they first met, their collaboration is based on a conscious choice: "We thought it would be richer to share something."[8]

Married in 1968, the Poiriers exhibited their first collaborative work in 1970 and went on to garner international recognition. By now, they are a familiar and respected team. Like Bernd and Hilla Becher, they have done a lot of research into the real ruins or sites they memorialize. But they also create cultures and ruins of their own invention.

They have even composed a beguiling myth about their relationship, claiming to have met in the Louvre, where one was sitting in front of a painting when the other came along. In conversing, they discovered their common love for the picture. Then, presumably after several years together, they discovered that they were twins who had been separated at birth and raised in different households.

When called to account about this story, they admit it is a hoax they play on the public. But they insist that the part about meeting in the museum is true. The Poiriers — like Christo and Jeanne-Claude — employ the metaphor of being long-lost twins to characterize how well they mesh as a pair. Actually, Anne and Patrick were born only a few days apart in the spring of 1942. Besides, there is a definite physical resemblance between them, and, like Gilbert and George, they often dress alike.

In an installation mounted in 1996, Anne and Patrick took a quantum leap in combining their imaginations by looking forward and backward in the same work. Offering a sleek construction of a future civilization in outer space, they also display artifacts of its eventual ruin. In *Ouranopolis* (the Greek word for Sky City), the Poiriers have deepened the complexity and subtlety of their thinking about time, place, and memory. Indeed, the "Our" in its title could aptly describe the fruitfulness of their collective identity as an artistic couple.

Andrea Robbins and Max Becher

Upon being introduced by mutual friends at Cooper Union, where both were studying for a bachelor of fine arts (BFA), Andrea Robbins and Max Becher "connected" very quickly. "It took an evening," Max said, smiling. "We were married from the beginning." Their collaboration is not based on any ideology. According to Andrea, it was a matter of having found "someone like-minded who could finish your thoughts, someone who you trusted unequivocally. We have almost everything in common."

While still students, the pair had long talks about their interests and goals. Disdaining materialism, they wanted to live a simple life, work on interesting projects of good quality, and avoid the distraction of "buying things." They agreed to pour whatever money they earned as artists back into their creative work.

Soon, Andrea began to work with Max on a film he had been making with a crew of assistants. He worried about whether or not the crew could be trusted to do things right; and he was uncomfortable being a boss. Max preferred the intimacy and equality of collaborating with Andrea. Functioning as the smallest possible team, they worked together smoothly and with complete mutual trust. Later, she contributed to another film he made as part of the thesis for his MFA at Rutgers University.

Eventually, Andrea and Max decided that still photography would be the best medium for a merger of their diverse talents. By 1986, only two years after they met, the couple publicly identified

themselves as a collaborative team at their first professional exhibits in New York and Marseilles.

Describing themselves as "quiet, private people," neither Max nor Andrea wishes to be identified as the "special one, the exception—the artist." Wanting their work to speak for both of them, they refuse to play cliché roles as characters in the art world, where people prefer, as Max says, "stars who make a big scene." Rather, they revel in the intimate cultivation of their love and creativity. "We feel so lucky to be able to do what we want to do. It's our pleasure," Andrea said. "We have our work. We have each other." Max went on, "It's intensely cooperative."

Katleen Sterck and Terry Rozo

The instantaneous attraction between Katleen and Terry occurred when Terry was taking photographs at a women's motorcycle club outside a bar in Greenwich Village. She spotted Katleen in the crowd, and, as they exclaimed, "We never left each other after that." Going to Katleen's apartment, Terry noticed her self-portrait on the wall. As soon as she saw the photograph, Terry announced, "We're going to work together." For these two women, "the word 'self' means both of us. We're one entity."

Their collaboration began when Terry exhibited her motorcycle pictures and Katleen took photographs for the announcement. A few months later, they went to Belgium, Kat's country of origin, to participate in the American Cultural Show *Two for the Road,* presenting a New Yorker's view of Belgium and a Belgian's view of New York. In this exhibit, both of them showed photographs they had taken separately. But that common exposure sealed their collective identity.

In the pictures they have taken of each other, Katleen and Terry blurred the details of their individual images beyond recognition. The viewer cannot discern the identity of the model, yet the matter of who does the modeling is of central importance to the artists. Once they tried using a friend, but "it wasn't the same, something got lost." Perhaps the presence of another person was jarring because it diluted the intensity of their private mode of communication.

Sharing every aspect of the process—from shooting and modeling to doing all their own lab work—enhances their intimacy. Formerly, both felt burdened by "going solo" and handling everything alone. But now, they told us, having incorporated artistic collaboration into their everyday life, each one feels much stronger individually. As Terry said, "The whole is bigger than the sum of its parts."

Suzanne Scherer and Pavel Ouporov

Suzanne was extremely moved on seeing one of Pavel's paintings in a student exhibit at the art institute in Moscow, where she had come to study. A highly sensitive and detailed rendition of flies on a grid, his picture stood out from all the other work, which still reflected the style and subject matter of Soviet Realism. She *had* to meet this person and asked friends to introduce them.

Pavel had heard about her arrival. No American had ever studied there before. Many people thought she would do abstraction and corrupt the school. He was regarded as a troublemaker himself because his work was not politically correct; and he had been suspended from his department for a few months. So, he was just as curious to meet her.

The pair "clicked" immediately. Communicating with the aid of dictionaries and their own drawings, they waited patiently for each other's response—"sometimes for half an hour," Pavel joked. They also went to museums together and discovered their common approach to art.

Pavel asked Suzanne to work in his studio, where he had a print-making press. Soon, she moved from the dormitory into his small apartment. Their collaboration began when Suzanne was having trouble rendering a hand in one of her paintings. Wordlessly, Pavel took a brush and started to paint over it. At first, she was in shock: What's this guy doing, touching my work? But she liked what he did and realized how well they could function as a team.

After two years of living and working together, in 1991 the couple came to New York for a visit. They had planned to return

to Moscow because it was much cheaper to live there and Pavel had already established excellent connections in the Russian art world. The attempted coup in Red Square convinced them not to go back. Pavel had only a visitor's visa, and the prospect of parting was unbearable to them. So they got married in order to remain in New York.

To make money, they had to take separate jobs and stifle their yearning "to be together, do what we loved, and to do only what we loved, and to somehow support ourselves doing that." For more than a year, they were able to paint only after coming home in the evening. Exhausted by this arrangement, they agreed to take a break from their jobs and just do their art. By 1993 they were exhibiting their paintings and etchings and selling enough work to live on. Like other pairs we have described, they, too, include images of themselves in many of their pictures.

While Scherer and Ouporov now exhibit in a variety of venues, their early work was shown primarily in galleries that focus on Russian artists. For some time they were pegged into what they refer to as a "Russian niche." People even tended to identify Suzanne as Russian. Now, however, they are rapidly moving beyond this stereotype on the strength of the universal themes they portray in their paintings.

Overcoming Problems about Public Identification as a Team

Elizabeth Diller and Ricardo Scofidio

This couple's artistic collaboration grew out of their initial attraction for one another, sparked by "the similarity about the way we thought and saw the world." At the time they met, Ricardo was Elizabeth's architecture teacher at Cooper Union. He was in an unhappy marriage, unable to express his deepest thoughts and feelings. As Liz and Ric said, their romance could be seen as a Pygmalion cliché—the professor and the student. But there was a free, meaningful, and mutually respectful discourse between them

from the start. In fact, Liz was first drawn to Ric because of his understanding and appreciation of her innovative ideas.

He waited until she was in her third year to declare his love, and they embarked on a passionate affair. After graduating, she started to work in his small architectural firm. Ric's marital relationship deteriorated further, and his practice was on the verge of falling apart. After divorcing his wife, he felt he had to stop one life and begin a new one.

Liz had never been interested in a conventional architectural practice. She wanted to get grants, do "guerrilla architecture," find sites—or "steal sites," as she said—and build things where you weren't supposed to build them. While maintaining their practice to provide the income they needed to survive, they worked together on the kinds of "alternative" projects Liz had envisioned. Soon, they became known for their unique way of combining various media in a single installation.

Although they quickly embraced their collective identity as a loving couple, Liz and Ric balked at claiming joint authorship for the work they did together. Instead of regarding the projects as "theirs," they assessed each one as "his" or "hers," depending on some arbitrary notion of how much each had contributed to it.

According to Liz, resistance to acknowledging their joint creativity was more in her head than in Ric's. "I suppose it was because I was very young and hadn't done anything yet. It had all happened very quickly between us, weaving everything together, and my autonomy became blurred." She wanted to establish her own career, earn her own money, and make a "name" for herself. It was "sort of like having my own private bank account." Besides, she had been negatively influenced by the prejudice—still tenacious in some quarters of the art world—that collaboration is of less intrinsic value than individual creativity.

Of course, Liz and Ric bring different ideas and abilities to their intimate creativity. But who thought of a particular concept, and who did what in implementing it, became more and more indistinguishable. As their work grew in size and their opportunities for collaborative projects increased, the issue of separate authorship became irrelevant.

Liz realized she needed to discard her old-fashioned idea of having to be the individual artistic genius and the sole author of a work. After approximately seven years, they publicly affirmed their teamwork and retroactively changed the authorship of their previous projects, labeling them with the joint name they have used ever since—Diller and Scofidio or D + S.

When Liz took a teaching job in the School of Architecture at Princeton University, she and Ric, who is still a professor at Cooper Union, were probably vexed more than ever before by the problem of defining their identity as a creative partnership: Are they architects or artists?

In the past, they reported, architecture was considered more of a "dirty profession" than high art. But this is changing rapidly. As a commentator on their work said in the journal *Sculpture:* "In an information age that no longer considers the tangible to be a touchstone for the true, art and architecture, many practitioners of both believe, must renegotiate their relationship."[9]

Diller and Scofidio are now widely regarded as a "team of artists." Their innovative integration of art and architecture is well established. They are eagerly commissioned by sponsors in many countries for the boldness and originality of their multifaceted creations. In his critique of the recent renovation of the Centre Pompidou (the extremely modern "pop style" museum in Paris, popularly known as the Beaubourg), Paul Goldberger states: "It would have been wonderful to see what architects like Liz Diller and Ric Scofidio . . . who specialize in using new media as the inspiration for architectural form, could have done with the assignment of updating the Beaubourg."[10]

Kristin Jones and Andrew Ginzel

Upon meeting in December of 1981 at the Hirshhorn Museum, where both were assisting friends in setting up an exhibition, Kristin and Andrew were struck by each other's talent and how much their sensibilities coalesced. In her estimation, he was "the magician who brought everything together." Quickly becoming involved in what they refer to as an "artistic conversation," they

developed a relationship as close friends. Soon, they started to collaborate in Kristin's studio at Yale—where she was completing her MFA—without admitting, even to themselves, what was going on between them.

Unlike Kristin, whose father was in the U.S. foreign service, Andrew grew up steeped in art. Both of his parents were serious artists, each a practicing professional and a college teacher, but he describes himself as basically self-taught. Dropping out of Bennington College after two years, he moved to New York in 1974 and began his own career.

The summer after they met, he was scheduled to do a large project in Tuscany. Since Kristin spoke Italian and could serve as a translator, Andrew persuaded the curator to fly her over and let her participate, too. Although they were collaborating on someone else's behalf, this experience laid the groundwork for their ability to interact effectively and meet deadlines. Residing in a converted monastery outside Florence, they deepened their intimacy and their artistic relationship.

After graduating from Yale, Kristin looked forward to spending a year in Rome on a Fulbright scholarship. Andrew also had a chance to do more work in Europe and announced that he was going with her. By that time their platonic friendship had blossomed into a romance. Just before they left for Italy, she moved into his house in Greenwich Village. In Rome Kristin made her own art while Andrew studied the city, but they continued their "creative conversation" and intensified their courtship.

Before returning to New York, Kristin applied for a studio of her own at the Clock Tower, feeling the need to maintain some autonomy and reluctant to work in the place where they would live. Yet she and Andrew continued to collaborate in that studio for the next few years—still not regarding themselves as partners in a co-career. As they said, "We were just working."

In the midst of their equivocation, a journalist came to Kristin's studio to interview her for an article. "Whose work is this?" she asked. Her question threw both of them into an "identity crisis." Each had to admit to the other that, "clearly, the work

is not mine and it's not yours." So they felt compelled to ask, "What are we doing here? Do we intend to go on doing this?"

Subsequently, Kristin had the idea to do a piece about a storm for a group show at Art Galaxy. Andrew contributed a crucial change, adding the concept of a time sequence and helping to construct that element in the installation. In 1985—four years after they had actually begun to collaborate—they agreed to call the completed creation "our work." Finally, in exhibiting that piece, *Spheric Storm,* they publicly presented themselves as a team.

Sharing every project since then, this couple has put the issue of individual authorship to rest. Instantly giving and getting feedback from each other's suggestions, they constantly serve, in their own words, as "mirrors for each other." Summing up how they now feel about the importance of their teamwork, Andrew said, "We want a situation where one plus one equals at least two, if not more." Kristin chimed in, "Always more."

Christo and Jeanne-Claude

Although they saw themselves as artistic partners from the outset of their marriage, Christo and Jeanne-Claude waited more than twenty-five years before publicly asserting their collective identity as a professional team. During that time, they permitted all of their collaborative works to be attributed to Christo alone. Meanwhile, the reality of their collaboration was apparent to close friends and the people they employed to assist in implementing their huge projects.

When we asked them why they delayed so long in "going public" with their professional partnership, they began their reply by recalling the financial pressures they experienced at the beginning of their career. An impoverished refugee, Christo was unable to contact his parents in Bulgaria for fear they would be persecuted. He certainly couldn't count on any aid from them. Jeanne-Claude was rejected and rendered penniless by her wealthy parents, who refused to countenance her marriage and even forbade her siblings to talk to her for several years.

After contending with poverty for some time, Christo had the good fortune to meet Leo Castelli, the internationally known art dealer, who encouraged them to come to America. By 1964, following seven successful exhibits in Germany, France, Italy, and Belgium, they had saved enough money to make the move. But it was extremely difficult for them to establish a new life in a new country. Still very poor, they had to start all over again at "point zero," and they were apprehensive about how they would be welcomed professionally. Since there was tremendous competition among artists to be accepted and handled by a gallery, they felt that it would be disastrous to say they worked as a team: "One newcomer was enough of a threat."

Fear for their economic survival is a plausible explanation: it may well have taken decades of success for Christo and Jeanne-Claude to feel secure enough to reveal their artistic partnership.

Still, other factors may have played a role in their protracted reticence. Perhaps Jeanne-Claude did not press for disclosure because she had not acquired sufficient confidence in her own creative abilities. After all, she had not studied art before they married, nor had she previously desired to be an artist herself. As she told us, "I became an artist out of love for him. If he had been a dentist, I would have become one, too."

On the other hand, the competencies she soon developed permitted the pair to launch and complete enormous projects, which could not have been done without their collaboration. Of course, those works were credited to Christo alone, and the fact that he had become a famous "name" on the international scene may have inhibited them from tampering with what was, in effect, a celebrity logo.

The ultimate impetus behind their decision to label themselves publicly as an artistic partnership came about in a very unusual manner. In 1994 Christo was invited to give a lecture at Cooper Union about the preparation for their famous wrapping of the Reichstag in Berlin, a project conceptualized in 1971 and realized in 1995. Jeanne-Claude informed the school that both of them would like to talk, since they were already recognized as a collaborative team in some European countries and had begun to make presentations together.

At first, the organizers of the Cooper Union program made an issue about wanting Christo to speak alone, but they finally agreed to Jeanne-Claude's participation.

After their lecture, an admirer, a charming elderly gentleman, approached them and asked in a syrupy voice, "And how is that marvelous young poet, Cyril Christo, the son of Mr. Christo?" Upon hearing the man's question, Jeanne-Claude told us, she became livid. "I pushed for three days and three nights to get the baby out of me, and suddenly he's the son of Mr. Christo? They didn't want me as an artist—but not even a *mother?*" At that point, she recalled, Christo looked at her and said, "That's it! We go official."

From then on, they have insisted on being presented as Christo and Jeanne-Claude in exhibition catalogues, interviews, and books published about their work. And the 1996 edition of the *Dictionary of Art,* a standard reference for the history of art, lists them as an "artistic partnership."[11]

Edward and Nancy Kienholz

This couple was also slow to present themselves publicly as a professional team. In their case, however, this hesitation cannot be traced to fear for their economic survival. In contrast to Christo, who was an artistic neophyte in his early twenties when he met Jeanne-Claude, Edward was forty-four and already an internationally acclaimed installation artist when he married Nancy in 1972. It was his fifth marriage and her first. Like Jeanne-Claude, she had never been involved with art. This initial disparity in their artistic status was undoubtedly difficult for them to overcome.

Edward Kienholz had grown up on a farm in the state of Washington. Coming to Los Angeles in the early 1950s, he soon attracted notice as a "brash naif" active in the Beat culture and the avant-garde art scene. Nancy Reddin had a very different background. The daughter of the chief of the Los Angeles Police Department, she had been employed as a medical assistant, a court reporter, and an emergency room attendant. She was

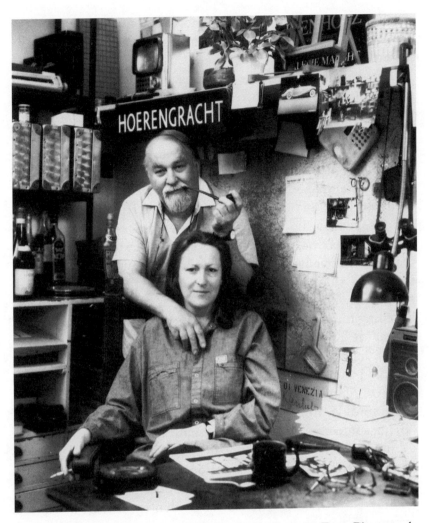

Edward and Nancy Reddin Kienholz, Berlin Studio, 1988. Fever Photograph; courtesy of Nancy Reddin Kienholz.

twenty-eight when she met Edward and immediately began to take part in his creative work, but "it was only gradually that he came to trust [her] and the relationship completely."[12]

Before the end of the 1970s, when they were working on installations for a series about the condition of women in society, Edward became convinced that it was exploitative not to grant Nancy credit as a co-creator. One of their pieces dramatized a

wife's suppressed desires and ambitions. Another condemned the social preoccupation with women as objects of voyeurism and sexual exploitation.

In those days, many male artists had begun to drop their chauvinistic attitudes in response to the women's movement. Edward's change of heart may have reflected the impact of feminism, but he was probably more directly influenced by having finally established a fulfilling relationship of love after years of marital misery, adeptly expressed in many of his earlier pieces. In Nancy, some friends observed, he had found "a woman as strong and independent and gruff and ornery as he was." One friend characterized her as someone who "'simply wouldn't take his shit.'"[13]

Nancy has described how Ed conveyed the total trust he ultimately developed in her: "We were in Berlin working in the studio, and I think I was reaching over to hang up a hammer or something. Ed was in his chair, rocking, as he usually did, just watching me, and suddenly he announced, 'O.K., Nancy, that's it.' 'What's it, Ed?' I asked him. He said, 'I give up. . . . That's it. I'm your hunk of meat.' I said, 'O.K., Ed, that's fine,' and kept on working, but to him it seemed important to have established that."[14]

According to Lawrence Weschler, who quotes this story, "Being someone's hunk of meat was Ed's idea of romance."[15] But calling himself her hunk of meat can also be interpreted as an indication of his willingness to yield himself to Nancy at last—to drop all the barriers he had placed around his own sense of self and merge with her in the collective identity of their loving and artistic relationship.

On the first page of the catalogue for their 1981 exhibition of *The Kienholz Women,* Edward openly acknowledged their *professional* identity as a team, stating that Nancy Reddin Kienholz should share the credit for all the work they had created together since they were married. "My life and my art have been enriched and incredibly fulfilled by Nancy's presence and I wish to belatedly acknowledge that fact here. . . . I further feel I no longer have a man's right to signature only my name to these efforts which have been produced by both of us."[16]

He goes on to specify her varied contributions: "She has labored beside me these past nine years exchanging ideas, making decisions, painting figures, managing homes, designing catalogues, and all the while maintaining a complete photo chronology."[17] In her reply, Nancy says that Edward's formal admission of her role in their art is "a gesture to society. To me, that's precisely what it is: it is a gesture, a statement—that he doesn't want to use me."[18]

As with other co-creations, it is impossible to delineate each artist's contributions with any precision. "Some critics point to a certain softening in Kienholz's fiercely distinctive production in the years after he met Nancy—her influence? the fact of his growing personal satisfaction?—yet that premise is hard to sustain, for some of the late works are as viscerally discomfiting as anything that preceded them."[19]

Reinventing Themselves as Artists

Bill and Mary Buchen

When Bill and Mary met as undergraduates at the University of Minnesota in 1971, neither aimed at being an artist. Bill was primarily interested in music, especially drumming. Mary, who had completed three-and-a-half years as an English literature major, lived in an apartment across the hall from him. "I looked at her and just fell in love," Bill told us, as she grinned with pleasure. They began living together a week after meeting and were married six months later. Soon, she was equally enchanted by the beauty of music, which opened new vistas for her. Like so many students in the counterculture of their generation, they dropped out of college—convinced that it could not give them what they were intuitively searching for.

Facing the world as freelancers without academic degrees, the Buchens had to take separate jobs to support themselves. Bill performed at musical gigs, and Mary was a cocktail waitress. While in this limbo state, they began to collaborate in producing an array of unusual musical instruments, some of which were later

exhibited in galleries and museums. Their first project was a dulcimer. At the time, they had no idea of "careerism," just a pragmatic need to make money.

By 1976 they were able to support themselves and had enough money for a trip to Brazil and other South American countries. Stimulated by what they saw, they began to wonder: Is this our future, or is there something greater out there? "We call it *Dharma*," Bill explained; "it's the push of your life. In Brazil we saw instruments. We 'saw' we had to make instruments, music. There was no doubt about it. That was it!"

Back in Minnesota, the pair made harps and performed as a team. But their work was too experimental for that region of the country. Bill was convinced that they had to go to New York. In 1977, despite Mary's trepidation, they moved, settling on the Lower East Side of Manhattan in a loft where they still reside. Ingeniously using materials they found on the street, they transformed the dilapidated and cavernous room into a functional and attractive living space.

Shortly after coming to New York, they were offered an opportunity to perform at The Kitchen, a prestigious setting for creative experimentation. They spent months in preparation, making instruments for others to perform on as well, and even wrote music for the event. Presenting themselves as "Bill and Mary Buchen," they were now publicly seen as partners.

After this successful debut, the couple received an artist in residency award at the American Craft Museum. They demonstrated and discussed their instruments, which were displayed as part of a group show that lasted for three months in 1978. As a result, they were interviewed on the *Today Show* and invited to make instruments as artists in residence at the Art Park near Niagara Falls.

Until that time, Bill and Mary had been identified with the "craft world." But at the Art Park, they mingled with professional artists and became inspired with ideas for creating sculptural works for outdoor sites. Looking at what the artists had done, they began to think, "Maybe we could do that, too." This impulse led them to alter the concept of their own collective identity. Mustering the courage to propose a design for a large wind harp at the Park, they constructed it the following year.

In addition to being self-taught, Bill and Mary took private lessons and courses at Cooper Union to learn whatever they needed to know: drawing, architecture, structural engineering, musical composition, and computer-aided design. They often travel to India, where they find stimulation and reinforcement for their work. Having propelled themselves into the creation of public art, the Buchens redefined their shared image of themselves from craftspeople and musical performers to "real artists."

The ability to shift, as the Buchens did, from one creative modality to another, is discussed by Robert and Michele Root-Bernstein in their *Sparks of Genius:*

> Ideas can be translated into one or more formal systems of communication, such as words, equations, pictures, music, or dance. . . . Regardless of the infinitely diverse details of the products of this translation . . . the process by which it is achieved is universal. Learning to think creatively in one discipline therefore opens the door to understanding creative thinking in all disciplines.[20]

Alexander Calder apparently "segued from an abortive career as an engineer to the invention of mobile sculptures."[21] Such a change in the particular way a person's creativity is expressed demonstrates that "creative thinking is integrative and transdisciplinary."[22] Further illustrating this phenomenon, the Root-Bernsteins note that although Picasso has been regarded primarily as a visual thinker, he "believed that all sensation, all forms of knowing, are interconnected: 'All the arts are the same: you can write a picture in words just as you can paint sensations in a poem.'"[23]

Facing the Loss of One's Partner

Fearing the Loss

Having overcome the obstacles to affirming their artistic partnership—privately and publicly—co-career couples become profoundly attached to their collective identity. Over time, this joint creation assumes more and more significance as the psychological

basis on which both partners define their personal identities. Instead of fearing the loss of their own individuality—as they may have done when starting to collaborate—each partner is likely to be shaken by the possibility of losing the other.

Every loving couple is, of course, vulnerable to the same fear. Yet most people do not realize that when their partner dies, they lose not only a lover but also their relationship and their collective identity. Through this interpersonal merger, both partners had fulfilled their potentials for loving and maintained a meaningful orientation for functioning in the world. But if a partner in intimate creativity dies, the survivor also loses his or her professional identity, which has been indivisibly tied to collaboration with the deceased.

"What would I be on my own?" Mary Buchen wondered. "We're together so much." She worried that she might not be able to do as well without Bill. Attempting to minimize his own fear, he wryly replied, "You might do better."

Lilla LoCurto freely confessed to the fear of being without the person she loves so much and has been with for so many years. "I think about that all the time because we've grown closer and closer every day, not further apart." Bill Outcault confirmed that they grew together by working as a husband and wife team. "It's an organic thing. And being lonely for the other." Lilla thought she could not do it with anyone else. "We're so much alike, we have the same goals, the same political and social values. Collaborative or not collaborative, our relationship has always been so tight."

Despite her formal training and academic status, Elizabeth Diller had doubts, similar to Mary Buchen's, about her ability to function successfully on her own. Feeling that she could never have done so well without Ric, she expressed fear at the prospect of having to work by herself. For his part, Ric said that their love and work are so synergistically intertwined, "we couldn't lose one and keep the other."

Kristin Jones agreed. "You can't help but be terrified that you might lose the other one. And then where would you be?" she asked. "Because you're on this course that truly is something other than you as an independent individual." For her, "it's not a

question of dependency. It's just that it's a way of working. The scary part is if a bicycle accident were to occur, how do you begin your life again? It's as if you might have to begin it again because it's such a different course. I don't think I'm doing work that I would be doing alone. It's something completely different."

Reactions to the Loss

The loss of a lover is emotionally shattering—generally the most stressful event an individual can suffer. Yet the bereaved partner remains alive and must, somehow, express and relieve his or her grief. People do both of these things by going through a period of mourning during which they show their anguish and repeatedly recall their memories of and interactions with the deceased. Some survivors remain mired in depression for a long time, unable to resume an active life on their own.

Jean Arp and Sonia Delaunay relied on their creative zest as a means of dealing with the crushing blow of losing their partners. They quickly concentrated their energies on efforts to transcend the irreparable separation imposed by death—keeping their loved ones alive in their own minds while also publicly promoting their work.

After Sophie Taeuber's death, Jean Arp had "conversations" with her in poetry and prose. He wrote detailed accounts of her profound impact on everything he did. *Le siege de l'air* ("The air besieged"), an anthology of his poems and several of their duo-drawings, was published in 1946. "The book provides a discreet and marginally confessional homage to Taeuber. Arp's poetic retrospective is enhanced throughout by the duodrawings, one of the couple's most sustained joint works. Arp transposed some of them into paintings, as though to prolong and upgrade the dialogue between the two partners."[24] He

devoted himself henceforth to [her] work and recognition. He still sought unity with her and collaboration: he expressed this desire in poems to her, in having her designs executed, in collages that integrate fragments of her works, and in his preoccupation

with her themes. . . . Here lies the tragedy and the uniqueness of their relationship, given meaning through Arp's perpetuated testament of despair.[25]

Immediately after Robert Delaunay's death, Sonia's "preoccupation was to keep [his] memory alive; in a sense, that was a means of keeping herself from dissolving." Two days after his burial, she started "gathering together all [his] papers and documents with a view of preparing a tribute to him and his work, while it was all fresh in her mind."[26] Sonia was "determined to establish Robert in what she perceived as his rightful place as an artist of the highest rank," and "her persistence on his behalf gradually began to bear fruit. . . . He was represented not only in most of the main museums and galleries in Europe, but the American galleries too began to seek out a Delaunay for their collections of modern painting."[27]

When asked, in anticipation of an exhibit she was arranging in the United States, to speak about the part she had played in his life, Sonia responded "that they had been not just husband and wife but 'working companions.'" When someone commented on how much Robert owed her for promoting his work after his death, she said, "'I consider our work, painting, so much a totality for which we both lived that it seems to me what I am doing is only normal.'"[28] Along with her tenacious promotion of Robert's work, Sonia continued to paint and design on her own until she died in 1979 at the age of ninety-four.

Nancy Kienholz appears to have adopted a similar strategy in dealing with her reactions to Edward's sudden death from a heart attack in 1994. As if to counteract her shock and hold on to him symbolically, "Nancy turned to their longtime assistant . . . and said, 'Get the plaster.' She made a death mask on the spot."[29] She also arranged for a previously made plaster cast of his entire body to preside over his memorial service, which was attended by relatives, friends, and artists from all over the world.

Ed had once said he wanted to be buried at his hunting camp in his well-preserved 1940 Packard coupe. Early on the day of the funeral, his son drove the car up the mountain to the camp with

Ed's embalmed body strapped into the passenger seat. He parked at the top of a ramp leading into a trench large enough to enclose the improvised coffin.

> After the service, members of the funeral party converged, convoy style, on the scene. . . . "So I got in the driver's seat and turned the key, and, of course, the engine wouldn't turn over," Nancy related. "Damn Packard—it happened every time. . . . But it's the one he wanted—probably the car he lusted for as a kid. . . . Finally, they had to push me down the ramp. I set the brake, got out, gave a last look."[30]

Afterward, she said she hopes to be buried by his side when she dies.

Nancy has been diligent in publicizing Ed's creations. In 1996 she was co-curator of an extensive retrospective exhibit at the Whitney Museum that contained installations done before and after her collaboration with him. Many of Ed's earlier works, which had never before been seen in America, were included in the show. In the catalogue for this retrospective exhibit, Nancy states: "It has been over a year since Ed died. Mostly, this period has been one of unbearable grief for me, but somehow with the support of family and friends I survived. The only place I have found peace and solace is in the studio, where I believe Ed is watching over me while I work."[31]

4

The Unending Conversation

Artists aim not only to express themselves visually but also to communicate with others by displaying their work. If they create individually and in isolation, their personal expression can be readily separated from social communication. They may, of course, conduct silent conversations with themselves before getting started on a project, going over all the pros and cons of the ideas and images coursing through their minds. This inner dialogue may continue as artists produce their work. But they can go through the entire process without saying a word to anyone else about what they are feeling or doing. Then, after completing something, they can refrain from ever showing it to others.

Yet every artist has some imaginary audience inside his or her own head. As Max Becher pointed out, "Nobody works alone. Everybody has something they work off of, either an idea or other people."

Whether or not they are consciously aware of it, all artists internalize historical and contemporary cultural forces that affect their work. In *Notebooks of the Mind,* Vera John-Steiner amplifies this principle by referring to the writings of the Russian psychologist Lev Vygotsky:

Central to his approach is a view of the mind which extends beyond the "skull," which does not situate thinking in the confined

spaces of the individual brain or mind. Instead, he proposes a sustained dynamic between other humans both present and past, books, the rest of our material and nonmaterial culture, and the individual engaged in symbolic creativity.[1]

This internalized influence may be experienced as an illusory person in the form of a mentor or critic who is looking over the artist's shoulder. But as Andrea Robbins explained about her collaboration with Max Becher, "With us, it's just that there is another person actually there. Someone who is going to edit."

Extolling the benefits of having Anthony Aziz as such an "editor," Sammy Cucher said, "Working alone, you yearn to have what you have as a couple—that critical voice and feedback. That's difficult to get when you're alone. It's difficult to develop your own set of critical tools. But when the feedback is there, it's great."

The Challenge of Consensus

The entire process of intimate creativity rests on a couple's ability to meet an *interpersonal challenge* that never confronts an artist who works alone. Partners in love and art are committed to the goal of attaining *consensus* on everything they put into their work. From the outset of their collaboration, they decided to make art together only by being true to this commitment.

For co-career couples, personal expression and interpersonal communication are bound together at every stage of the creative process. Before starting a project, partners must talk to each other in order to decide what they want to do. Each member of the team feels free to express—verbally and visually—whatever he or she is inspired to create. These expressions automatically become communications, since each hears or sees what the other suggests.

When equally excited by divergent ideas, partners have to sort out their differences in order to converge on a decision about which creative trip to take. If one feels exceptionally turned on by a tantalizing conception at a time when the other's mind is idling,

the highly enthused partner has to persuade the other to get fully on board.

At every step of the way, each is an audience for the other's contributions, and each must agree with what the other wants to do. The visual feedback partners get from a work in progress stimulates them into further discussion about how they are objectifying their artistic intentions. This conversation, in turn, leads them to give visual expression to new ways of going forward with their co-creations. As their work progresses, they are in constant communication about any unexpected problems that arise, and they make whatever new decisions are needed to sustain their consensus on the path to completion.

∾०∾

Individual artists have to trust their own perceptions and judgments, of course. Otherwise, they would be unable to decide whether something they imagine is worthy of serious consideration—let alone how to make a work of art out of it. This capacity for *self-validation* is called into play, and put to its most rigorous test in sustaining self-confidence, whenever they expose their creations to possible rejection by viewers or critics. Because esthetic self-reliance is so essential, artists cultivate it by keeping in close touch with the contents of their consciousness.

It is crucially important for collaborative partners to remain tuned in to whatever is going on in each other's minds. Every pair knows that their professional co-career—indeed, the fulfillment of their common romantic dream—hinges on their ability to cultivate, as Shakespeare wrote, a "marriage of true minds." Unlike artists who work individually, both of them rely on access to each other's ideas and feelings about every project they take on as a team.

To plumb the depths of their minds, these partners are required not only to scan what is going on inside themselves, but also to talk about it; not only to be equally responsible for providing personal input into the creative problem at hand, but also to share equally in resolving whatever disagreements emerge in the course of their collaboration. By communicating with this level of

affectionate candor, they successfully combine *self-validation* with *mutual validation.*

Since both partners have committed their whole lives to the flowering of their love and their art, they are intent on being as honest as possible when they converse about whatever they are creating. This desire to be open with each other fuses into a steady charge of synergy. Making sparks fly together ignites them with a "high" neither one could produce alone. As Elizabeth Diller noted in our interview with her and Ricardo Scofidio, "If we couldn't talk about our work together, it would diminish the pleasure of making something."

Partners know they can create and sustain these exquisite states only through their collaboration. It is small wonder, then, that they are so content to spend most of their time in each other's company, so willing to sequester themselves from other people and keep on producing one project after another.

Nonverbal Communication

In their search for artistic unanimity, collaborative partners learn to decipher each other's silences. There are many things that Robbins and Becher do not need to talk about because they already know how much they agree on esthetic issues. As Andrea said, "We can guess each other's interests before we even start. And we have each other's voices in our heads."

Even the basic idea for a major project may be communicated nonverbally. While observing the workmen wrapping the Pont Neuf in golden cloth, Christo and Jeanne-Claude were simultaneously struck by the magnificent image of light reflected upward from the Seine and shimmering through the diaphanous fabric. Both of them love water, and many of their installations have been situated near it. They looked at each other and smiled. They didn't say a word, but that glance led them to design *Over the River.* This work, yet to be implemented, would suspend sheaths of fabric panels over a section of the Arkansas River in Colorado, allowing light from the sky to shine through and be perceived from below by viewers on the riverbank.

The reports these couples give about the effectiveness of their unspoken communication are not surprising. Psychological research has shown that "nonverbal sensitivity does increase with increased depth of or commitment to the relationship."[2] It has also been found that close couples do much better at reading each other's nonverbal messages than do the professional judges who are observing them.[3]

Constructive Conversation

Few couples have as much opportunity to communicate as partners in a co-career. Even so, when asked to rank the activities they value, couples of every kind place good communication, along with gratifying sexual relations, very high on the list of factors that contribute to their satisfaction.[4] For some people, conversation has a higher priority.

Robertson Davies, the Canadian writer and journalist, met his wife of over fifty years at the Old Vic in London. At the time, both were interested in a stage career. As a prompter, she had every word of the repertoire on the tip of her tongue:

> And Shakespeare has played an extraordinary role in our marriage as a source of quotations and jokes. . . . I feel that I am uncommonly lucky because we've had such a terribly good time together. It's always been an adventure and we haven't come to an end yet. We haven't finished talking, and I swear that conversation is more important to marriage than sex.[5]

In happy relationships, partners report that they always enjoy talking to each other, no matter what they are discussing. They never lack for something interesting and meaningful to say.[6] Recognizing these facts, most programs that help unattached people prepare for marriage emphasize training in communication skills. Similarly, therapeutic interventions with couples in distress encourage partners to develop their capacity for honest and mutually considerate self-revelation.

These interventions offer their own special systems for improving the ways in which lovers speak and listen to each other: step-by-step guides on how to convey thoughts and feelings in a

clear and compassionate manner; and how to consider—without undue defensiveness—what one's partner is saying.[7] But to apply these instructions, a couple must spend more time than ever before in face-to-face constructive conversation. Just being willing to devote themselves to enhancing the quality of their communication signals an advance in the relationship. That decision, in and of itself, may account for the proven effectiveness of some of these programs.

Conversation in Artistic Creativity

The term *conversation*—which partners are so fond of using to describe their artistic dialogues—was largely popularized by Helen and Newton Harrison. Since 1970 this couple has relished "their abiding habit of beginning each day with a ritual discussion, and their discourse became the central metaphor in all of their . . . work."[8]

Their collaboration "encompasses performance, written texts that formalize their dialogues, photography, drawing, mapmaking, installations, and actual modification of the landscapes that are the subject of all their art."[9] The scope of this creative work draws upon the skills each one brought to their joint endeavors. As Newton puts it, "In a sense, Helen became an artist and I became a researcher in the process of teaching each other to be the other party."[10]

Helen and Newton conduct a poetic kind of meditation—asking and mulling over questions, taking different roles in their conversation, and playing the devil's advocate for one another. "But the relationship of Harrison to Harrison is also a concrete comradeship within a marriage that has endured. . . . Domestic, everyday."[11]

Seeking to encourage specific environmental improvements through their art, the Harrisons also converse with many people from different professional disciplines and areas of society: scientists, engineers, landscape architects, ecologists, and politicians. "Through their dialogue with one another, and through their discussions with various audiences—in both the art world and the

Helen and Newton Harrison with Installation at Blue Coat Gallery, Liverpool, England, 1998. Photo by Helen Mayer Harrison, Newton Harrison; courtesy of Ronald Feldman Fine Arts, New York.

real world—they often manage, as they say, to 'change the conversation.'"[12] In 1991 the Harrisons publicly symbolized this approach to ecological problems in an exhibit that they named *Changing the Conversation*. In 1992 they suggested the title "Conversational Drift" for an article in *Art Journal* about their work,

> which . . . is meant to reflect both the process of interchange that occurred between [the Harrisons and the author] and also to suggest how their ecologically oriented art functions in general: their work sets up situations both in art galleries and in the halls of government that encourage the conversation to open up, to change, and to drift toward innovative and creative solutions to real-world problems.[13]

The Harrisons aptly summarized the significance of their mode of collaboration: "We've empowered *ourselves* through our work. And our greatest concern is establishing models wherein *anybody* can start *anywhere* and radiate out change and transformation by engaging the discourse."[14]

Conversation in Literary Creativity

The word *conversation* has also been used as a metaphor for total collaboration between a pair of writers. A collection of essays on current views of collaborative writing in literature compares "conversation" with the other distinctive styles of communication practiced by co-authors. *Monologic* is a hierarchical mode: Only one author's voice is heard at a time, and the writers do not yield to one another. In the *dialogic* form, two speakers engage in an equitable exchange of ideas, yielding the floor to one another at predetermined points in the text. Although they do not compete for control, their voices do not overlap. The final and most complete form of collaboration is called *conversation,* denoting social interaction in which authority or ownership of ideas and words is unspecified. This term is used to "describe collaboratively produced texts where the participants discuss and reach consensus on every point."[15]

The five novels written jointly by Louise Erdrich and her husband, Michael Dorris, exemplify the conversational approach to literary composition. Although the partners shared responsibility for all the writing in these books, they shied away from acknowledging their co-authorship early in their career. Louise's name appears on three of the works and Michael's on one—"presumably an attempt to avoid the marketing problems often associated with collaborative works."[16] Finally, in 1991, both were listed as co-authors of their fifth novel, *The Crown of Columbus.*

The couple's long denial of their co-authorship implies that they harbored apprehensions similar to those we heard from Christo and Jeanne-Claude as well as Diller and Scofidio. Still, Erdrich and Dorris were not afraid to give their separate selves over to intimate creativity so wholeheartedly

that they are not able to specify who wrote which sections of their five collaborative novels, that it is impossible to separate their contributions. They argue that, even if they could identify ideas or portions of the text as clearly "Louise's" or clearly "Michael's," specifying individual work contradicts the collaborative process.[17]

In a 1986 interview with *Publishers Weekly,* Louise emphasized how much she and Michael talked about the scenes and characters. Reading aloud and discussing drafts, they maintained this pattern of communication until they "achieve consensus on literally every word."[18]

"Nothing goes out of the house without the other person concurring that this is the best way to say it and the best way of presenting it," Dorris reported. "One of the beauties of the collaboration is that you bring two sets of experience to an issue or an idea, and it results in something that is entirely new." Louise concurred: "We both really influence the course of the book. You can't look back and say which one made it go this way or that way, because you can't remember. You just remember that you had that exciting *conversation.*"[19]

Exchanging Ideas

Whatever medium is used to manifest their combined creativity, co-career partners employ very similar approaches in making mutually acceptable decisions about their work. In art or written discourse, "when participants do not share goals, nor discuss and negotiate their differences, nor trust and respect each other's judgment and talents, communication — and collaboration — fails."[20]

Speaking for Mary and himself, Bill Buchen told us, "We're two minds trying to come to mutual decisions about projects. Over the years we've developed a way of brainstorming together and talking where in some ways we're each other's worst critics. That's very helpful, actually. What we've learned is to depersonalize it. So it's never really my idea versus your idea. These are ideas. First, we come up with anything. The ideas are up, with no value judgments. We might take a week at this. The next week, we start to cull them before we refine. If I attack an idea — even if it's Mary's — then I'm attacking the idea, not Mary."

"It's not about personalities," Mary confirmed. "It's about ideas. I try to write them down."

Many partners rely on writing as a way of sorting out their individual thoughts. Lilla LoCurto and Bill Outcault typically

come up with separate ideas and write them down. When something inspires either of them, they start talking about it. Then they do more writing to clarify the concept. Occasionally, he or she raises an issue just to provoke a dialogue, but writing is a crucial part of their creative process.

Lilla and Bill repeatedly consult with technical specialists to assess the feasibility of what they are inspired to do. That is like "a sounding board for us, a winnowing process," Bill said. Written documents are what they send around for their consultants to review. With or without such reviews, they continue to have conversations and exchange written material, supplemented by more drawing and research.

Sharing Notebooks

Thoughts and images "may be kept solely in one's active memory. A scientist may remember . . . important conversations that have a bearing upon one's current research. Many individuals find it useful to keep records of these important components of their craft in a more permanent form." As a basic part of the creative process, "Notebooks such as these are indicators of the inner activities of the mind. They serve as fixed points on a lengthy trajectory."[21]

Kristin Jones and Andrew Ginzel sit down and have a conversation, paying no heed to whether she or he comes up with a particular idea. Then they crystallize their spoken exchange in notebooks containing both writings and drawings. In fact, they have three notebooks: one for him, one for her, and one that is shared.

Although intimate co-creators may record their inspirations separately, they do not use these outpourings—as some lovers use a private diary or journal—to conceal thoughts from each other. On the contrary, these collaborative artists want their individual notebooks to be read by both of them, clarifying and embellishing concepts that occur to each of them on the road toward launching a common project.

Like many of the artists we interviewed, Claes Oldenburg has always carried a pocket notebook filled with sketches and ideas. His wife, Coosje van Bruggen, developed the same habit. The couple met in 1970 in Amsterdam, where she was an assistant curator at

the museum that was presenting a retrospective exhibition of his work. Their 1977 marriage led to artistic collaboration between them. Although she still writes independently in her field of art history and he unilaterally exhibits some of his own work, they have co-created more than twenty monumental public projects in countries around the world—gigantic outdoor sculptures of ordinary objects, including a tube of lipstick, paper clips, a trowel, a pickax, a pocket knife, and a man's collar and tie.

As Claes and Coosje fill up their notebooks,

> good ideas are torn out, discussed by the partners, and pasted into new notebooks. Finally the discarded notebooks are torn in half. . . . One day, as Oldenburg was tearing up some drawings while van Bruggen was doing the same to a failed piece of writing, the pages "all flew together on the wall on their way to the garbage can," van Bruggen said. The pages came together in a form that the couple recognized as an interesting combination.[22]

That accident served as a precursor to *Torn Notebook*, one of the couple's most acclaimed works. Installed in 1996 on the campus of the University of Nebraska, this project represents a thorough intertwining of each partner's skills and personality. The director of the gallery that commissioned the installation considers it "one of the most personal works of the artist team to date. . . . I don't know of a piece that better reflects their twenty year collaboration."[23]

"For Oldenburg and van Bruggen, the torn pages seemed to represent a visual image of the two halves of their collaboration, the metal spiral an analogy for the spiral of marriage and artistry that bound their work together," the Root-Bernsteins write. "The metaphor had additional reverberations in the twisting tornadoes that sweep the plains of Nebraska and the whirlwinds of creative activity that integrate image, word, and process."[24]

The sculpture incorporates the actual notes the pair made about their impressions on an investigative trip to Lincoln, Nebraska. "My notes tend to be in the form of objects. . . . Her impressions tended to be more poetic phrases," Oldenburg states, conveying the complete melding of their differing approaches.

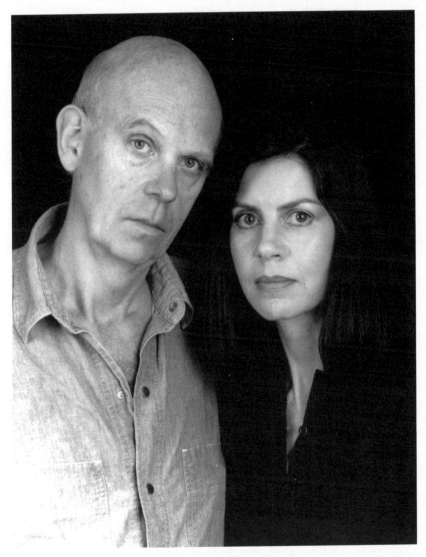

Claes Oldenburg and Coosje van Bruggen. Photo by Robert Maplethorpe; courtesy of the artists.

We made a selection of the ones that looked the most interesting when they were written and sort of fit together. Then we divided them, so Coosje's were on the top and mine were on the bottom. . . . Then they were alternating backwards and forwards. . . . And if you turn the page, it's the other way around.[25]

Some of the notes reproduced on the final pages of the completed work are in his handwriting and others in hers. The sculpture is made up of aluminum half-pages mounted on a steel armature. The words are cut out of the pages, permitting light to shine through. These openings not only change the way the sculpture looks at different times of the day and night but also help it withstand the strong Nebraska winds. The installation "is in keeping with Pop art concepts, the style within which both artists work." It gives the impression of a student's notebook, "a throwaway, torn in half to be discarded at the completion of the semester . . . fluttering across the campus."[26]

Until the age of fourteen, Coosje had been a serious dancer. "And it is very ironic," she says, "but now I am wielding the pen behind my desk and hardly move. However, rhythm is a very important thing to me."[27] Designed with intrinsic rhythmic movement and lightness of form, *Torn Notebook* seems to float in defiance of gravity, typifying the characteristics she has brought to the couple's style.

In describing how they work together, the pair have commented that they "painstakingly examine each piece, going over the forms with their hands and discussing corrections in detail."[28] According to Claes, "a lot of communication on a project arises spontaneously from just being together and looking at the same thing." Confirming the experience of the partners we interviewed, Coosje adds, "I think that what we are doing is we try to be vulnerable, and together we make something we would not produce if each of us was working alone."[29]

Shared Reading and Research

Along with maintaining notebooks, co-career couples do a lot of reading to prime the pumps of their imagination. Robbins and Becher review the literature on whatever interests them. Usually one reads extensively on a subject and thinks more deeply about it. "You do it internally at first," Andrea said. "Then you think of how the other will react to it and you entice the other to go along." Each one feels: "If you're so passionately interested in a subject, then I should look into it, too."

Katleen Sterck and Terry Rozo also search for books and articles related to their subject matter and photographic style, urging each other to read whatever stirs either of them. The key to communicating about both their work and their personal lives is each one's willingness to be open to the other's opinion. They habitually go out and take some shots in whatever locations or poses happen to appeal to them. Then they get a specific idea and start to talk about it. Since they don't like to work too fast, they often go back to the same site to do more shooting—always talking about it.

Suzanne Scherer and Pavel Ouporov investigate writings about the symbols that inspire the content of their paintings. To bolster the universality of their work, they tease out the symbolic significance of organic objects that persist over time: stones, fossils, animal skins, and skeletal structures. In addition, they do a lot of photography together and have a bank of diverse images to draw on—places, people, and memories. One partner will get an idea and offer it to the other. Then they discuss it. If this discussion evokes disagreement, both draw sketches or write out their own versions of the concept. To facilitate communication, they use computer simulation to anticipate how something might look if they actually painted it. Meanwhile, they continue to converse until they dissipate their doubts and uncertainties.

Fighting for a Common Cause: From Yours and Mine to Ours

Every artistic conversation between collaborative partners is implicitly an attempt to articulate what each thinks and feels about the creative problems they have to solve. Unlike many alienated spouses, their revelations are not fraught with secret grievances that they have been afraid to air. Still, partners in intimate creativity make themselves vulnerable to contention whenever they open up to each other about their work. Paradoxically, however, they advance their projects by stimulating opposing views in each other. This opposition lays out the specific differences they need to reconcile in further conversations.

A study of what couples in general fight about found that conflict over decision making was the most frequent category.[30] Since co-career couples constantly face the need to make mutually satisfying decisions about all aspects of their artistry, they can be expected to engage in a great deal of fighting. Indeed, when we asked Elizabeth Diller and Ricardo Scofidio how they evolve the conception for a particular project, their simultaneous response was, "We fight a lot."

Since their work falls between art and architecture, a relatively unexplored area, they have few cognitive guideposts to follow, and no recourse to established rules and parameters. Instead, they are trying to formulate their own approach to this esthetic realm. Perhaps the sheer novelty of this exploration induces them to adopt a deliberate mode of working. In contrast to artists who function intuitively and impulsively, Liz told us, "Neither one of us is ever struck by a bolt of lightning. We tend to be very analytical about our work. We take it apart. The process is quite verbal. It evolves slowly with hard work. We have lots of discussion and fighting about ideas."

Likewise, Christo and Jeanne-Claude give one another thorough and uncensored criticism. They do not hesitate to put each other up against the wall, arguing and screaming. But, she assured us, "Whenever we scream, it's about the work."

All the partners we interviewed expect outbursts to flare up as they struggle to dissipate the tensions and frustrations of their efforts to resolve esthetic conflicts. They do not regard these as indicative of either personal contempt or incompatibility, but rather as an inevitable and useful feature of their common commitment to finding optimal solutions to their artistic tasks. They ride out their emotional storms until the sunlight of agreement shines on both of them.

Describing how he and Mary deal with dissension, Bill Buchen acknowledged: "Sure we have our disagreements. But we try to keep from being crabby with one another while we talk it out. It becomes in some way a debate." Building safeguards into the design of their work

is quite a trick. You have to have so many practical considerations—durability, vandalism, functional aspects. That makes it much harder. But our goal is to apply all these rigid criteria to it and still keep the playful care. The main thing is, don't kill yourself over it. Keep a childlike wonder and awe.

Fair Fighting

Social scientists have found that "a good fight, fought fairly and with respect for the other participant, can promote intimacy. . . . It is possible to view conflict as an opportunity to learn more about oneself and one's partner and as a way to strengthen the relationship."[31] The way a couple handles conflict—rather than its presence or absence—is the major determinant of whether or not their relationship will grow.

In the course of making an endless stream of creative decisions, partners in love and art acquire what relational experts consider the skills needed to fight fairly: honest communication, empathic listening, taking responsibility for one's personal opinions, and providing mutual validation. For these couples, a major benefit of "fair fighting" is the likelihood that the issue in dispute will be resolved.[32]

Co-career couples in other occupations use the same style of argumentation to dissipate their disagreements:

Pat, the co-owner with her husband of a small grocery store, said, "Oh, we go to it. Don't we ever! We just get down and get loud. We hassle *everything*. But our solemn oath is to never give up, never walk out until we are both satisfied. Did I say both? That's important. We don't quit until we get it right. That does us good—we always come to some kind of working it out."[33]

Another benefit of constructive contention is that it reduces each partner's fear of fighting.[34] As Ricardo Scofidio said, "One of the incredible things I've learned from working with Liz is that we can have a big fight over something and three minutes later, we've forgotten about it and things are back to normal."

By fighting with mutual compassion, any pair of lovers gains confidence that they are capable of treating each other with good will and positive regard. As a result, both are increasingly convinced of being central to each other's basic interests and concerns.[35]

Robbins and Becher have reaped such rewards repeatedly. They told us that coping with artistic conflicts helps them to confront and deal with problems in every facet of their shared lives. Resolving disagreements in their work makes them feel more loving as a couple.

❧

When we began to collaborate as co-authors, we quickly mounted bitter battles over whose ideas should prevail. These struggles between us became so fierce that we were on the verge of throwing in the sponge and scuttling our hope of writing together. Horrified by that prospect, we became more willing to talk about what was really bothering us. Through these conversations we got in touch with how egoistic and competitive each of us felt. Who had the best judgment? Whose writing style was more appealing? Who would get the most credit for the work? How would our collaboration affect each one's individual career?

Similar contests cropped up when we started teaching as a team. After putting up a united front during our lectures, we frequently berated each other "backstage": "Why did you make that stupid comment?" "Why didn't you let me answer that question?" "You were trying to upstage me!" Fighting over who talked more or was more admired by the students, we vied for prominence in our joint endeavor. We were also venting the same fear of losing our personal autonomy by deepening our interpersonal union.

The more we talked about the fear and defensiveness behind this competition, the more insight we derived about our competitiveness in other areas of our married lives: rearing and disciplining our children; managing and spending our money; deciding where to live, whether to rent or buy, and how to furnish our home. As our candor and understanding increased, we gradually arrived at more satisfying agreements about these crucial issues

and made better decisions for everyone concerned. Naturally, we did not obliterate our tendencies to become fearful and competitive. But we did learn how to catch ourselves more quickly when those disruptive feelings arose. Over time, we managed to limit the corrosive impact of these negative emotions on our relational harmony, increasing the pleasure we experienced in our private and professional lives alike.

Compromise and Patience

In our interviews we often heard about the significance of compromise and patience in attaining consensus. Research on the psychology of loving relationships supports this insight. Howard Markman, an expert on marriage, describes the value of compromise for every couple:

> Although it is easy to see the value of agreement, some people have trouble with the idea of compromise. . . . [I]t sounds more like lose-lose than win-win. Obviously, compromise implies giving up something you wanted in order to reach an agreement. But we . . . emphasize using it in a positive manner. [A relationship] is about teamwork. Two separate individuals may see things differently and might make different decisions. But often the best solution will be a compromise in which neither of you gets your way all the time. The reason is that you won't have a great [relationship] if you get your way all the time. Our goal is to help you win as a team, with solutions that show mutual respect and bring you closer as a couple. Sure, at times you may give up a little as an individual, but if you can gain as a couple, the exchange can be more than worth it.[36]

Scherer and Ouporov, who are extremely critical about their own work, shake each other up until they feel no residue of doubt about having made a mutually acceptable compromise. Robbins and Becher also observe that working together demands a willingness to arrive at compromises that are agreeable to both of them. "You can't always have things your own way. But," Max said, "that's a good limitation."

Aziz and Cucher articulated the functional connection between compromise and patience. "You have to learn to be patient with each other," Sammy said. "That's a very great challenge, to let the other person speak and to learn to listen and compromise in the relationship and the artistic work." For his part, Anthony believes that a very high level of patience and compromise is needed to overcome adversity between partners—not only in their interactions as lovers but also in their ability to fulfill their creative desires. For him, "a trusting relationship requires loving compromise." Partners have to "recognize what qualities each brings to the collaboration and be willing to allow those qualities to flourish in the work." Sammy concluded, "It's amazing how the relationship becomes a mirror for yourself, how much you learn by seeing yourself reflected in the other person. You learn about your limitations and can let go and trust the other to do what he or she does best."

For spouses in general, well-intentioned attempts to solve a problem often fail because couples do not take enough time to understand and deal with it together. This can prevent them from coming up with a solution that is acceptable to both partners. Markman makes a similar point.

> Most of us are not all that patient. We want it now. Unfortunately, quick fixes seldom last. . . . This tendency reflects the hurried pace of our lives. . . . We've had many colleagues visit us from Europe . . . and they often comment about how crazy we are in America. They see us as rushed and always busy, with little attention left for the really important things. . . . But . . . hasty decisions are often poor decisions. We must be committed to spending the time to work things out if we're going to make good decisions together.[37]

Lovers can decide to approach decision making as a pleasurable process, drawing out their deliberations until both of them have explored their truest feelings about all the relevant issues. Then they are ready to let go and experience what Eugene Gendlin, in *Focusing,* has called a "felt sense" of closure—an ineffable feeling of rightness that permeates each one's being.[38]

Preserving Personal Integrity while Attaining Consensus

Within their collaboration, partners transcend their individualistic cultural conditioning. Renouncing competition with each other, they pool their creative and professional aspirations into a unitary drive for artistic excellence. Such intense unity, however, does not blind them to the desirability of preserving their individual integrity. No matter how cooperative and unified they become, they can never shed their individuality. Even as they come to occupy the same psychological space, both of them remain permanent inhabitants of their own inner lives. Each is always sensing and sifting meaning from the welter of ideation, emotion, and imagery streaming into his or her consciousness.

In fact, each partner's singularity is indispensable for a couple's intimate creativity. From their separate minds, they dredge up the basic ore to be refined in their verbal and nonverbal communication. Taking their individual and mutual assessments to the limit, neither one lets the other off the hook until both are satisfied that they have found the optimal solution. Both recognize not only the special contributions each makes to their collaboration but also the artistic and relational advantages of working together.

Every pair works out a congenial way to preserve each partner's individuality as they unite to cope with creative conflicts. Over the years, Diller and Scofidio have come to realize the importance of tapping fully into their individual conceptions instead of automatically deferring to one another. Because they have so thoroughly internalized each other's critical sensibilities, Ric admitted, there is always the possibility that they will inhibit themselves from developing and articulating independent ideas. "But then I have to stop and say, well no. That would be censoring each other unconsciously. That's a danger. I really have to put forth my own ideas. And then we'll argue it out."

Although LoCurto and Outcault argue all the time, they have cultivated a common sense of humor to soften the emotional impact of their artistic disagreements. "I'm always right. It's fine if we maintain that," Lilla jested good-naturedly. "But," Bill chimed

in, "when things start clicking, you don't argue any more. You're just right there." Lilla went on, "We're both so stubborn, we wouldn't work on anything unless both of us were one hundred percent behind it."

Jones and Ginzel say that sustaining a low level of tension between them—along with personal rigor—is their way of egging each other and pushing the situation forward. According to Kristin, their mutual prodding "feeds the team so both can be enriched." Seconding this thought, Andrew said, "You need to think for yourself and not allow total reliance on the other. Working together creates a discipline and a fine edge."

Although each has internalized the other as "audience and editor," Robbins and Becher recognize the importance of retaining a sense of individuality. "You don't want to take something away from the other person," Max said. "On the other hand, you want to contribute as much as you can." This team cooperates to prove a project is worthwhile. If one feels very strongly about something, the other, while less enthusiastic, usually goes along. But the acquiescent person really has to like the idea. If one of them is tenaciously resistant to a notion the other likes, they scrap the project. When one has mixed feelings about a proposal, he or she may sometimes trust the other's enthusiasm and give it unequivocal support.

"In the end, it just seems to go that way," Andrea informed us. "But it takes several go-arounds playing with the ideas until we both fully agree and feel sanguine about it." Keeping a balance between the contributions each makes to their collective work has helped them to preserve a similar balance in every aspect of their relationship.

Bill and Mary Buchen have also devised a method for proving to each other that their individual ideas are viable. When one of them poses a concept, the other asks: How is this possible, will it work, how can it be changed for the better? Provoking one another to say what they mean and mean what they say, Bill and Mary—like all the partners in love and art—not only strengthen their individuality but also become more unified as a couple.

Inventing an Invisible Mediator

As a way of overcoming their creative disputes, Leo and Diane Dillon, painters and book illustrators, have invented the "third artist"—a personification of their relationship and professional identity as a team. In an article based on an extensive interview with the couple, Diane stated, "Our work was not something that either one of us would do ourselves. . . . It was something that was a combination of the two of us, more like a separate entity. If we were arguing and wouldn't speak to each other, the third artist forced us to."[39]

"All the third artist cared about was that we were able to do the work," Leo said. "If I was furious with Di, I was still compelled to sit down, be cordial, and work with her. . . . It's kind of weird to talk about it, but the third artist is a very real entity for us. It sounds bizarre, but we never knew what the hell it was going to do next."[40]

The Dillons rely on this mental embodiment of their collaboration to set aside their dissension and get on with their projects. While actually doing their utmost to come through creatively for each other, they appear to invoke the "third artist" as a reminder of their commitment to place their collective artistry at the pinnacle of their aspirations. This ingenious device may also provide them with some relief from the constant strain of feeling personally responsible for the contributions each one makes to their joint endeavors.

Having met as students at the Parsons School of Design, Leo and Diane married in 1957 and soon opted for a co-career. Their son was born in 1965. Together, they won the Caldecott Medal in 1976 and 1977 for outstanding work in the field of children's book illustration—the first time anybody had ever won the award for two consecutive years.

Leo was the first African American recipient of that honor. Although he is black and she is white, the Dillons decided—from the outset of their co-career—that they weren't a black artist or a white artist. "We are both," Diane affirmed. "We thought we might as well expand it out from there so we would be multicultural—but that was before *multicultural* was even a term."[41]

Despite their groundbreaking unity, however, there was friction between them because each one tended to cling to a different image of whatever they had agreed to create. As Diane explained:

> We would talk to each other and decide what we were going to do and we'd both nod, but Leo was picturing one thing and I was picturing another. One of us would take the illustration and start to form it, and the other would look at it and say, "That doesn't look like what I was picturing." But the third artist said, "No, let it go. Be creative. This is what creativity is all about. Take advantage of the accidents that happen." Then when it came back to me, and it's blue and I was picturing red, the third artist said, "Go with it and take it from that point." So we stopped pulling everything back to our own vision and let the creative process happen. The third artist freed us from the tension.[42]

Diane and Leo have taught themselves how to minimize mishaps in their collaboration. "If we are doing watercolor, we both individually do little watercolor studies and keep practicing to get our hand so that when we pass the work back and forth, we're able to blend our technique." Leo underscored the basic premise underlying their collective work: "The idea is not the individual ego, but the end product." Diane added: "We're really one artist now."[43]

∽o∾

Although none of the couples in our study showed any awareness of the professional literature on conflict resolution, all of them practice the skills that psychological experts advocate for lovers who want to overcome relational problems and become more united. Concentrating on the creation of *concrete and tangible* works of art, these partners have taught themselves how to communicate in ways similar to those that marital therapists recommend to couples who seek to comprehend and alter the *intangible and evanescent* patterns of their dysfunctional interactions.

As we have pointed out, a relationship consists primarily of the agreements partners make about everything they wish to do in

uniting their lives. Day after day, a co-career couple makes a myriad of agreements about how to proceed with their artistic projects. Every time they arrive at a consensus, they reinforce the solidarity of their relationship. In describing his collaboration with Anthony Aziz, Sammy Cucher said, "Talking intimately about our work increases our familiarity with each other—with our mental processes, our physical processes, and our physical relationship."

Clearly, the process of intimate creativity offers couples a means of cultivating the art of constructive communication. For partners in love and art, the attitudes and behaviors that nurture their creative work simultaneously improve the quality of their loving relationship. Still, to succeed in their chosen field, they have to move beyond conversation and produce work for others to see. Accordingly, all the couples would probably agree with Scherer and Ouporov: "We are very visual, very into the art object. The things we do are things that we cannot put into words."

5

From Inspiration
to Implementation

People have tried to delineate the chronology of the creative process, postulating stages such as preparation, inspiration, incubation, illumination, elaboration, and implementation. But these stages rarely follow a fixed sequence. As Csikszentmihalyi states, the "classical analytic framework leading from preparation to elaboration gives a severely distorted picture . . . if it is taken too literally."[1] A period of incubation may occur at the very outset of the process and reoccur each time the artist is confronted with a new task along the way, and a fresh inspiration may emerge just as he or she is on the verge of finishing the project.

The creative itinerary is largely determined by the medium in which a person works, and everyone evolves his or her own style and rhythm for traveling from the initial phase of the journey to its completion. So the "process is less linear than recursive. How many interactions it goes through, how many loops are involved, how many insights are needed, depends on the depth and breadth of the issues dealt with." Darwin's theory of evolution emerged slowly, in little pieces at different times, before it came together as a coherent whole. "It was a thunderous 'Aha!' built up over a lifetime, made up of a chorus of little 'Eurekas.'"[2]

Similarly, for collaborative couples, the interplay between an

inspiration and their shaping of it is not restricted to the beginning of the creative process. Instead, after being moved to action by a mutually accepted idea, both partners get continual feedback from every visual objectification they make to actualize it. Then the pair must agree on every other decision, big or small, that has to be made along the complex and convoluted path to the ultimate completion of a work.

Involuntary Inspiration/Voluntary Decision Making

All professional artists have faith in their ability to be inspired by original thoughts and perceptions. Without this confidence, they could not sustain their vocation. But inspirations also deliver psychological rewards. When a notion flashes into the forefront of their awareness, they are lifted into what Abraham Maslow referred to as a "peak experience" of exceptional animation.[3] This joyous jolt of excitement spurs them into mobilizing their imagination, and unleashing one's imagination is a most delightful form of play. With their imaginative powers on alert, artists are eager to discover the values and emotions an inspiration may symbolize and to explore how its expression can further the development of their talents.

Creative inspiration is always mysterious, however. Its messages pop up from an unfathomable void, appearing unbidden at any time or place; it is impossible to account logically for the compelling grip an inspiration exerts on an artist's consciousness.

Like emergent feelings of love, inspirations arise *involuntarily* from the subconscious. Once fully sensed, these ideational attractions—like amorous ones—require people to make the utmost use of their capacity for *volition*. Should they embrace the mental illumination and transform it into a work of art? Discard it as a transient titillation, insufficiently novel and significant to warrant pursuit? Can they surmount the dread of being unable to implement a particularly grand visualization?

Inevitably, the *involuntary* emergence of an inspiration triggers the *voluntary* process of decision making. Sometimes, this

transition is conducted and concluded so rapidly that artists seem to be giving it no conscious consideration. In reality, they choose among three possibilities: reject it; keep it on hold for further consideration; or put it into visual form at once—as Jackson Pollack did in his drip paintings.

Although his work appears to be wildly impulsive and without structure, Pollack exerted voluntary control over the process of expressing the emotions that rose up involuntarily from his unconscious. As Arthur Danto explains:

> The problem for the artist was to find a technique that enabled the creative unconscious to express itself on the surface. But for just this reason the paint had to be disciplined. A drip refers to a disposition of undisciplined paint rather than an act of artistic power. That is why controlling paint was a defining value for Pollack: It enabled him to yield to the unconscious and to bring up from its depth the forms that were its gift to consciousness.[4]

Like Pollack, partners in love and art are individually inspired by exciting ideas or impulses. They may also feel impelled to impose their own personal controls on these floods of inspiration, making sketches or written descriptions with lightning speed. Eventually, however, unlike Pollack and other solitary artists, their commitment to consensus requires collaborative partners to put a halt to these separate outpourings, review and discuss what each has done, and find a common vision that both can endorse with equal fervor.

This interactive procedure constrains single-minded surrender to whatever impulses either partner may be moved to express. But they turn this constraint into a creative enrichment by profiting from all the ideas, skills, and comfort each can give the other.

In this respect, co-career couples have advantages that are unavailable to individual artists. As Michael Dorris said about collaborative writing, an artistic team has two people who can get inspirations and feed them into their work. Andrea Robbins and Max Becher concurred. "We're two people who have a lot of

interests. We're lucky to have ideas." If they both like an idea, then they have much more confidence in it, and, together, they do things with greater enthusiasm.

Each partner can draw on abilities that he or she lacks but the other possesses. Like many of the couples we interviewed, Suzanne Scherer and Pavel Ouporov feel that they balance each other's strengths and weaknesses. While both are quite meticulous, he is more controlled, and she is more expressive. She's fond of color; he likes monotones. Having learned so much from each other, their separate weaknesses are now their common strengths.

Since they share responsibility for the ultimate outcome, collaborative artists can seriously contemplate projects that each would feel inadequate to entertain or pursue alone. Through their conversations, Kristin Jones and Andrew Ginzel nurture ideas that go beyond their individual capabilities, allowing them to explore the unknown and experience suspense without too much worry on either one's part. "Together, you come up with an idea, together you build it. And sometimes, it becomes something else. Neither one has to take all the load."

∽∽

Committed to reaching consensus on everything they do, co-career couples may be especially attracted to projects that require a considerable degree of deliberation and careful planning. These requirements are most evident in the large installations done by Christo and Jeanne-Claude, Diller and Scofidio, Jones and Ginzel, the Buchens, and Lilla LoCurto and Bill Outcault. To conceive and carry out such works, the artists consciously modulate the pace of the creative process, slowing it down to accommodate discussion of the myriad of details involved.

Contemporary artists are free to contemplate work that previous generations could neither imagine nor implement. Technological innovations continually widen the range of creative options. But the rapid proliferation of available techniques confronts artists with the task of learning how to apply them. They frequently have

to do extensive research on these applications before they can adequately conceptualize a project—much less construct it.

When they began to collaborate, LoCurto and Outcault radically changed not only the style of their work but also the materials they used. "All of a sudden, we realized there was a whole new technical world out there beyond plaster, bronze, and fiberglass," Lilla said. "It can be video, electronics, computers. Once we saw that, we never went back." Going forward with advances in technology, both have enjoyed learning new things.

Many of the couples we interviewed have familiarized themselves with the potentials of computer imaging. Several teams have delved into the complexities of digitized photography. Others have acquired detailed knowledge about the use of lightweight metals, malleable plastics, and other synthetic materials. Some are figuring out how to combine technologies—including computer programming and audio and video equipment—in a single multimedia installation.

But even in the theoretically looser medium of painting, Scherer and Ouporov strive to anticipate every aspect of a picture before they do any rendering. Together, they plan out the composition, images, and colors in precise detail. Picking up their brushes, they take turns working on the same piece. To portray a person in a natural setting, Pavel may begin by painting the landscape. Then Suzanne paints the figure and may make modifications to the background, and Pavel may add details to the figure and polish up the landscape.

Seeing a specific form or structure in its created reality, they may be pleased enough to move forward with their work. On the other hand, one or both may feel that it is not "right," that it fails to convey the synthesis of affect, thought, and imagery stirred up by their germinal inspiration. Although Suzanne and Pavel always agree in advance on what to paint, they are sometimes unable to produce the desired effects. When this happens, they may be at a loss to identify exactly what is wrong and what to do about getting the work back on track. Feeling inwardly oppressed, they have no recourse but to wait for an illumination from his or her unconscious to provide the "correct" solution.

Emotional Burdens of Incubation

Regardless of when it occurs during the creative process, this gap in the appearance of a conclusive and tension-releasing idea has been referred to as *incubation*. The liberating thought or image does not hatch until it is properly warmed in the invisible incubator of the subconscious.

While waiting, many artists experiment with ways of resolving the troubling discrepancy between what they see before them and what they intuit is missing. But their gnawing dissatisfaction may persist until another insight beams up from the capricious workings of the mind.

Often the pervasive sense of helplessness is accompanied by feelings of failure, loss, and despair. Even the most accomplished of creative individuals may become afraid of losing his or her basic concept of self. The poet Mark Strand described his own experience of this existential terror to an expert on creativity:

> Sometimes the hiatus will last not overnight but for weeks, months, and years. And the longer [it] is between books that you're committed to finishing, the more painful and frustrating life becomes. . . . [I]f it goes on and on, and you develop what people call a writer's block, it's painful, because your identity's at stake. If you're not writing, and you're a writer and known as a writer, what are you?[5]

Alarmed and upset, people in creative fields may seek professional assistance to dissipate their blocks. In New York City, the Gotham Writers' Workshop prefaces its catalogue of courses with the alluring promise: "We'll help you beat writers' block." In the same city, the monthly *Poetry Calendar* contains an advertisement for therapy specifically aimed at removing these psychological impediments. And troubled aspirants in visual art can troll for insights in Marion Milner's *On Not Being Able to Paint*. In this autobiographical work, Milner, a psychoanalyst who pursued art as an avocation, gives a candid—and graphically illustrated—account of the unconscious bases of her own creative blocks.[6]

The suffering of someone who creates individually, like Strand, may be all the keener for having to be endured alone. On the other hand, the individual does not have to bear the misery of an intimate collaborator. Nor does he or she have to provide solace to a lover in distress.

Co-career couples are not immune to the agonies of incubation. It is most demoralizing when both partners lack an initial inspiration powerful enough to launch a project or advance its development. While these partners implicitly trust the fertility of their combined imaginations, they must be willing to sweat out any stretch of sterility until a fresh and vibrant shoot of ideation breaks through the seemingly parched soil of their minds.

If an arid period is protracted, both may feel that the success of their creative teamwork is at stake and the efficacy of their collective identity is in jeopardy. In addition, each partner can be stricken with self-doubt and insecurity. Meanwhile, to salvage their morale, they may busy themselves with a huge amount of conscious exploration—playing with a plethora of ideas and images, reading and doing research—all in the hope of preparing the mental ground for a fresh message from the unconscious to take root.

How long it takes to get past a particular block in a couple's work can vary—a day, a night, a week, or several months. Sometimes LoCurto and Outcault let things simmer for years before coming back to a particular project. When deeply committed to an idea but unable to move it forward, they said, it feels as if a black cloud is hovering over them.

During their creative blocks, Scherer and Ouporov become depressed, anxious, and angry. Diller and Scofidio experience the same kind of anguish when they are bereft of inspiration, whether the shortfall involves major aspects of a project or a tiny detail. It's worst when both are hung up simultaneously. For Jones and Ginzel, blocks often occur at the planning stage, and they have to work hard to develop their ideas. But blockage is a continual issue for them. "We're always questioning the premises of what we're doing."

When Aziz and Cucher come up against a creative impasse, Sammy tends to interpret their ensuing torment as a basic

existential problem. Bemoaning their state, he asks such meta-physical questions as "What is the meaning of our work? What is the meaning of our lives?" At such times Anthony compassion-ately implores, "Don't go down that road, Sammy!"

Mutual Support Systems

Fortunately, partners in intimate creativity can provide consola-tion and encouragement for one another. "That's where the ad-vantage of collaboration comes in," said Aziz and Cucher. "We have each other to help us unblock."

Louise Erdrich confirmed this view in describing her collabo-ration with Michael Dorris. "There's this whole romantic idea of the artist as the lone sufferer. You know, there are times when no amount of being together with someone can save you from the blank page. But I'm sure it's much easier because we have each other."[7]

Robbins and Becher acknowledged that if they were on their own, each one might go slower and be more blocked by fears. "With two people, you don't get so blocked." The challenge of finding a balance between their individual ideas might seem like a limitation, "but once you have that balance, there's no longer any block about moving forward with the work."

If every little thing starts to bother Pavel Ouporov, Suzanne Scherer knows it's because their work isn't going well. Without that awareness, their relationship would be too difficult to bear. Luckily, she doesn't take it personally. If just one of them gets blocked at a particular time, the other will help him or her get through it.

Sterck and Rozo reiterated that position. "Usually you don't both have a bad day," Terry said. "One has a good day and helps the other." Although they've been blocked many times, Kat feels that working together is good in this respect. "Each one gives the other encouragement."

Like Suzanne Scherer, when Bill and Mary Buchen are blocked, they accept it as part of the creative process. Instead of regarding the situation as proof of their personal shortcomings,

they try to communicate objectively about how to overcome their difficulties. Although they talk a lot about the problem, Mary said, "I try not to obsess about it." Bill added cheerfully, "Eventually problems get solved."

Avenues of Escape

Claustrophobia may accompany the unresolved ambiguity of incubation, and despite the most conscientious efforts to support one another, partners may feel suffocated. So they look for avenues of escape and diversion. A change of scenery frequently brings some relief.

Diller and Scofidio used to go to a baseball game to divert themselves. They would eat good food at a fine restaurant, or get away for a weekend just to relax. Lately, they are too busy to do that; Liz regrets this and thinks they were better off before. Now, they are so fragmented with multiple projects that it's harder to get through the blocks when they occur.

Usually, Scherer and Ouporov visit a library or museum. Going to a party is an even better distraction. Returning to their studio, they feel refreshed and ready to tackle their work again. They also find that changing to another medium—intermingling painting with etching—helps them get out of a rut. Sometimes just "sleeping on the problem" gives them a new perspective.

Withdrawing from consciousness into sleep may actually be an aid to creativity. The German chemist Friedrich August Kekule conceived the structure of the benzene ring after falling asleep in front of a fireplace while watching the circular shapes made by the sparks. During his reverie, he saw "six snakes in a ring, each swallowing the tail of the one ahead," an image that provided the solution to the scientific problem he had been working on.[8]

A recent investigation of scientists' working habits found that "over half the scientists reported having their best ideas while falling asleep, dreaming, or on waking in the morning." Those scientists with the most publications "had an unusually high probability of solving their problems while dreaming."[9]

"Most scientific problem solving does not occur while addressing scientific problems,"[10] this study found. "Only half the scientists reported that they ever solved their problems while directly grappling with them." Some said useful ideas occurred to them as they were shaving, bathing, or taking a shower. A fourth of the sample said they came up with creative solutions "while relaxing, suggesting that hobbies provide useful problem-solving time." The most successful ones "tended to continue athletic activities that could be carried from youth into old age (walking, swimming, sailing, and tennis)."[11]

∽∘∾

Some partners separate mentally and physically from both the work and each other. Jones and Ginzel do different things on their own. While he teaches at the School of Visual Arts, she takes the opportunity to study yoga or visit friends. They regard these brief separations as "the air between them."

When Mary and Bill Buchen come up against a block, she goes out and participates in recreational activities with other people, like community gardening or arranging playful and spontaneous community events. She likes to do "quick, fun things" to take her away from the serious brainstorming she and Bill have to do for their long-range projects. To lessen his malaise, Bill has trained himself to jog, rollerskate, listen to music, or bicycle every day. He believes it is very important to "allow energy to come in, until one's state of consciousness brings in new ideas for an approach. If the body is strong, things work out."

Julia Cameron, author of *The Artist's Way*, is quoted as saying, "Walking is the most powerful creative tool I know."[12] Blake, Whitman, Wordsworth, and Keats all seem to have been walking enthusiasts:

> The simple act of taking a walk can dramatically boost insight and understanding. There's something about stretching your legs, breathing fresh air, and experiencing the passing landscape that stimulates the mind. A long stroll by yourself offers the

perfect chance to reflect on the world around you as well as what's going on inside your own head.[13]

The Benefits of Diversion

But how does "taking time out" help someone to break through a creative block? During this seemingly fruitless time, the unconscious is presumed to be working hard at solving the problem that has defied the artist's conscious attempts to crack it. "Some kind of information process keeps going on in the mind even when we are not aware of it, even when we are asleep," according to cognitive psychologists. "When we think consciously about an issue, our previous training and the effort to arrive at a solution push our ideas . . . along predictable or familiar lines." This kind of linear thinking does not necessarily lead to the best creative solution. When artists free their minds from concentrated attention on a problem, their thoughts often flow haphazardly in various directions and combine in unforeseen and unusual ways. "Because of this freedom, original connections that would be at first rejected by the rational mind have a chance to become established."[14]

Madeleine L'Engle, who won the Newberry award for children's literature, says that to get "unstuck"—in either her personal life or her writing—she sits down and plays the piano, breaking "the barrier that comes between the conscious and the subconscious mind. The conscious mind wants to take over and refuses to let the subconscious mind work, the intuition," she writes. "So if I can play the piano, that will break the block, and my intuition will be free to give things up to my mind, my intellect. So it's not just a hobby. [Piano playing is] a joy."[15] Einstein's violin playing was a similar diversionary tactic.[16]

Rollo May describes how wonderful it feels, after having struggled unsuccessfully with a problem for some time, to be freed from a creative block when you least expect it:

> There is a curiously sharp sense of joy . . . that comes when you
> find a particular form required by your creation. Let us say you
> have been puzzling about it for days when suddenly you get the

insight that unlocks the door—you see how to write that line, what combination of colors is needed in your picture, how to form that theme you may be writing for a class. . . . When my "insight" suddenly breaks through—which may happen when I am chopping wood in the afternoon—I experience a strange lightness in my step as though a great load were taken off my shoulders, a sense of joy on a deeper level that continues without any relation whatever to the mundane tasks that I may be performing at the time.[17]

Implementation

The Simultaneous Pursuit of Multiple Projects

All of the co-career couples we interviewed work on several projects at the same time. This means that they are continuously confronting the disparate problems that crop up at various stages in the creative process. It is difficult enough to cope with the anxieties aroused while incubating the answer to a crucial artistic question. But the rapid emotional, intellectual, and physical changes involved in jumping from one piece to another can be bewildering. The Buchens commented that the psychophysical gymnastics can make it difficult to maintain a focus.

But working on a variety of projects—at different points of development—permits partners to make something happen every day. While painfully incubating one project, they can be happily putting the finishing touches on another. Sterck and Rozo said that going back and forth from one picture to another provides benefits similar to those derived from diversionary activities or idle time, giving them "more space" to see each work with a fresh eye. This observation dovetails with the finding that many scientists "solved their problems by working on different scientific problems, either related or unrelated to the initial problem."[18]

Since Jones and Ginzel are always dealing with projects in different places and using different materials, Andrew said, "We're sort of reinventing the wheel every time." They enjoy the stimulation that comes from exposure to this diversity, however.

Robbins and Becher may be simultaneously juggling twenty-five projects, giving scant attention to some but zeroing in with gusto on those that are more articulated or nearly finished. Their work seems to have "its own rhythm." For them, stress comes less from dealing with multiple projects than from having to take care of all the practical chores of their daily lives. They are most frustrated when the "irritations of life" interfere with their creativity.

Andrea and Max would like to devote themselves more thoroughly to their work, to do it better, faster, and without interruptions. Yet, Max said, "We have this contradiction. We both want structure. But as soon as we have it, we rebel against it. So we're constantly inventing new structures and constantly dismissing them, every two or three days." Andrea nodded in agreement. "We have a fantasy of having a very harmonious structure that works—which does happen when we're traveling," she said with a smile.

Leaving their studio in New York to do a shoot, Andrea and Max are together in the same place to accomplish a specified task they have set for themselves. There are no phone calls or disruptions. Since these field trips are quite short, they formalize their ideas promptly and get to work with optimal intensity. "That's the best time," she said. "When we're traveling light—completely independent, meeting many other people but no ties to anyone, friendly but no obligations. We're the happiest then."

In the past thirty years, Christo and Jeanne-Claude have sustained eighteen projects at various phases of development. In fact, they've had more unrealized projects than actually completed ones. Employing the reproductive metaphor once again, Jeanne-Claude said, "We were pregnant with all of them, and we didn't know which one would be born first."

Making several trips to every location earmarked for one of their installations, the couple researches sites, does feasibility studies, and tries to obtain permits. While some artists might regard all this activity as overly taxing—especially when no one can be sure any of the projects will materialize—Christo and Jeanne-Claude thrive on it. They like having to handle everything that's going on at once. Expending so much effort and energy makes

things exciting. "Our work is so overwhelming, we're never bored." For viewers, their projects impart a memorable blend of distinctiveness and power. The couple described the impact, even for themselves, as "mesmerizing."

Perseverance and Hard Work

Edison has been quoted as saying that creativity involves one percent inspiration and ninety-nine percent perspiration. He

> demonstrated his faith in his statement . . . by inventing the light bulb. Early in his work, he had the idea of passing electricity through a filament placed in a vacuum in a glass sphere. Nevertheless, he had to conduct 2,004 experiments, using different materials for the filament, before he discovered that carbonized thread would not burn out quickly.[19]

Co-career couples possess a similar tenacity and perseverance. After agreeing to implement a concept, the Buchens continue to edit and refine it on the computer. This arduous task of elaboration calls for an extraordinary amount of persistence. There are so many factors for them to incorporate that they never seem to reach a point of equilibrium. They keep changing the design until the deadline for submitting it for a competition or a grant. Once their plans are in the mail, they relax a bit. If their work is funded, however, they usually go on altering the original design—even as the installation is being constructed.

Nina Holton, an accomplished sculptor, was a subject for Csikszentmihalyi's study:

> Tell anybody you're a sculptor and they'll say, "Oh, how exciting, how wonderful." And I tend to say, "What's so wonderful?" I mean, it's like being a mason, or being a carpenter, half the time. But they don't wish to hear that because they really only imagine the first part, the exciting part. . . . That germ of an idea does not make a sculpture which stands up. It just sits there. So the next stage, of course, is the hard work. . . . And sculpture is that, you see. It is the combination of wonderful wild ideas and then a lot of hard work.[20]

Bill and Mary find both good and bad features in their evolution from crafting musical instruments to designing an entire playground. "It's very rewarding to bring off a big project. But such projects also bring a lot of detailed headaches." Even as a two-person team, they can no longer do everything on their own. Being dependent on other people means that they have to coordinate and deal with contractors and others who help to fabricate their work.

Although implementing a project is an exceedingly intense experience for Jones and Ginzel — almost theatrical and often exhausting — it strikes them as less exciting than the process of conceiving the original idea. Because their work is usually massive, they also have to hire other people to assist in the actual construction, and they must attend to a lot of administrative detail. The first phase of a collaboration — proceeding from an inspiration to its conceptual shaping and visualization — is the zenith of their creative enjoyment.

For Diller and Scofidio, likewise, deciding what they want to do is the hardest and most fulfilling step in the creative process. With this formulation, both feel that they have crossed "the big threshold." From then on, it's easier to divide the labor. Owing to the multiplicity of the commissions they accept, either Liz or Ric starts a project, but they volley it back and forth, "like a tennis game," to get each other's suggestions and critiques. Although employees help in implementing their plans, both of them review and approve everything that comes out of their studio. "We tend to be control freaks." If any detail happens to slip past their notice, they are extremely regretful.

For Christo and Jeanne-Claude, by contrast, transforming a design into its intended installation is the most satisfying part. He describes their projects as having two major steps. In the "software period," the work is more or less invisible, consisting only of the drawings, scale models, technical information, and legal applications. The production phase, which Christo calls the "hardware period," is based on the accumulation of all these previous projections. "The physical making of the work is probably the most enjoyable and rewarding because it is the crowning of many

years of expectation. The hardware period is very much like a mirror, showing what we have worked at. The final object is really the ending of that dynamic idea."[21]

The exacting process of putting their complex ideas into paint is also a thrilling fulfillment for Scherer and Ouporov. For years, they created only two-dimensional pictures. Gradually, they started incorporating three-dimensional elements — shadow boxes, skeletal structures, and even metal etching plates — as integral parts of their pieces, some of which are now quite large.

Their most recent body of works is called *Dream Ikons*, which they conceived after sharing dreams with each other, family members, and friends. In his commentary for the exhibition catalogue, Donald Kuspit, an art historian, writes: "Personal dreams are points of departure for universal vision. . . . [T]he labyrinth is a familiar symbol of the human predicament. The animal skeletons that abound are clearly death symbols." These images are "profoundly evocative . . . imaginative presentations of haunting archetypes that convey their continued relevance to our lives."[22]

The couple's pleasure in the intricacies of production is evident from their own description of the creative process:

As in Russian icon painting, we first create a "covcheg" (Russian for "Noah's Ark") by carving into a wood panel. The ark is a metaphor for a vessel, . . . cave, womb, and the bearer of life and regeneration. . . . [T]he use of a wooden support is symbolic of the tree of life and embodies the dualistic life and death principle.

We are drawn to . . . icon painting because each step is symbolic; from the application of the gesso, clay bole and gilding to the grinding of the pigments with egg yolk. . . . Our painting process is a marriage of fifteenth century Eastern and Western techniques, combined with contemporary practices. . . . [It] can be understood metaphorically as a pyramid or mountain. At the . . . base . . . earth colors are used to represent our cosmic nature. . . . Our goal is to reach the center of the painting, or top of the pyramid, where the colors are the brightest. . . . The gold application is the last part . . . or tip of the pyramid. . . .

The act of gilding symbolizes the "breath of life" because when we apply the gold, we must breathe deeply from within

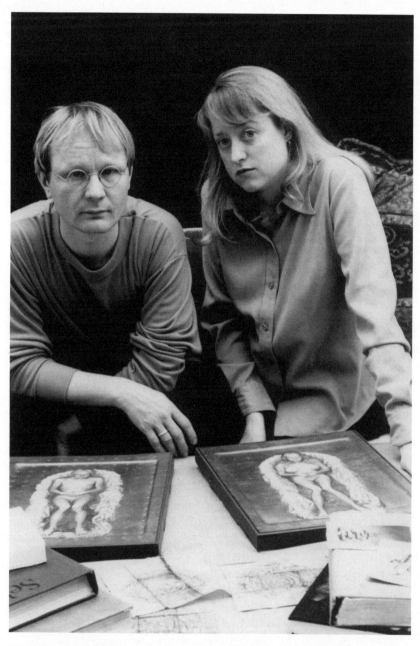

Pavel Ouporov and Suzanne Scherer. Photo by Luba Proger; courtesy of the artists.

onto the clay bole for it to adhere. The moisture from one's breath wets and creates a tacky surface, allowing a perfect bond. The clay and gold together represent man's dual cosmic and earthly nature, material and spiritual sides.[23]

Abandoning a Project

Scherer and Ouporov do not achieve such a happy outcome with every picture they paint. Occasionally, they look at what they have done and decide that it is not "working." So they give it up. Having more creative ideas than time to implement them, they don't want to waste their energies trying to salvage a work that strikes them as irreparable.

LoCurto and Outcault have abandoned projects for various reasons. Sometimes they come to an epiphany that simply says, "It sucks." Or they may realize that the same concept has already been addressed by another artist and implemented as well as they might have done it. When this happens, Lilla feels that a burden has been lifted off her shoulders. It frees her up, and she doesn't feel bad about giving up the idea. But Bill has a slightly different reaction. "Sometimes when you see an idea has been done by someone else," he said, with mild regret, "you think, gee, that was quite a good idea after all."

Sometimes, after struggling for years to obtain the necessary permissions, Christo and Jeanne-Claude have decided not to follow through on a project. This decision may be totally irrational: "It's a feeling." Regarding their art as a work of joy, beauty, and pleasure, this team believes in being true to themselves about implementing any project they propose. Sincerity and honesty are the most important things. If they lose interest over time, or have a change of heart about the significance of a particular work, they will abandon it. For them, this means that "the love was gone." As they say, nobody needs art, so they cannot justify or explain their artistic decisions. Similarly, Jeanne-Claude asserted, "I know I love Christo, but I can't explain why." Yet she added that when seeking permission to do their work, they try to be very rational.

For some couples, on the other hand, abandoning a project is out of the question. The Buchens said that they wouldn't take anything on if they couldn't fulfill the obligation. Diller and Scofidio feel the same way. They don't start projects that they can't complete.

Perfection and Completion

Artists feel driven to give objective form to the image of perfection they behold on the formless screen of their imagination. Striving for this goal, they expend their energies unstintingly and tolerate the accompanying tribulations. Yet they also attain sublime fulfillment, and they want to keep on getting the kicks that only this pursuit can give them.

Nevertheless, professional artists realize the impossibility of producing perfect translations of what they see in their mind's eye. Ideas and images always appear flawless to the imagination; shapes, colors, and structures are infused with a vibrancy too luminous to be duplicated in any medium of visual art. The quest for perfection is foreordained to fail. This awareness is poignantly described in Joyce Cary's novel, *The Horse's Mouth*, whose hero bemoans his inability to capture perfectly the pictures he imagines.[24]

Generally speaking, artists do not surrender easily or quickly to the inevitability of imperfection. All of the co-career couples are unrelenting in their efforts to bring their work closer and closer to their intuitive sense of what it should be and how it should look. Sometimes they are reluctant to let a piece go out of their hands and into the world. This desire to produce a perfect work can become a serious and self-imposed obstacle to its completion. As a practical matter, however, these couples accept the inevitability of having to finish and display their work—even if it remains, for them, an imperfect expression of the template inside their heads. Having forced themselves to relinquish a piece, they may be left with a bitter aftertaste, thinking of all the improvements they might have made.

These afterthoughts may be persistent enough to motivate the most polished co-creators to revise work they had considered ready for public scrutiny. "We thought *The Beet Queen* was completely done in November," Erdrich and Dorris recalled. "We sent it out; it was duplicated at the publishers. But it just nagged at us and nagged at us. Right after Christmas, we started rewriting it from page 206 on. In a month, we rewrote pages 206 to 393 and made a whole new ending. The last fifteen pages are completely new."[25]

We found similar tendencies among partners in love and art. Jones and Ginzel always want to improve whatever they have done. In this respect, they are constantly dissatisfied. No matter how much time they have, they always want more. They would like to "spend a life" on every piece, but deadlines force them to complete the work.

Sometimes Sterck and Rozo think something is finished, and then decide to go back and do it over. Since Katleen is the more perfectionist partner, Terry will usually defer to her judgment.

Because of the nature of their work, the Buchens never feel a project is completely finished. "You build it, you photograph it, and then you leave it. But you get calls and have to help with maintaining it. So you don't ever quite leave it."

LoCurto and Outcault feel worn out when a project is finished and set out in the world. Still, by then they're beyond it and on to other work. "It's not like you're ever in this happy state of mind," Bill lamented. "You're already in turmoil, arguing about the next piece."

Sometimes Scherer and Ouporov deliberately leave a painting unfinished, "giving it air to breathe." Thanks to their careful planning, however, they usually have no disagreements about when a picture is completed. Sealing their unanimity with a ritual of closure, they'll sit for half an hour looking at a piece and then say, "O.K., it's done."

Afterward, each reacts differently to the fact of completion. Using humor to cloak any residue of ambivalence, Pavel may ask facetiously, "Where am I going to find wall space for it?" For Suzanne, their accomplishment is accompanied by a feeling of

depression. She is sorry the process is over, "like when you finish reading a really good book and you don't want it to end." She also starts to think about the next picture: "This one turned out pretty good. How are we going to beat it?" Ironically, being delighted by a finished painting can make it even more difficult for them to move on because they worry about doing as well—or better—the next time.

Highly critical about their own work, Diller and Scofidio may complete a piece but resist seeing the creative process as "closed." Rather, they feel that the project "is still cooking and could be cooked a little longer." They regard a work as done when it has a material presence in the world. Some projects give more closure than others—like the immediate reaction from the audience in a theater. They enjoy getting reactions from other people, whether positive or negative.

In apportioning time among their multiple projects, Liz and Ric give priority to the one with the most pressing deadline: "Deadlines are a definite point of terminus." Sometimes they are pleased with a work at that end point, and sometimes not. If pleased, both experience a tremendous sense of satisfaction. "When you finish a project and you look at it, you think, Wow! That's something neither one of us could have done alone. We recognize that it's a complete meld of ourselves."

Deadlines also serve an important function for Aziz and Cucher. Doing everything on schedule helps them to treat their work more professionally.

For Robbins and Becher, however, the subject establishes its own rules. In doing their project, *Dachau,* they went back many times to take more photographs and focus in on a limited number of images, which were essential to evoke the chilling atmosphere and mood they strove to convey. "There is a feeling of trying to get to the point you want—the sense that you've finally 'gotten it.' " Even after completing a series of pictures on a general theme, they allow for revisions later on and are very flexible about making changes.

Andrea and Max told us how much the resolution of creative conflicts helped them to overcome problems in their relationship.

But they also brought up an intriguing corollary of that dialectic: Resolving conflicts in their personal lives has had a positive impact on their work. In confronting their parenting patterns, both of them realized that they didn't have to be absolutely perfect about everything they did. This insight also released them from the unattainable perfection they had been demanding from each other in finishing their work.

Since Christo and Jeanne-Claude are always doing co-created "labors of love," they thoroughly enjoy completing a project. The goal of their art is to *realize* a work, which usually involves many years of preparation — it took three years to determine the exact position of the thousands of umbrellas they planted simultaneously in Japan and California.

After all the time they have invested, Christo and Jeanne-Claude thrill to the beauty of the completed installation. Taking a leisurely walk, arm in arm, through and around such a massive creation, they absorb the sheer physicality of it. "We feel the sensuality in the gut." No longer merely conceptual, their sense of satisfaction is almost sexual in nature.

In addition, the temporary nature of each installation gives the pair an incomparable incentive to savor its pleasure. A fundamental aspect of their approach to art is an emphasis on the temporary. Christo and Jeanne-Claude believe that transience infuses their projects with more energy and intensifies viewers' response.

At Little Bay in Sydney, Australia, the coastline remained wrapped for ten weeks. In 1970 the wrapping of the monument to Leonardo da Vinci on the Piazza della Scala in Milan was removed after three days. And the wrapping of the monument to Vittorio Emanuele on the Piazza Duomo, which was done at the same time, lasted for only forty-eight hours.

Contrasting their philosophy with the traditional aspiration for permanence, one of their biographers states: "The immortality of artworks, inscribed over the centuries into our consciousness of sculpted stone or printed page . . . has never been more radically defied than by the Christos' works — often involving elaborate technical operations, months or years of planning, and

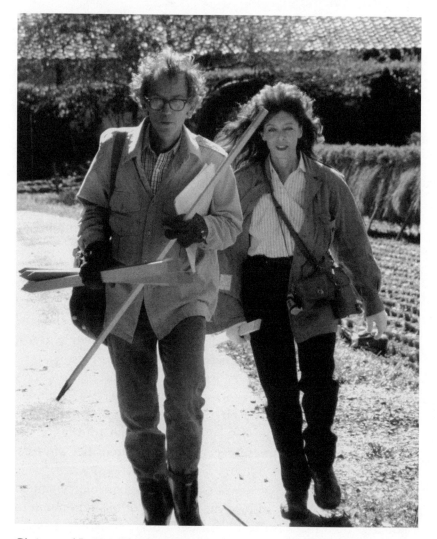

Christo and Jeanne-Claude during the staking of the locations for *The Umbrellas, Japan-USA*, at the Ibaraki, Japan, site, October 1988. Photo ©Wolfgang Volz.

the labor of many, only to disappear, leaving no trace at the site where they were created."[26]

Yet Marina Vaizey, another scholar, insists: "After the work has been prepared and . . . has been put up and taken down, it remains. . . . It remains in the memory of thousands who will have

experienced it first hand; it remains in the memory of those who will have seen the work on film, on television, in the newspapers."[27] Surely, the magnificent drawings of their proposals, which are works of art in and of themselves, preserve each project for posterity.

Besides, Christo and Jeanne-Claude asked, with a mischievous twinkle in their eyes, having invested millions of dollars of their own money to bring a project to life, how could they *not* enjoy its successful fulfillment?

6

The Harmony of Equals

It has taken many years for women to achieve, by law and social acceptance, the right to step forward for whatever occupational goodies America provides. The economic playing field is still, of course, far from level, and women continue to encounter impenetrable glass ceilings in their efforts to make it to the top in the corporate world. But contemporary women are imbued with an unshakable desire to actualize their talents by pursuing careers as seriously as men have always done.

In today's economy, moreover, playing the stereotypical role of Helpmate Harriet to the man's Obermensch Ozzie is no longer a viable option for most couples. It takes the paid employment of two people to make as much money as one person could bring in forty years ago. Both partners must generate income to avoid poverty or a sharp reduction in what they have learned to regard as an adequate standard of living.

As we move into the twenty-first century, men and women have become increasingly alike in two vital respects: both have to work and both want to work. Given this commonality of motivation, it is no surprise that the dual-career marriage has emerged as the new social norm.

Theoretically, harmony between men and women should increase as society provides them with equal opportunities to pursue their careers. But our socioeconomic system defines vocational

success as the ability to advance in a societal hierarchy of status, wealth, and power. As they advance, therefore, both men and women become more and more unequal in relation to those on the lower rungs of the ladder. This situation of invidious distinction tends to foment disharmony and dissatisfaction among all those who are competing, as George Orwell said in *Animal Farm*, to become "more equal than others."

The damaging effects of socioeconomic competition often spill over into the domestic realm. As a study of dual-career couples explained, "The work world . . . with its emphasis on success and achievement and its many barometers of progress (promotions, salary, prestige), provides ample opportunity for comparison and competition between spouses."[1] Many of the husbands

> acknowledged that their views on comparative income were bastions of tradition and even chauvinism; discussion of salaries elicited these recognitions more frequently than any other topic in the interviews. . . . For one man . . . his wife's higher income has been a source of shame and frustration. He reports that over the years he has accommodated somewhat to not living up to the ideal of being a "macho" provider [but proclaimed,] "It would make me feel like a million bucks to earn more than she does."[2]

Loving relationships may become troubled when the intimate equality partners feel privately is opposed by the *public inequality* attached to differentials in their earnings or the respect given to their careers. Even supposedly "liberated" couples continue to jump into this oppression. With limitless aspirations for achievement in their occupations, both partners personify the single-minded competitiveness that formerly typified male "go-getters." Sprinting in separate lanes on a "fast track," neither partner is protected from the severe stresses that only men used to bear. Although these contemporary careerists may find it easier to empathize with each other's suffering, they may also find it more difficult to switch from being "hard-nosed" all day at work to becoming compassionate lovers at night.

As we noted in our previous book, however, a woman and a man have the option of refusing to look at one another through

the eyes of society's system of self-aggrandizement.[3] By definition, this structure is unjust. Why bring its injustice into a loving relationship? Instead, they can recognize that what matters most is how equal they feel as lovers—how much of a match they really are for each other emotionally and intellectually, regardless of their status in the workplace. Given this essential awareness, both can view the fact that one partner is "doing better" in the institutionalized inequality of the social order as an economic boon to the relationship they share in common—not as a divisive force.

In the work on dual-career couples cited above, an academic in his mid-thirties accepted and appreciated the fact that his wife earned a higher income: "It would be nice if I were paid better for what I do. But I am glad she is paid as well as she is. It keeps me from feeling like I need to support the family single-handed." His wife is just as comfortable about their situation: "Bob jokes that I allow him to dabble in research. It's nice to make a good salary, especially as a woman. It gives me a good feeling, a sense of security. I know I could support myself and the children if anything were to happen to Bob."[4] With this perspective, the more successful partner does not get carried away with a grandiose sense of power, and the less successful one does not feel inadequate and worthless.

Nevertheless, in a celebrity-crazed society under the self-centered sway of capitalism, it is extremely difficult for members of most working couples to remain impervious to the appeal of promoting their separate careers. And the more partners individually strive to rise in the hierarchy of social inequality, the less energy and motivation they have to maintain their relational equality as lovers.

Partners in love and art have decided to bypass such competitive conflicts by mounting a joint career. Through their collaboration, they reject the inequities and divisiveness of differential pay, status, and power. Contrary to the clichés of pop psychology, they show that both women and men can come from Mars as well as Venus. No matter how different in background and temperament, these partners prove that a woman and a man can inhabit the same planet of emotional sensitivity, intellectual awareness, verbal communication, and creative skill.

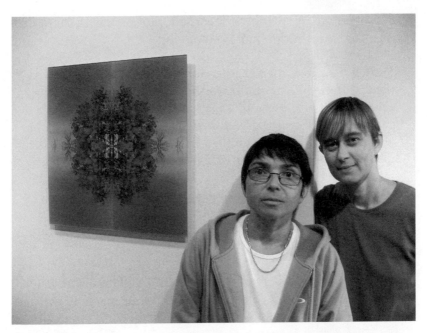

Terry Rozo and Katleen Sterck with *Untitled 7,* DNA Gallery Installation, Provincetown, Massachusetts, July 2001. Photo by Colleen Longo; courtesy of the artists.

Naturally, same-sex partners have no gender differences to consider or overcome, but they can become chronically enmeshed, as many heterosexual and homosexual lovers do, in a struggle to dominate or get one-up on each other. We found no evidence of such contention among the same-sex couples we interviewed. Rather, they are as cooperative, considerate, and feel as mutually empowered as any of the male/female pairs. Confirming our findings, Katleen Sterck and Terry Rozo's partnership in intimate creativity was celebrated in an article entitled "The Equal Other."[5]

Minimizing the Woman's Contribution

It was customary in the past to minimize the woman's part in a couple's joint creativity. While Jean Arp and Sophie Taeuber are

now professionally acknowledged as a pioneering collaborative couple, her contribution had been downplayed.

> During their lives together and afterward, Arp's work received the most recognition; similar works by Taeuber were regarded as executions of his ideas rather than as of equal value. This disregard can probably be attributed to prejudice against women in general, and to the low prestige among the arts of the textile media used by many women. And because Taeuber earned a living for both herself and Arp with a steady job for many years, she did not fulfill the image of a female artist at the time and was relegated to the role of an artist's wife. In addition, many of her acquaintances attest to the fact that she herself gave preeminence to her husband.[6]

The extent of Robert and Sonia Delaunay's collaboration is also often overlooked, as when Calvin Tomkins made no mention of Sonia in his review of a recent Guggenheim Museum exhibit of paintings produced by Robert between 1909 and 1914.[7] Yet those very years, just after they were married, were the most creatively fruitful for both Robert and Sonia, the period during which they jointly devised the concept of simultaneity in painting and had the greatest impact on one another's work.

The lack of any reference to Sonia in this review reveals how difficult it is for some contemporary critics to appreciate and accept the inextricable mutuality of the influence that intimate partners exert on each other's creativity. These commentators may be particularly blind to the possibility that the female member of the pair could have an equal impact on their work. Discussing the Delaunays in their latest book on women in art history, the Guerrilla Girls "shake a hairy finger at any dense-headed critic or art historian who doesn't mention both of them in the same breath."[8]

In 1956 the celebrated team of industrial and architectural designers, Charles and Ray Eames, were interviewed on the *Today Show*. Arlene Francis introduced Ray in a typically condescending manner: "Almost always when there is a very successful man there is an interesting and able woman behind him. This is Mrs. Eames and she is going to tell us how she helps Charles design

these chairs.' Charles squirmed, while Ray seemed less anxious about the introduction."[9]

Ray is said to have "enjoyed playing the wife behind the great man, but another part craved recognition in her own right—a recognition she deserved. To the extent that the Eames style of the 1940s and 1950s was 'progressive' and 'avant-garde,' Ray was certainly as responsible as Charles."[10] In fact, many of their colleagues believe the appeal of their classic molded chairs resulted from her exceptional sense of form and interest in abstract art.

Charles always emphasized Ray's abilities, saying, "Anything I can do, she can do better." But what some people regard as the "prettiness" in many of their collaborative designs has been attributed to her feminine esthetic sensibilities and criticized "as a deviation from the strait and narrow path of orthodox modernist concerns."[11] This situation is not unique:

> There are parallels between the way Charles and Ray Eames have been viewed and the way another famous pair of designers, Charles Rennie Mackintosh and Margaret MacDonald Mackintosh, have been evaluated since the 1930s. In both cases, the man (trained in architecture) has been hailed as a genius in the field of modern architecture and design. The talents of both men are undisputed; however, in view of the intensity of the admiration for Charles Eames and C. R. Mackintosh, it is all the more surprising to find that the women designers they not only greatly admired but chose to live and collaborate with have been relegated to the margins of history.[12]

Mackintosh has been quoted as saying that his wife, Margaret, had genius, whereas he had only talent. Although this outstanding team of designers viewed the decorative aspects of their work as integral to its quality, Margaret's contribution has been denigrated as merely decorative rather than structural, and her preference for symbolic decoration has been "blamed for holding back her husband from a bolder, purer form of modernism."[13]

In an article written as recently as 1990 for the German journal *Kunstforum*, Pialo Bianchi identifies one source of this bias: "Collective works have always embarrassed art historians, particularly

when the artists live together on intimate or communal terms (even a married couple). Male dominance, rigidly determined by society, leads them to categorize the spouse as a mere helper or to consider her a second-rate imitation of her male companion."[14]

This pejorative attitude toward the female members of collaborative couples has also prevailed in other fields. In the foreword to *Creative Couples in the Sciences*, the editors state:

> The practice of collaboration clearly has profound implications for the work and careers of both partners, but historically it has been the women in such partnerships who have borne the brunt of society's asymmetric evaluation of the genders. . . . The gender hierarchy of a patriarchal society cannot, however, so easily ignore women who have been co-authors with men or whose contributions have outlasted those of their male partners. Because it is no longer possible to render the women's share of the work invisible, society's solution has been to regard the women's contribution as merely derivative. Influence could flow only one way, from men to women, not vice versa.[15]

Such an "asymmetric evaluation" was imposed on Carl and Gerty Cori even after they received the 1947 Nobel Prize as a team for their collaborative work in physiology and medicine. Upon emigrating from Europe to pursue their research in the United States, they encountered opposition to their collaboration and were forced to take positions in separate departments of the scientific institute that had hired them. Later, when Carl was offered a job at a university in New York State, Gerty was told that it was "un-American" for a man to work with his wife, and that she was standing in the way of her husband's career.[16]

The Impact of Feminism

Such sexist attitudes have been changing since the 1963 publication of Betty Friedan's book *The Feminine Mystique*, which sparked "a new wave of feminine awareness that culminated in the current women's movement."[17] Regarding female artists who

work on their own, the Guerrilla Girls see mixed results: "More women's art has been exhibited, reviewed, and collected than ever before. Dealers, critics, curators, and collectors are fighting their own prejudices and practicing affirmative action for women and artists of color. Everyone except a few misogynist diehards believes there are—and have been—great women artists. Finally, women can benefit from role models and mentors of their own gender." On the other hand: "Women artists still get collected less and shown less. The price of their work is almost never as high as that of white males. Women art teachers rarely get tenure and their salaries are often lower than those of their male counterparts. Museums still don't buy enough art by women, even though it's a bargain!"[18] In one of their poster campaigns, the Guerrilla Girls pointed out that, for the money spent on one painting by Jasper Johns, a collector could have purchased a work of art by every woman included in their recent book on the female contribution to the history of western art.

The present success of heterosexual *couples* in art is attributable not only to feminist consciousness but also to the relational equality these pairs commit themselves to preserve. Rejecting any presumptions of masculine superiority and free of internalized self-deprecation, the female partners affirm the right to equal power in their intimate relationships and professional co-careers. Reciprocally, their male partners accept these affirmations as just and essential to the couple's success in loving and making art.

When Helen and Newton Harrison first started to collaborate in the late 1960s and early 1970s, their division of labor was still based on stereotypical gender roles: "Nurturing, washing, and cooking were allocated to Helen; Newton built and maintained the tank and ecosystems." At that time, "they established the methods and routines possible with collaboration, and . . . experimented with gender-coded, highly determined performances and rituals."[19] Gradually, they began to reject those separate roles in their personal lives.

They also began to depart from the collaborative divisions of labor . . . so that Helen Harrison was no longer the "researcher"

and Newton Harrison the "maker." The creation of new gender-less identities . . . reflected a conscious desire to move away from binary cultural opposites such as male/female, nature/culture, work/leisure, and good/bad. . . . [T]hey did this by eliminating the signs of their identifiable individual personalities in favor of many roles and voices.[20]

The women in such artistic partnerships are finally receiving as much recognition and credit as the men for the work they create together. Moreover, as the following example suggests, they do not hesitate to defend themselves against even the most genteel show of condescension from their male partners.

Claes Oldenburg tells the story of how Coosje van Bruggen confronted him about the extent of her contribution to a work completed early in the 1980s, before their artistic collaboration was firmly established. *Cross-Section of a Toothbrush with Paste*, he said, "reminded me of Coosje's body in its combination of angular and soft forms, dressed in the red sweater and blue jeans I had often seen her wear. . . . One evening, struck with how much of her was contained in the sculpture, I offered to 'dedicate' the work to her."[21]

Coosje told him she did not believe in dedications and felt her contribution transcended the role of muse. Oldenburg acknowledged that she was the one "responsible for the idea of the cross-section that gave the work its special identity." And, overall, it "signified her approach of cutting through a situation to reveal the connections of its parts."[22] Having attained this insight, he suggested an addition to the title: *Portrait of Coosje's Thinking*. She was pleased; the new title reminded her of Rodin's *Thinker*—an appropriate association, since she had played an important part in conceptualizing the basic design of the piece.

Harmonizing Goals and Roles

The roles partners play in loving relationships evolve in two basic ways:

Role taking refers to the processes by which partners adopt or conform to preexisting cultural or social guidelines. . . . In contrast, role making refers to the processes by which partners create their own idiosyncratic rules, expectations, and goals. . . . Partners may actively discuss and think about their relationship, hammering out agreements, and discussing points of difference. They may "fall into" habit patterns or discover what seems to "work best" for them on the basis of individual values, interests and skills. Close relationships usually involve a mix of both role taking and role making.[23]

Partners in intimate creativity engage more in "role making" than in "role taking." These couples are guided by two major goals: to function optimally in their creative work and to maintain the harmony of their loving relationship. To achieve these objectives, they jointly agree to play whatever roles are required—in both the professional sphere and their day-to-day lives—as effectively, flexibly, and pleasurably as they possibly can. Each one handles what he or she does best and enjoys most, and they divide the chores both of them find unappealing as equitably as they can.

The homosexual couples in our study follow a similar pattern. Research suggests that, in general,

most lesbians and gay men today actively reject traditional . . . masculine–feminine roles as a model for enduring relationships. . . . [E]xaminations of the division of household tasks, sexual behavior, and decision-making . . . find that clear-cut and consistent husband–wife roles are uncommon. . . . [T]here is some specialization of activities, with one partner doing more of some jobs and less than others. But it is rare for one partner to perform most of the "feminine" activities and the other to perform most of the "masculine" tasks. . . . Specialization seems to be based on . . . skills and interests.[24]

In defining and enacting their relational equality, the co-career couples in our study resemble the dual-career couples the sociologist Pepper Schwartz describes in *Love Between Equals*. The relationships of that "small but provocative group" are based "on a mix of equity (each person gives in proportion to what he

or she receives) and equality (each person has equal status and is equally responsible for emotional, economic, and household duties)." Schwartz calls this kind of pairing a peer marriage: "a marriage of equal companions, a collaboration of love and labor in order to produce profound intimacy and mutual respect."[25] For these spouses, the point "was not to share everything fifty-fifty. Rather, the shared decisions, responsibility, and household labor were in the service of an intimate and deeply collaborative marriage." Furthermore, "people in peer marriage for the most part are not ideologues." Like the partners we interviewed, those couples "construct and maintain a peer marriage because they find it rewarding."[26]

Feeling equally needed, appreciated, and respected, partners in egalitarian relationships are motivated to give as much as possible to one another. According to Kathy Weingarten, a clinical psychologist: "To sustain a balance of giving and taking," it is important for lovers to "individually assume the responsibility of monitoring their own behavior. Maintaining 'gave/got' tally sheets is not the best way to effect the balance. A genuine desire not to exploit one's partner is much more likely to result in reciprocity."[27]

Managing Day-to-Day Living

Some partners in love and art agree to divide the household labor according to a predictable routine. As Sterck and Rozo told us, Kat likes to eat, and Terry enjoys cooking for her. So Terry prepares all the food. In addition, she does the repairs for their car. However, she "washed out" in her one attempt to do the laundry: She accidentally left some metal screws in her shirt pocket, and a lot of their clothes got ripped up. After that incident, Kat took over the laundry chores. She also manages their money and keeps the books; Terry regards her as "a financial wizard." But nobody does the cleaning—"only when Kat's mother comes from Belgium to visit," Terry said laughingly.

Suzanne Scherer would like Pavel to share more of the cleaning and dish washing, as her father had done with her mother. Pavel has displayed his resistance by proposing that they use paper

plates and cups. While Suzanne also does most of the cooking, she is "struggling with it." But Pavel is very good at fixing things around the house.

Because Suzanne knows more about banking, she manages their finances, and Pavel depends on her for that. But since they are equally helpful about reminding each other to do whatever has to be done, she does not feel unfairly burdened.

The Buchens are also pleased with their division of labor. Most of the time, Bill is the self-appointed cook. But Mary does the washing up and more of the cleaning: As she remarked, "My husband's personality changes when his hands are in dishwater." Both are very neat and have contributed equally to the serene orderliness of their beautifully renovated loft, where they have their own "zones" for solitary work and meditation.

Mary takes care of their joint checking account and income taxes. She and Bill believe that separate bank accounts are divisive. "We've never had 'his' or 'her' money," Mary said. "If it's one hundred dollars or more," Bill explained, "we talk it over. We always talk it out."

Kristin Jones does the dishes and takes out the trash. Although she and Andrew Ginzel like to cook, she winds up doing most of the cooking. A woman comes in once a month to help her with the cleaning. Andrew initially opposed this assistance; now, he looks forward to it and is gratified to see their place looking organized and attractive.

Andrew is the couple's bookkeeper and frequently monitors the accounts while Kristin is working in the kitchen. Since she is expansive by temperament and believes in living in the moment, Kristin is more carefree about money and inclined toward extravagance. Andrew has to caution her repeatedly against increasing her personal spending. They have both decided that it would not be prudent to put her in charge of their finances.

The household occupies a very low place in Elizabeth Diller and Ricardo Scofidio's set of priorities. They eat out a lot because it is easier; they do very little entertaining at home; and they are quite casual about the appearance of the living space in their huge loft, which they have separated from the much larger area devoted

to their art and architectural practice. Like Andrew Ginzel, Ric supervises the couple's finances. Liz makes the bed and does other basic chores. Still, she feels he is a bit happier than she is with this apportionment of roles.

In Aziz and Cucher's relationship, Sammy prefers to do the cooking and most of the housework. Since he is harder to please, gastronomically speaking, Sammy prepares the food that he likes to eat, and Anthony enjoys whatever he makes. For his part, Anthony shops and does the dishes. They try to divide the financial responsibilities, taking turns paying the bills. But Anthony is more skilled and efficient in keeping the books. They still have separate bank accounts, which, they admitted despairingly, are usually empty by the end of every month.

A few of the couples are comfortable with more fluid arrangements. Andrea Robbins and Max Becher divide about 20 percent of the necessary tasks around the house. They alternate in doing the remainder on the basis of who has the most energy or who happens to get there first. Some things just never get done. When it comes to finances, their money is in one big pool. Both decide on how to keep or spend it.

Christo and Jeanne-Claude are similarly flexible. Whoever sees work that needs to be done in the house attends to it. As she noted, "It's common sense to share. It's our home." When we interviewed them, she took our heavy coats and hung them up; he offered and served the refreshments.

As a result of growing up in France, where she was trained in the fine art of elegant homemaking, Jeanne-Claude is a gourmet cook. In the past, she and Christo entertained large groups for dinner. Currently, they eat light meals and help each other in the kitchen. Lacking a dishwasher, they do the dishes together. Nevertheless, Jeanne-Claude has assumed sole responsibility for managing the complexities of their personal and corporate accounts. She keeps the records and writes the checks. Demonstrating his confidence and trust in her, Christo has never met either of their two accountants.

Bill Outcault responded to our question about domestic roles with his tongue-in-cheek wit: "I do all the work." In fact, he and

Lilla LoCurto are the only pair who perform all their domestic chores in unison—including shopping, cooking, and cleaning. "We always do everything together," she said. "That's because each one of us is so opinionated." They combined their money even before they were married. Both participate in managing their funds and are equally frugal in deciding how their limited assets should be spent. The money goes where it needs to go.

Coordinating Roles in Creating Art

In the artistic realm, however, Lilla and Bill agree that she does some things better than he can—and vice versa. In producing their projects, each does what he or she is most competent at doing. "It's marvelous to put those things together," Lilla said. By contrast, Sterck and Rozo, who divide their household labor, do every aspect of their photography together—from the initial modeling and shooting, to the lab work and supervising the exhibitions of their pictures.

Aziz and Cucher also exercise comparable skills in their professional collaboration, but they bring somewhat different attributes to the commonality of their creative functioning. Anthony has had more training and experience in high-end photography. Sammy is more skilled in working with computers, possesses an excellent photogenic sensibility, and knows a lot about the equipment and materials required for their projects.

The couple used to do all of their own lab work together. Now, however, they find it is more efficient to send it out. Since Anthony is more fastidious about the final finish of their photographic prints, he is the one who deals with the labs.

Andrew Ginzel employs his knowledge of engineering and physics to take more responsibility than Kristin for designing the technological features of their installations. He also obtains the materials for these constructions. When he and Kristin build the final piece together, he does the heavy welding. She, however, is their "front" person. This role fits her more sociable and outgoing personality; and it is what she likes to do. Dealing with most of their professional contacts and phone calls, Kristin "takes the

heat," as Andrew called this external communication, for both of them.

Bill Buchen does the structural engineering for the art he creates with Mary, since he is more expert about the tuning and acoustical features of their sonic sculptures. In considering the structure for their designs, he usually concentrates on the metals to be used, often showing a preference for stainless steel. Mary gets immersed in the colors, textures, and shapes. For her, it is very important for an installation to embody the feeling of a place and the idea of warmth. She loves blending the "old" with the "new." Describing herself as "the dreamer" interested in esthetics, she and Bill often battle about beauty versus function.

"I think Bill finds it difficult to accept the fact that I don't understand structural engineering as much as he does," Mary commented. "I do rely on him too much for that." She researches the quality and availability of their materials, however. Sharing in the promotion of their work, Mary utilizes her writing skills to prepare much of the information they disseminate to the public as well as their proposals for grants and competitions.

People are eager to know what Andrea Robbins and Max Becher do individually in producing their photographs. The couple regards this kind of inquiry as an attempt to drive a wedge between them and undermine their collaboration. Their position is very similar to the one taken by the co-authors Louise Erdrich and Michael Dorris, who observed that even if they could identify which parts of their writings were his or hers, specifying their separate input would contradict the collaborative process.

Andrea and Max have adopted a policy of not disclosing who does what. Because they hand the camera back and forth to each other so rapidly, they often do not know who took a particular picture. Historically, they informed us, it has been assumed that clicking the shot is when the picture is made. But their work requires complicated operations that extend far beyond this narrow concept of "shooting." Contemporary photographic art is not about when or how the picture is taken, but more about how the negative is developed, enlarged or digitally manipulated, and ultimately printed.

In the early stages of their collaboration, Max and Andrea did divide the creative labor. "Now," he said, "each of us can pretty much do what the other can. And we're getting better at it, more technically skilled." Elaborating on their approach to creative equality, Andrea asserted: "Everything doesn't need to be like a financial transaction, even in terms of how you work on it. It's not as if we're exchanging goods for money or trying to create some other abstraction about the way we work."

Perceived Differences in Femininity and Masculinity

While liberated from confining sexist attitudes regarding their roles, the couples we interviewed vary in their adherence to concepts of femininity and masculinity—attributions of some traits and characteristics to women and others to men. Their differing views echo the controversy among psychologists about whether these attributes are intrinsic or learned. Experts even disagree "on the usefulness of the conception itself."[28]

A number of partners talked about presumed gender differences in each one's personality and esthetic inclinations. Within the Scherer-Ouporov partnership, Pavel cools down Suzanne's emotionality. She used to be very excitable but, as a result of his influence, has grown much calmer. He has also helped her to improve her technique. Painting with him on gesso, which cannot be easily changed or erased, requires perfect concentration. The sense of control she has developed helps her to channel her energies in a very positive way.

For his part, Pavel used to be jealous of Suzanne's sensitivity, but he has responded to her exuberance by coming out of his shell. Formerly a person who held everything inside, he now feels free to express his emotions. Art criticism had never been part of his training, whereas her education in America included a great deal of verbal discussion. Now both of them enjoy spending time exchanging self-revelations as well as ideas about historical and current trends in art.

Scherer and Ouporov often put male and female imagery into their pictures, each serving as a model for the sex portrayed. For a

painting of caves, which are generally associated with the womb, they agreed it was correct to show a female figure. To represent other symbols, they decide whether to depict a man or woman, simultaneously coming up with the same idea.

Jones and Ginzel implied that their contrasting traits could be seen as feminine and masculine. She tends to be more visual, tactile, emotive, and intuitive. He is more conceptual, disciplined, and intellectually rigorous.

Discussing how their art reflects its creation by a woman and a man, Kristin and Andrew said they have no idea how anyone would react who did not know it was done by what they called "this two-headed fiend." But people do try to pigeonhole them in terms of stereotypical assumptions about gender differences in personality. The curator of a Swiss museum, watching them construct a major installation, remarked that Andrew was working from the head and Kristin from the heart.

Although their art is not explicitly concerned with gender, this pair has always been fascinated by the drama of opposites—the duality "between chaos and order, stasis and change, light and darkness, even between reason and faith." Meticulously researched, their pieces are intended to stir a sense of wonder in the viewer. The "magical environments" the couple creates can "be read as interior landscapes where the conflicts and resolutions of physical forces offer a mirror for various psychological states."[29]

Kristin and Andrew delight in such contrasts: "You couldn't know one without the other." In their *Vis-A-Vis,* two propellers are in constant but random flux across a thirty-foot pool, always in motion, playing on the water like a sensitive instrument. This installation is about currents, like political tensions, that cause reactions, but it can also be viewed as autobiographical, the couple said—a representation of the different currents passing between a woman and a man, influencing their interactions.

In the exhibition catalogue *Team Spirit*, Rimma Gerlovina and Valeriy Gerlovin, a Russian couple who began collaborating in 1971, describe their artistic thrust in similar terms: "Our work as pARTners is a natural result of our coexistence, complementary of the two opposites—masculine and feminine dynamic

symmetry." For them, "Duality is just an aspect of unity. Personal ego drive, limited within self, is transformed within the synthesis of polarities. This fusion, but not without integrity, produces another 'other.'"[30]

This pair began working together at a time of great social and political unrest within Russia. They now live and work in upstate New York, but before emigrating in 1980 they led the *samizdat* movement, which involved underground or private publishing. The Gerlovins' creations include photography, performances, complex video installations, paintings, and texts. Their art is "often based on the use of archetypal or mythological relationships or images," which they believe people of all cultures understand on a subconscious level.[31] In one work, they superimpose drawings of symbolic and mathematical images on photographs of themselves. "Body and skin become human parchment for our visual formulas," the couple is quoted as saying. "We view art as an organic union of interrelated parts whose balance, as in any living organism, is important to maintain."[32]

Aziz and Cucher know people may look at their collective creations as expressive of masculinity or femininity. But the couple discounts the validity of such an interpretation, describing their photographs and installations as rational and analytical. Aware that these qualities are generally considered masculine, Anthony and Sammy said such a characterization of their work could be made simply because it is created by two men.

Diller and Scofidio disavow any gender differences in their approach to art. Liz credits Ric with a better spatial sense in dealing with structural engineering; he thinks that's a big cliché—"a conventional male thing." Sometimes, Liz is more intuitive, but not always. "We're not clones," he insisted. "Liz has certain strengths, and I have certain strengths. But they're not gender-connected."

Robbins and Becher "play off each other" during the process of integrating their esthetic differences. They do not attribute these differences to masculinity or femininity: Neither one is more forceful or direct than the other. While they do not address the subject of gender in their photographs, their Havana Cigar series could easily be interpreted as reflecting a masculine theme. Yet

both regard these pictures as an expression of their shared interest in social and political issues.

Andrea and Max have discovered that it is often expedient for her to be the spokesperson in dealing with people who are in a position to facilitate their artistic work—for example, asking permission to set up their tripod and camera. Max might arouse animosity or suspicion if he tried to solicit this cooperation. So they adopt what they call "a male-female strategy," consciously taking advantage of what *others* consider to be differences in masculinity and femininity. Privately, they enjoy the prospect of deviating from the expectations associated with these gender stereotypes.

LoCurto and Outcault deliberately use their art to communicate opposition to gender stereotypes. In *Contemporaneou.s.,* a group exhibit of American artists held in London, they showed *Titillatiae,* a piece that documents the concepts of beauty to which women have been pressured to conform over the centuries. Focusing on the female breast and symbolic representations of women, it "is composed of images of various Venuses from art history." To illustrate the lengths to which many women have gone to attain a culturally contrived ideal, the work includes "real silicone breast implants which are held up for scrutiny by the viewer with the aid of surgical clips and magnifying glasses."[33]

According to the catalogue for this exhibit, the couple's "direct approach to body and gender politics" and their "unique sense of humor" are evident in a more light-hearted work called *Vrouwke Pis*—a satire of the famous fountain in Brussels, Belgium, in which the artists have replaced the statue of a cherubic boy pissing with a video of a live, smiling, naked girl who is pissing standing up.[34]

In their first collaborative piece, *Self-Portrait,* Lilla and Bill also convey their conviction that everyone's nature is androgynous. This installation makes the connection between people with AIDS and the inherent vulnerability of all human beings. It is an outstanding example of how this pair brings together a great diversity of technological information to create a room-sized multimedia work that places the viewer in direct interaction with the sculpture.

KharchenkoShabanova BS 1sph (8/6)7_98 by Lilla LoCurto and Bill Outcault.
Chromogenic print mounted on aluminum, 1999. Courtesy of the artists.

The viewer/participant is invited to sit . . . at some distance from
the nine-foot diameter, metal-ribbed, clear bubble suspended
from the ceiling, and to place a hand on the pad of a pulse oxim-
eter sensor. As the sensor picks up the viewer's pulse, it interfaces
with an audio device which amplifies the pulse into a room-
filling, rhythmic heartbeat. The sensor pad also activates a
pumping system, synchronized with the audio heartbeat, that
circulates a deep-red fluid through a network of plastic tubing on
the outside of the bubble's membrane. A video camera . . .
records the viewer's face and plays it back on the top monitor of a
stack of four, which are suspended within a chain-link fence en-
closure that hangs in the middle of the bubble. The four moni-
tors present a composite human body to the viewer; it incorpo-
rates the head and shoulders, the torso, the pelvis and thighs, and
the legs and feet. The viewer's head remains constant in the top

monitor, while the other three monitors change independently of each other every five seconds. They show the designated body section from some thirty-five to forty people of differing genders, races, and ages, clothed and unclothed, in a seemingly infinite composite of human possibilities. The viewer thus becomes both a visual and visceral participant in the work . . . as one set of appearances replaces another, and self becomes the other.[35]

Clearly, regardless of their attitudes toward androgyny or any of the differential roles they play in managing their lives and creating their art, all of the partners are very satisfied with their particular agreements. Knowing in their hearts that they are totally united, interdependent, and equal in pursuing their common goals, they are not concerned about whether anyone else regards them as deviant, conventional, or gender-stereotyped.

True to their own inspirations and humane values, co-career couples in art create their imaginative works in a spirit of harmony that can be realized only by partners who treat one another as loving equals. This egalitarian cooperation gives both partners much of the strength they need to succeed in a society based on competition and inequality. In turn, their professional success, whatever its degree, has the effect of reinforcing their relational cohesion and validating them as an artistic team.

7

Making Art/Making Love

For collaborative couples, making art is analogous to making love. Partners agree to cooperate in a creative process aimed at fulfilling a common desire. Communicating verbally and nonverbally, they coordinate the decisions needed to express the involuntary stirrings that arise within and between them. Once impelled by a shared artistic inspiration, they make a series of choices aimed at manifesting its overt form. When erotically aroused by one another, lovers begin to actualize their feelings through the stream of decisions they initiate in foreplay. Using their bodies as creative media, they heighten their arousal in every move they make to gratify it—just as they intensify their fondness for an artistic project by agreeing on how to proceed in realizing its potential.

Ultimately, partners in love and art feel that a work is done well enough to go out into the world. After deciding to release it, they may be suffused by a rare emotional transport of lightness and serenity. Likewise, when feeling that they have created the zenith of their sexual excitation, a couple decides to end foreplay and let themselves be carried away by the irrepressible waves of orgasm into an ocean of incomparable bliss.

All pairs do not necessarily travel from inspiration to completion—and from sexual arousal to consummation—in exactly the same manner; they also differ in the extent to which their joint artistry affects their lovemaking. But as we explored this linkage

with them, most couples gave relevant examples of it in their own relationships, and some immediately affirmed the underlying experiential similarity between these two creative processes.

The Impact of Making Art on Making Love

When we asked Christo and Jeanne-Claude if they saw any connection between their artistry and their lovemaking, her spontaneous reply was, "Completely! Because we're making love when we work—not physically, but emotionally."

Both of them have remained turned on to each other since they first met. Despite the staggering amount of time and energy Christo and Jeanne-Claude put into their creations, they still make love whenever they feel like it. "There's always time. We find the time. If you like to do things, you'll do it." But their intimate creativity also gives them what she describes as a tremendous "adrenaline high." When viewing a completed project, the long-awaited artistic closure gives them a satisfaction akin to a sexual climax.

Gilbert and George employ a similar metaphor. In a television documentary about them, Gilbert characterizes their response to an exhibit of their newly created work: "Every time we have an opening, we have an orgasm," he says with great relish. "We do it for that. When you see people's reactions, that's the explosion."[1]

Achieving an artistic breakthrough is also sexually stimulating to Liz Diller and Ric Scofidio. But "when we hit creative impasses, that converts into not having time for each other and not even thinking about sex."

In discussing their pattern of lovemaking, Suzanne Scherer and Pavel Ouporov said, "We don't plan anything. We're more instinctive about it." Yet they noted, "When we're happy about our work and career, we are more physically close. But when things go bad, we tend to withdraw from each other."

When not under pressure from their work, Lilla LoCurto and Bill Outcault are much more sexually aware of each other. But when they run into esthetic dilemmas, Bill said, "That creates tension and

frustration — and arguing. That's the worst part." Lilla concluded, "When things aren't going well, you're not as happy."

The Impact of Making Love on Making Art

By contrast, Bill and Mary Buchen rely on sexual gratification as a means of dissipating feelings of mutual alienation that arise from disputes about problems in their art. "Every day is not a good day," Bill observed. "You may have argued about your work. But you go to bed together that night and sexuality helps to relieve tensions. Of course," he emphasized with a gleam in his eye, "we can make love during the daytime, too!"

For Mary and him, Bill said, "Sex is the glue of marriage." She enthusiastically agreed, "I think that's what's kept us together all of these years." He went on, "We have a fabulous sexual relationship and I think it helps us to work. If you feel good about the person with whom you work, if you love them and feel satisfied by them, then it's fun to work with them."

We had heard similar reports from a couple we interviewed during our earlier research on marital relationships. One pair who collaborated in a glassblowing enterprise extolled the personal and professional benefits of "great sex," saying that it left them more peaceful in their general sense of being. "I think that when we feel sexually satisfied," the wife elaborated, "both of us are much more relaxed at work, and our work is better." Although she hadn't thought of it exactly in this way before, she concluded, "We're actually closer physically. Ordinarily, it's easy not to be so near each other in our big workshop."

The husband went into greater detail about how sexual gratification affected their work: "It makes me feel more centered. Glassblowing is very spontaneous, like sky-diving. You free-fall, but you've got to open the parachute and plan your landing. The same is true in our work. Otherwise, you don't finish anything. You have to plan the design, but then allow room for spontaneity as the piece is being made. It's the same kind of spontaneity as a potter has on a wheel."

This couple acknowledged that working together sometimes interfered with their sex life "because more things can go wrong than if we weren't so close to each other." They often brought the stress from their studio into their bedroom at night. But they were conscientious about setting aside time to make love, "or it wouldn't occur at all." Both emphasized that their desires had to be reciprocal for lovemaking to be enjoyable.

సౌ

Some partners are so inspired by the sexual aspect of their loving relationship that they celebrate their physical intimacy in their art. Such couples have photographed themselves to represent the sexual and affectionate wholeness of love.

While many of their pictures are erotically provocative, Pierre *et* Gilles, a famous French pair who have been living and working together for twenty-five years, openly express the tenderness between them. Sometimes, they temper it with touches of gently self-mocking humor. A book about them and their work contains a whimsical photograph of the two men posed as a bride and groom, Gilles dressed in a traditional white wedding gown and Pierre in a tuxedo.[2]

Combining "the candy-colored wonder of childhood fantasies and the provocative glamour of more adult ones," the pair constructs sets, selects the props, and does the lighting. "Pierre, the photographer, shoots fifty to eighty frames, and then chooses a single print for Gilles to paint. 'It's more interesting for us to work with our hands,' Pierre said. 'The image is more alive because it's part of this organic artisanal process,' Gilles added."[3]

Their first American retrospective was held at the New Museum of Contemporary Art in the fall of 2000. A review in the *New York Times* called the exhibit "a must-see for anyone interested in the intertwining histories of postmodern (especially set-up) photography, fashion photography, commercial illustration, the male nude in art and the emergence of a gay sensibility." Choosing one word to characterize the show, Dan Cameron, the museum's senior curator, described it as "pleasure-full."[4]

Diana Blok and Marlo Broekmans, a Dutch couple whose lives and work are presented in *The Sexual Perspective*, "explore erotic images of women that include aspects of sexuality, fantasy and dreams. In their photographs they deal with the complexities of their own relationship as well as the relationships between women in general."[5] Their first contact with each other took place at a festival in southern France in 1976, where they were showing and trying to sell their pictures. Sensing many similarities in their work, they avoided a direct meeting. Formally introduced at a party in Amsterdam two years later, they discovered that they not only shared the same ideas and style, but were born a week apart. Clicking immediately, they started modeling for each other and became inseparable.

The introduction to a 1981 show of their work in Amsterdam said, "This unusual partnership is not based on a particular conviction, like feminism or socialism, but on knowing each other's dreams and thoughts, illogical and mystical with love as the basic drive." Posing in the nude together in their pictures, Diana and Marlo unabashedly "display an exhilaration with their own bodies and with each other. . . . At their most expressive, [they] evoke the intense and passionate discovery of love between two women."[6]

In much of their art, Gilbert and George represent themselves dealing directly with sexual issues. They explicitly "draw attention to everyday things hidden by taboo. Gilbert says, 'the morality of the West has been telling us for the last two thousand years that we are not allowed to be naked and that excrement means bad.' Gilbert and George ask why that should be."[7] They believe these attitudes represent a moral misunderstanding. "Politeness and niceness have held back civilisation, it is only when you say something that informs the individual that we can advance. We are all naked under our clothes, nobody is not naked. . . . We want to take the pornography out of nakedness and make [it] acceptable. . . . We don't want to shock people, but rather to free them."[8]

In creating such daring portraits as *The Naked Shit Pictures*, in which they display their own nudity as well as their excrement, the couple also freed themselves from the constrictions of

conventional prohibitions. "These pictures were the most diffi-
cult pictures for us to create ever, emotionally, sexually, and psy-
chologically. People say ban it, rip it down but that is anti-
freedom. Only if we accept everything, our nakedness, our shit,
can we become freer. If the artist is not confronting taboos today
then who is?"[9]

Gilbert and George reject stereotypical labels of homosexual-
ity and heterosexuality. "We believe in sexuality . . . there are sex-
ual beings. People say, 'I feel horny tonight', they don't say 'Gosh,
I feel heterosexual tonight.' The feeling is the same, it's a sexual
one, whether for a male or female."[10]

Impediments to Lovemaking

Excessive Devotion to Work

All couples—including the partners we interviewed—are en-
gaged in the challenge of finding fulfillment in both love and
work. This is precisely the existential issue that Freud addressed
professionally—yet failed to solve personally.

As a physician, Freud viewed his great invention, psychoanal-
ysis, as a means for helping people to develop their inherent ca-
pacities for loving and working. He did not venture to spell out
how to harmonize that double involvement in the context of daily
life. Nor did he say whether one of these potentials deserves to be
given priority over the other.

In his own life, Freud opted in favor of work over love, devot-
ing day and night to the construction of psychoanalysis as a form
of therapy, a method of psychological investigation, and a theory
of personality. His creative efforts paid off abundantly, yet his lop-
sided involvement in work cost him—and his wife—dearly in
terms of their ability to share the pleasures of erotic and affection-
ate contact.

By his own admission, Freud ceased all lovemaking activities
after he reached the age of forty. "At forty-one, Freud wrote to
his friend Wilhelm Fliess complaining of his depressed moods

and added 'Also sexual excitation is no more use to a person like me.'"[11]

What makes Freud's case so poignant is the fact that his monumental achievement centered on the sexual aspects of loving. Ironically, he seemed willing to sacrifice his own chances for gratification in lovemaking to an all-consuming preoccupation with the function of sexuality in shaping human psychology and behavior.

Of course, Freud's working activities were carried out apart from the relationship he maintained with his wife. As is still true for most adults today, this kind of separation puts temporal and emotional barriers between lovers—no matter how keen they may be to preserve the erotic intimacy of the love with which they began their relationship.

Because our society values work so greatly, a person's occupation has become almost equivalent to his or her existence. Typically, strangers start conversations by asking each other: "What do you do?" The answer, it is implicitly assumed, is the most reliable indicator of anyone's basic definition as a human being.

According to this equation, vocational success necessarily enhances a person's self-image. Naturally, feeling good about oneself is a condition most people welcome, and it is understandable that contemporary adults are willing to lavish a great deal of time and energy on advancing their careers. Today, in contrast to Freud's era, both partners in the typical couple pursue separate occupations, and both are tempted to become more involved in striving for personal recognition through their work than in furthering the development of their loving relationship.

In one careful study of dual-career couples,

> Participants were asked to describe sexual relations in their marriage and in particular the impact of their work life on their sex life. Over three quarters of both men and women reported that their sex life was impeded by work. The most common pathway was that work precipitated a state such as fatigue, depression, emotional withdrawal, anxiety, or hyperactivity that then interfered with sexual intimacy.[12]

Although the collaborative partners in our previously mentioned exploration of marriage were not separated all day by different jobs, most of them reported the same negative impact of work on their sex lives. When we asked a co-career couple in the antiques business to describe their sexual relations, the female partner instantly mumbled, in a deflated tone: "Married." A couple who run a real estate agency gave more specific examples of how preoccupation with their business reduces their sexual zest. "You can't leave work at the office. It's with you all the time," the man said. "When a big sale falls through, you come home at night feeling lousy. You avoid contact. I don't want to talk about it and she doesn't either. We just sit together and watch TV." Expressing frustration over the heavy schedule she and her husband maintain as collaborative silversmiths, one woman commented sadly, "We could use some more sexual harassment in the workplace."

<center>∽o∽</center>

All the partners in love and art aspire to make a mark in their highly competitive work domain. Certainly, they could not hope to have and sustain that level of success without striving relentlessly to produce the best art they are capable of doing. When a couple makes love, however, they have nothing to show for it but the most exquisitely pleasurable of human experiences. Their sexual coupling is private and evanescent. No one sees the satisfaction they share. They produce no object that can be publicly displayed, bought, sold, or reviewed. The ecstasies they create for one another cannot bring them any prizes, grants, commissions, or invitations to participate in prestigious competitions. From this perspective, their lovemaking, by itself, is professionally unproductive. That may be one reason why these couples do not engage in sexual relations as often and spontaneously as might be expected, given their togetherness and freedom from the schedules of the ordinary workplace.

Defining themselves as workaholics, Scherer and Ouporov told us they often stay up past midnight, letting their artistic activities get in the way of their lovemaking. They have a deep

understanding between them about their pattern of work. Her former relationships suffered, Suzanne said, because the men did not understand her need to be creative. Although she and Pavel have no conflict over it, he is upset when she continues to paint until five in the morning. And it does bother her when he's at the computer for a very long time.

Kristin Jones and Andrew Ginzel also have a tendency to become absorbed in artistic production. Over the years, they have grown greatly in mutual erotic desire and intimacy, feeling increasingly comfortable with each other. Their sex life has improved and become more enjoyable. In that respect, working together and sharing their minds is exhilarating. As Kristin said, "When we're really talking and our minds are alive and dreaming of work, I feel more alive in every way. Sharing minds is sexually stimulating."

They rarely translate this artistically generated stimulation into actual sexual contact, since there is so much work for them to do. In fact, Kristin and Andrew told us that they need to "make a date for sex." As a hypothetical example of how they could include more lovemaking in their busy schedule, she said they would "have to go to bed by midnight."

Midnight is earlier than their frequent bedtime of 3 A.M. But even then they might feel too debilitated for sexual activity, especially after a demanding day of work. Both of them claim to want more time for sexual gratification. Kristin doesn't like to be in a rush when they make love. But she often wrestles with grant proposals until very late at night, and Andrew may have to plead with her to stop working. Somehow, they allow the myriad of details that need attention for every project to preempt their sexual pleasure.

Similarly, Sterck and Rozo said they don't have much time for sex because they're so busy with their co-career. "With no family nearby to distract us," Katleen pointed out, "we're working all the time." Terry added, "We're very stable together. I think we're very affectionate, not necessarily sexual."

Diller and Scofidio also forgo spontaneity in the expression of their sexual desires. "We have to 'slot sex time' into our schedule." They have no sexual problems—only time problems. "It's a time

thing," Liz said. "We don't give ourselves enough personal time to close off work." So she and Ric are preoccupied with residual creative tensions.

Ordinarily, the two do not even indulge their appetite for good food or pay much attention to its preparation. Often they grab a quick bite in the neighborhood and return to their studio right away. But when taking trips in connection with their work, they give themselves pleasure by going to fine restaurants. For Ric, "Eating a good meal can be just as important as having good sex." Nevertheless, they felt that they have been depriving themselves of erotic and sensual pleasure, and that aspect of their life has deteriorated over time. Both acknowledged, "We try to talk about this, but then put it aside."

According to Anthony Aziz, "Every relationship is impacted by what's going on professionally. When anxious about what we have to do tomorrow, and what we could have done better today, we get stressed out by the work, and that affects the sex negatively." Without going into detail, Sammy Cucher added, "Also, we're sexually different in ways. I can use sex as a way of relieving stress. I think for Anthony, stress inhibits sexual desire." Anthony summed up their situation: "When work is going poorly, it affects sex negatively. But for the most part, we have a fairly regulated life."

Still, even the most loving partners go through periods of less than optimal erotic functioning. In describing his sexual relations with Sammy, Anthony said, "We go up and down like every couple." Sammy was more specific. "It's possible that when there is a sexual problem, we're in a bad mood with feelings of dissatisfaction and neglect. And that, of course, creates a problem in the matter of how we treat each other. At the same time, we're so professionally inclined, so consciously responsible, that is, clearly when we have a deadline to meet—even when we're not on speaking terms—we'll go into the studio and get to work."

Consequently, Anthony and Sammy turn to their collaborative creativity as a way of reducing whatever sexual stress they may experience. Coming through for one another in coping with

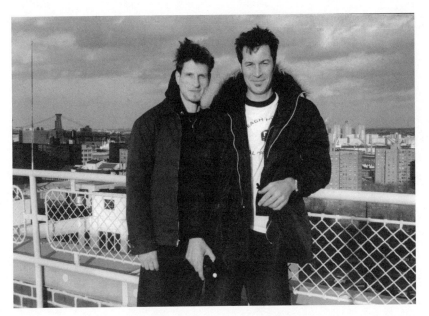

Sammy Cucher and Anthony Aziz. Courtesy of the artists.

their artistic commitments, they stay in close mental and emotional contact despite any transient erotic distance between them.

Like other partners in our study, they said that traveling together enables them to renew and reinforce their intimacy. When going abroad to arrange and attend exhibits of their work, they give themselves extra time just to have some fun. "We find the moments for mini-honeymoons," Sammy said. Anthony agreed smilingly. "Having pleasurable recreation is conducive to having good sex."

Traveling to far-off lands is something most co-career couples do primarily in the interest of their art. Some, of course, use these extended breaks from their usual routines as Diller and Scofidio do, to explore gastronomic delights, or as Aziz and Cucher do, to get more romantically involved in their sexual relations. None of the partners, however, take vacations merely to steep themselves in the pleasure of each other's company or to luxuriate in the unencumbered joy of making love.

After saying that they never take holidays, Christo and Jeanne-Claude told us about a getaway they once planned purely for rest and recreation. They had reserved a place for a five-day sojourn on a lovely Caribbean island. Yet by the third day they had become so bored that they canceled the remaining two days and flew back to their work in New York.

The Distractions of Technologically Driven Projects

Most of the couples we interviewed design projects that require extensive planning: long periods of discussion, conceptualization, research, and the use of specialized methods of production. Kristin Jones spoke nostalgically about how much she and Andrew missed the day-to-day hands-on sensations of the more traditional forms of painting and sculpture. They also lament the fact that they do not have any work that has a tangible, visual result every day. Not getting this kind of daily gratification is a source of frustration.

Even Scherer and Ouporov plan all the details of their paintings in advance, going so far as to try out color layouts on the computer before doing the final rendition by hand. Indeed, for every couple, reliance on technological devices has drastically reduced their opportunities to obtain the tactile charge that older generations of artists once enjoyed as a routine feature of their creative work.

Rodin, as a prime example, passionately integrated the handling of sensual materials with the erotic content of his sculpture, drawing, and painting.

> Rodin's *Balzac* (1898) thrusts up from the earth like a roughly hewn primeval stone marker, the artist's energies and the man's forms furled in the column of his cloak. In the last years of his career, Rodin created another kind of monument that elicited a technique with equally elemental connotations. Each drawing and watercolor may have been modest in scale and intention, but seven thousand of them added up to a massive project. According to contemporary witnesses, Rodin barely looked down at his work, so rapidly was his pencil moving in apparently automatic

response to what he saw, and what he saw was usually the part of the woman he identified as the origin of life.

The marks of vigorous modeling Rodin left in clay, or the swift signs on paper, his ability to combine human figures in endlessly new permutations, the sheer quantity of his output and, above all, the erotic themes of his sculpture, all became indistinguishable from his personal sexuality. No one seemed able to write about Rodin's work, least of all Rodin himself, without using sexual metaphors.[13]

The large installations envisioned by many co-career couples can be implemented only with the help of technical experts and numerous assistants. To make sure their original design is properly carried out, these partners monitor everything that needs to be done for its construction.

Christo and Jeanne-Claude often oversee and direct hundreds of workers. In response to our question about how they manage to maintain enough privacy for lovemaking on a site surrounded by so many people, the couple said that the bedroom is the only place where they guard their privacy. Sometimes, they admitted, a project may even deprive them of a bedroom. When they installed the Japanese sections of *The Umbrellas, Japan–USA,* the men and women, including Christo and Jeanne-Claude, had to be separated. Eight men slept in one room, and four women in another.

On other occasions, the pressures of implementing a project might keep them in a state of vigilance that is hardly conducive to erotic intimacy. While setting up the *Valley Curtain,* they slept only three hours a night—and Jeanne-Claude kept her jeans and boots on in case an emergency should arise. They have never been deprived of physical privacy for more than ten days, though. "We can stay for ten days without jumping each other," she jested.

༺◦༻

By developing several projects at the same time, most partners lock themselves into a futuristic orientation. This persistent bondage to time is antagonistic to the liberating process of

spontaneous lovemaking. To get into the moment and go with the flow of erotic exchange, lovers need to feel mentally free to give their entire attention to one another. They do not precisely plan the sequence of their moves or carefully calculate the outcome of each kiss, touch, or embrace. Open and attuned to the immediacy of their changing expressions of desire, they cherish every sensual surprise on the way to the climactic finale.

Since many of their works require years of sustained effort, some partners may also fail to experience the erotic and emotional benefits of creative closure. Instead of reveling in a celebration of completion, they may be anxious about the next project looming on their artistic radar screen.

For co-career couples in art, intimacy is largely based on communicating the contents of their separate imaginations and blending these thoughts and visions into a single coherent work. In effect, they are continually performing countless acts of *mental intercourse* while producing their joint creations. This symbolic form of lovemaking is an indirect form of sexual excitement, turning the couple on and making them feel "high" in a manner similar to entering the altered state of erotic arousal.

Because this pleasurable experience is self-reinforcing, it increases a couple's motivation to immerse themselves in artistic work for long hours—day after day—without feeling that they are missing any other kind of fulfillment. As they go deeper and deeper into exchanging everything they think and feel about how to bring a specific project from initial conception to completion, they are unknowingly keeping each other in a constant state of unrequited sexual tension. As we discussed this issue with Lo-Curto and Outcault, Lilla had an epiphany. "No wonder I'm always exhausted!" she exclaimed.

Opening the contents of one's mind to someone—and receiving his or her mental offerings—is a very enjoyable exchange. These partners go all out to share their insights into what they are doing together as artists. Undoubtedly, they demonstrate the intensity of the *affectionate component* of their mutual love by gladly spending most of their time together; by treating each other's efforts to contribute to their creative collaboration with

care, respect, and consideration; and by communicating the contents of their consciousness through unrestricted conversations. Still, they generally restrain the direct expression of the *sexual component* of loving. Accordingly, they implicitly substitute the enjoyment of their artistry for the most holistic and intimate sharing of their beings.

Having made collaboration the centerpiece of their collective identity, many couples explicitly say that art is their life. Given this common priority, partners are likely to feel most alive when working together. The combined strength of their intrinsic creative drive and professional aspirations renders them reluctant to depart from their artistic pursuits. Whatever else they do as a pair—including making love—may strike them as not only less enlivening but also as less worthy of their time. Consequently, the couples seem quite willing to tolerate whatever sexual frustration results from their ardent involvement in the production of art.

In his years of pioneering sexual research, Wilhelm Reich discovered that attaining full orgasmic release on a regular basis frees people from their accumulated emotional and bodily tensions.[14] In addition, it heals the rifts partners feel inside their own beings and between the two of them.

When a couple makes love with a willingness to share the entirety of their psychophysical energies, they create more synergy and intimacy than they could by any other form of interaction. At its culmination, this sexual interpenetration permits them to experience a joyous dissolution of the boundaries that ordinarily underscore their separateness. As Reich has written about the outcome of such wholehearted giving and receiving in lovemaking: "It's not just the fuck, you understand, not the embrace in itself, not the intercourse. It's the real emotional experience of the loss of your ego, of your whole spiritual self."[15]

Paradoxically, most of the partners in our study may feel threatened by the very temptation to initiate such ecstatic abandonment frequently and regularly. Perhaps they are afraid of losing not only the motivation to sustain their artistic productivity but also the basic ability to control their emotional and intellectual

functioning. So they defend themselves by minimizing their immersion in lovemaking.

If, however, they took time away from work to fulfill the promise of sexual pleasure, they would be likely to experience just the opposite effect. With their bodies refreshed, their heads cleansed of worrisome clutter, and their compatibility validated, they could return to their art with increased zest and clarity of concentration.

Symbolic Children/Real Children

Throughout history, "Reproductive metaphors appear widely in the work of both male and female artists and writers."[16] Although Christo and Jeanne-Claude have a son, Cyril, she frequently refers to their projects as "our babies" and describes how they "are pregnant" with many at the same time and never know which one will be born first. Similarly, Bill and Mary Buchen, who are child-free, regard their artistic creations as symbolic offspring.

We, too, regarded our books as our babies, especially after our son and daughter grew up and left us with an "empty nest." Our intellectual cross-fertilization in jointly conceptualizing the theoretical concepts and structure of our writing felt almost as exciting as when we deliberately made love to make a baby. It was surrounded with the same aura of magic and mystery. We never knew which seed of an idea would take root and gestate into a viable product—just as we never could tell from a particular lovemaking experience whether that would be the time when we rang the great gong of conception.

While a couple's relationship is the *intangible* offspring of their love, an actual child—more than anything else they could create together—personifies, enlarges, and celebrates the fruitfulness of their union. When they conceive a child, mates blend their separate identities more inextricably and irrevocably than they do in creating their collective identity or collaborating as a professional team. Each one's individual characteristics merge unpredictably to form their offspring's unmistakable uniqueness as a person. As

in the case of a couple's loving relationship—and their artistic works—the child is more than a mere summation of their separate selves or creative input.

Confronting the Question of Having Children

Ambivalence is the word that sums up most partners' attitude toward the question of whether or not to procreate. Scherer and Ouporov, both in their late thirties, would like to have children, but they said that it would be very difficult at this point in their career. It's a genuine dilemma, especially since their parents are pressuring them for grandchildren. Putting this decision on hold, the couple fondly nurtures the two iguanas who share their apartment.

They insisted, however, that having a child remains a high priority. "I can't imagine a life without children," Suzanne said. "But at the same time, it's not right now. It will be good," she went on wistfully, "because I know I'll learn from the experience. It'll be part of the work. It's such a part of life that our art work wouldn't be complete if we didn't have that experience."

Meanwhile, she and Pavel worry about the detrimental effects of not having enough time to devote to raising a child. "Yet it would still be wonderful," Suzanne mused, her glazed eyes reflecting the depth of a private fantasy. "We're both home all the time. We might need a separate work and living space—a split level with a facility for print-making and a separate studio for living, but connected," she conjectured.

This ambivalence is not limited to partners in a co-career. In writing about what he and his wife encountered before having a child, Michael Kimmelman, the chief art critic of the *New York Times,* stated: "The pressure to have children today can be enormous for middle-class heterosexual couples. Increasingly, I had the distinct feeling that our being childless was perceived as a failure by many of the people around us, and I don't mean just my mother."[17]

When we raised the issue of procreation with Jones and Ginzel, they said it was the most difficult question in their lives.

Happy within their relationship, they are very hesitant to threaten it. They have a hard enough time concentrating as it is. Involvement in their career leads them not only to postpone parenthood but also to limit the amount of time they spend with their respective families. Besides, they have more economic freedom without children.

Kristin had promised herself to resolve the issue by her fortieth birthday. That time has come and gone, but they have still not made a definite and mutually agreeable decision. They implied that remaining child-free might represent a wish to perpetuate their youth and avoid being reminded of the reality of their aging. "We're still floating in a timeless realm," Kristin remarked. "You have no twelve-year-old child looking at you."

Without parental responsibilities, they lack the motivation to become more grounded in their neighborhood or the overall community of New York City. On the other hand, both regard anonymity as good—"to some extent."

Sterck and Rozo have also considered the possibility of becoming parents. For them, the issue is *who* would have the child. Without any hesitation, Terry said, "It would be Kat." But Kat replied, "We're still not ready for it, for the responsibility. It's just a thought. You want to be successful enough to afford it." So they go from day to day and keep changing their minds. "But we have two parakeets," Terry joked.

In discussing whether they ever thought of adopting children, Sammy Cucher responded equivocally, "Yes and no, but the responsibilities and difficulties make it impossible." Anthony said he has never had an impulse to reproduce, although he admires others who do. Both of these men regard their work as a basic expression of the creative forces within them and the love they share.

✺

Considering the time, expense, and hazards involved in rearing a child, the prospect of becoming parents in today's world can be intimidating to any couple—whether they work separately or

together. Having striven so diligently to establish themselves in their careers, partners are likely to fear any risk that could result in an outcome detrimental to their economic security, professional standing, or peace of mind. LoCurto and Outcault said they haven't had children because it has been so hard for them to "make it."

Ironically, however, a couple's vocational success may reinforce their resistance to parenthood and their motivation to continue focusing on their work. The same is apparently true for those co-career couples in art who have finally attained recognition and economic security. Having fashioned a predictably rewarding way of functioning, these partners, like Jones and Ginzel, may well be fearful of exposing themselves to the unknowable consequences of conceiving and rearing a child.

As Michael Kimmelman writes:

> Of course I knew in advance that having a child would be a big change. But I was nonetheless shocked by the full realization that I had traded in a life I liked and felt was finally pretty much under control for one that was completely out of control.
>
> The older you get, the more you realize that the world is basically chaotic, that everything in it is contingent and borderline crazy. So you labor to create an orderly, or at least a comprehensible, life from the maelstrom; then a child comes along and all hell breaks loose.[18]

∾o∾

Apprehension about such a loss of control might be a formidable barrier to procreation for partners in love and art. They funnel almost all of their combined energy toward imposing control over the ambiguities of their creative work. Assuming the additional uncertainties of having a child may strike them as an unmanageable and overwhelming burden.

Indeed, forfeiting a smoothly operating lifestyle is an inevitable consequence of bringing life into the world. "To acknowledge the loss that accompanies parenthood is to risk seeming like an

ungrateful jerk—or worse, a child-hater. But," Kimmelman asserts, "that's wrong: the fact is, to have a child is simply to make a choice not to live a life without a child, and vice versa. Either way, it's impossible to know what you are missing, except to know that you are missing something."[19]

The Buchens appreciate being child-free because it allows them to devote themselves to their art and to each other. They can indulge their fondness for travel to India and South America, which frequently stimulates their creativity. Still, Mary wonders what might have been different in their relationship if they had had children.

For his part, Bill views their art objects from a parental perspective: "I raised them, built them as best as I could with the best materials. I want them to have nice happy lives and send me a card now and then. And I want to see what the public thinks about them." He extended the analogy to postinstallation care for their sonic sculptures: "Sometimes they call home, sometimes need to borrow some money and clothes. Sometimes they need a little TLC. I can handle that. But I can't baby-sit with every little piece for the rest of my life."

Occasionally, Diller and Scofidio think that they would have had a kid, or that house in the country, if they had led a more "normal life." Ric has four sons from his previous marriage and stays in close contact with them. He and Liz talked a lot about having a baby together, but never took the step. They wanted to do it, but were frightened by the practical difficulties of raising a child with their busy schedule. Liz said she sometimes regrets that their life has not been "a little more conventional."

∽o∽

Although attitudes are changing somewhat, in our society many people still "believe that everyone who is married should have children as a matter of course because that is normal and typical. . . . No couple, after all, has to explain why they decided to have a baby. But explanations are usually in order if a couple decides not to have children." Despite these expectations, however, approximately 10

percent of married couples remain child-free, and this number is increasing.[20]

A principal reason people give for not becoming parents is the desire to keep the focus of their energies on their relationship, as partners in love and art do. "Those in child-free marriages talk about the freedom they have, and the continuing romance and sex in their relationships." They feel they are able to spend more un-encumbered time together and develop a deeper level of intimacy. One female artist in her forties, who chose not to have a baby, is quoted as saying, "I don't want to sacrifice my marriage to the children. I've seen other people do that. We won't. Our relation-ship means too much to us."[21] Other men and women feel that they will find greater fulfillment through their work and personal interests than through parenthood. Still other couples express concern about being a good parent. Like Scherer and Ouporov, they do not want to have children until they can give them an ad-equate amount of care and attention.

The Intimate Creativity of Childrearing

Contemplating the conception or adoption of a child, every couple is beset by a host of fateful questions regarding their readi-ness and motivation. To rear a child from infancy through young adulthood, they have to go on making a steady stream of serious decisions.

Consequently, childrearing—in and of itself—is an enor-mously challenging process of intimate creativity. To meet this challenge successfully, parents call upon each other to engage in an unending conversation about how to provide their collective nurturance. Just as consensus is necessary for an artistic couple to work effectively on their joint projects, it is crucial for parents to get on the same wavelength about what values to impart, what hopes to engender, what limits to establish, what educational practices to adopt, what aspects of the child's behavior to praise, worry about, ignore, or seek to alter.

Out of this multiplicity of agreements, parents help to create not only a person, but a unique personality. In the process, they

also continue to create their own relationship, enhancing the most constructive of their interpersonal skills. Naturally, they may disagree about many particulars of childrearing, putting themselves at odds with one another and confusing their child. But in resolving those differences, the couple grows closer, feels mutually strengthened, and presents the child with a precious gift of emotional security.

Christo and Jeanne-Claude

Although their life can hardly be regarded as "conventional," Christo and Jeanne-Claude spoke very positively about being parents. Their son traveled with them throughout Europe as a baby. "He grew up with us," she says. "We were three people — not mommy, daddy, and a child." From the earliest age, they always took him to art galleries and restaurants.

Because they were poor and struggling to establish their career, however, they couldn't afford to have another child. Jeanne-Claude disclosed to us that she had, in desperation, had two self-administered abortions. Becoming severely infected, she had to be hospitalized. Now she has enormous empathy with young women and favors legalized abortion.

After the couple came to America and acquired a loft in New York, they built a bedroom for themselves, a separate one for their son, and a living room. "We couldn't do what other artists do in Soho, just throw a mattress on the floor. If we didn't have a child, maybe we would have been sloppy like the others," Jeanne-Claude said. "I don't think so," Christo protested.

Both of them have always been in agreement about how to rear and educate their son, and they have maintained an excellent relationship with him. Cyril has accompanied them to Australia and other countries where they have done installations. He was also a key participant in implementing the *Surrounded Islands* project.

As a poet, photographer, and filmmaker, Cyril has published several books of poetry and was nominated for an Academy Award for a 1987 documentary film, *A Stitch for Time,* about anti-nuclear campaigners in Boise, Idaho. A *New York Times* article

about his recent marriage describes him as someone "who swears he will never work a regular job because he doesn't want to 'lose the wonder of existence.'" He has traveled to remote locations "to study and observe everything from botany to courtship rituals to bamboo architecture."[22]

Shortly after meeting Cyril, Marie Wilkinson, an architect, "quit her nine-to-five job and began collaborating with him on various photography and documentary film projects." The year before they married, they spent nine months "traveling around the world doing research on a new film project about creation myths. They interviewed Aborigines in Australia, hill tribes in Thailand, Hindus on Bali and climbed partway up Mount Everest, spending nights zipped up together in a double sleeping bag." She is quoted as saying, "You're on the roof of the world, and the sky is so close. . . . You just realize how small you are . . . and how lucky you are to have each other."[23] As a team, Cyril and Marie seem to be following the romantic model set by Christo and Jeanne-Claude.

Andrea Robbins and Max Becher

Andrea and Max made the decision to have a child in 1993. "On the day before the baby was due, we were photographing cigar factories in Union City, New Jersey. Later the same day Andrea went into labor at MoMA. Oscar was born the next day as predicted."[24] Both of them thoroughly enjoy having a child and watching him grow. They once thought that parenting would make them "less productive," and they worried about it. "But it turned out to be the opposite," Andrea said. She and Max agreed that neither of them would have wanted to miss the opportunity to be a parent.

The couple aims to divide the responsibilities of parenting evenly. Still, Andrea does a bit more, claiming that her extra involvement is based on Oscar's wishes. While she and Max disagree about "little things" in regard to childrearing, they are basically in accord and very cooperative. If one is a bit lax in discipline, the other calls it to his or her attention.

Andrea Robbins and Max Becher. Photo by Kathy Huala; courtesy of the artists.

Actually, Max is somewhat more "laissez-faire" in dealing with their son. "I grew up on a long leash." His parents, Hilla and Bernd Becher, the pioneering collaborative photographers, were not strict with him, and, Max said, he liked that. Raised in Germany among a community of artistic bohemians, he evolved his own pattern of self-discipline. Max was amazed to see how thrilled Hilla and Bernd are to be grandparents—how much they dote on Oscar and how interested they are in all the details of his life. "Maybe there's some kind of inherent grandparenting gene," he chuckled.

In reflecting on how parenthood has influenced his collaboration with Andrea, Max said, "The time when you think you can do everything is over." He used to make a list of all the things he wanted them to accomplish. Starting with the minor projects, he would save all the "good ones" for last. Now, they have to do it the other way around and "get going on what's important because there's so much less time." His old goal was

to spread himself as thin as possible. But that's no longer an option. Doing their best on fewer projects, they are now much more focused.

Andrea concurred: "We've been so much more productive." Although they are not overly structured in their scheduling, they must be organized when it comes to schooling and obtaining services. Like so many working parents, they are "really tired."

As a child, Max accompanied his parents on their travels throughout Europe and the United States in a Volkswagon bus. He and Andrea have also taken their son with them on their working trips. Oscar seems to have as much fun on these adventures as they do. At ease in the variety of hotels they occupy, he calls each different place "home."

We met Oscar at the opening of an exhibit of the couple's work. On introducing him, Andrea was overcome with feelings of love. Hugging the child close to her, she looked up at us and proudly declared: "This is our best creation."[25]

8

Couple and Community

Although collaborative couples are highly motivated to display their art publicly, they must withdraw from others in order to create it. In order to preserve the integrity and originality of their intimate creativity, they stay out of society as much as possible while continuing to function within it. In general, these partners are quite content with this arrangement.

Enjoying each other so much, Suzanne Scherer and Pavel Ouporov feel no need for separate friends. People always invite them as a couple, and this can sometimes be a problem, since nobody can spend time with either of them alone. However, Suzanne affirmed, "We just like doing everything together."

Devoting themselves to "making their own world," Kristin Jones and Andrew Ginzel invest little time in developing outside friendships. Other artists, who work individually, cannot understand how they can spend so much time together. Kristin sometimes feels socially isolated and laments her lack of contact with people. Their situation doesn't bother Andrew as much—perhaps because he teaches a course at the School for Visual Arts, which gives him regular interaction with students. He frequently reminds Kristin that they are not unusual. "Everyone else is working their butts off, too. It's not like everyone is having dinner parties all the time."

Likewise, Andrea Robbins and Max Becher do not have

much of a social life. Both told us they probably have less need to socialize with others than most people do. Andrea's relatives cannot understand their work or their way of life, and they are particularly upset that she and Max do not participate in celebrations with her extended family. His parents, Hilla and Bernd Becher, are not bothered by such considerations, since their lifestyle is similar to Andrea and Max's.

"We feel so lucky to be able to do what we want to do," Max told us. "We don't want outside controls for happiness." The couple gives no priority to rituals—even within their own nuclear family. Andrea concluded, "We're making a life for ourselves. That's what counts."

Art as a Bridge between Couple and Community

While striving to keep their intense intimacy and creative productivity from being diluted by outside social relationships, all the couples fervently desire to give the best of themselves to society through their art. Implicitly or explicitly, their work expresses the values they seek to fulfill in their own lives as a cooperative and loving team. In this respect, their artistry coincides with the ideas put forward by William Glasser, author of *Reality Therapy*. "Psychiatry must be concerned with two basic psychological needs: the need to love and be loved and the need to feel that we are worthwhile to ourselves and to others."[1]

In fact, these partners maintain an involvement with the community that is as genuine as it is constructive. True, they rarely spend time simply socializing. But through their art they communicate with more people than they could possibly reach in a lifetime of face-to-face encounters. Indeed, they provide others with a tremendous source of visual pleasure and beauty. Stimulated by the deep-seated emotions expressed in these works, viewers gain insight into their own buried and unexpressed feelings. Moreover, the concepts conveyed through images and forms enable people to develop a greater understanding of the physical and political environment around them.

Co-career couples vary in the public accessibility of their work. The creations of some are exhibited primarily in galleries, where they are seen by relatively few people and sold to private collectors, or in museums, where they are viewed by a wider and more heterogeneous audience. A few pairs design and/or participate in multimedia dance and theatrical performances held in galleries and theaters. But more of the couples create installations for public sites, which can be enjoyed by the largest possible segment of the population. A few have jumped into the electronic cyberspace of the virtual. Information about most of these couples is available on the Internet, and some have their own Web sites.

Expressing Humane Values

Aziz and Cucher regard their photography and installations as "anthropological." Before collaborating with Anthony, Sammy tended to look inward. Now, he wants to see how the world affects him and others. "Putting our eyes out to society, we are creating metaphors from what is around us." Elaborating on an earlier photographic series, which illustrated the impact of technology on people, the team mounted an installation in 1997. This work—a set of poles draped with amorphous forms that represent lumps of protoplasm connected by computer plugs and wires—shows how technological devices have become extensions of the human body. In turn, it suggests how people are dehumanizing themselves through their increasing use of such equipment.

Anthony and Sammy do not utilize their own relationship as a social theme for their art. Nor are they gay activists. In this respect, their public stance resembles that of Gilbert and George, who have also refrained from participation in gay demonstrations. Nevertheless, by incorporating images of themselves and their intimate relationship in the content of their work, and through its widespread display, Gilbert and George contribute to the global struggle for gay liberation:

> From the earliest days we always fought the divisions in sex. . . .
> In the beginning a lot of gay people were anti our views, they said

we should be fighting with them, marching. And we said we
have a more subversive way.

We didn't want to go out on the streets and show people a
picture of two men fucking and say, "Do you agree with this? If
not you're a twit." Instead we put subjects in museums, and men,
women and children come in and see them. We're getting away
with it, but it's an amazingly slow, subversive job.[2]

An interviewer observed that Gilbert and George "constantly refer
to the fact that they're getting away with it, pushing back the
boundaries, exhibiting images of tolerance that will eventually fil-
ter down from the art world to everyday life."[3] In effect, they
present "these personal subjects as emblems of the human condi-
tion." They have also portrayed "political subject matter, introduc-
ing images of urban derelicts and decay, and of adolescent prole-
tarian youths," to show "the underside of contemporary life."[4]

In explaining the moral basis of their art, the pair once told
an interviewer that they follow their own version of the Ten
Commandments—among which are: "Thou shalt fight con-
formism; Thou shalt be the messenger of freedoms; Thou shalt
give thy love; Thou shalt have a sense of purpose; Thou shalt
give something back."[5]

Like many contemporary artists, Robbins and Becher do not
restrict themselves to a single theme. "Rather," they are quoted as
saying, "we each have a wide variety of interests and where they
intersect is the 'place' that we focus on."[6] Many of their notable
"intersections" have centered on domination of one group by an-
other. Surely, this issue is chillingly depicted in their series on the
killing rooms and landscape of Dachau.

Another compelling body of the couple's work illustrates how
architecture is a revelation and a repository of a nation's past dom-
ination and exploitation by colonial powers or foreign financial
institutions. A series of photographs entitled *colonial remains*,
taken in Namibia, a former German colony, highlights

the remaining traces of German buildings within the geophysical
and political context of a recently reconstituted African state.

Every detail of the colonist's architecture now appears as a mani-
festation of historical oppression: even the intensity of the blue
sky behind the innocuous "northern" neo-classical structures in-
stantly betrays that the normative displacement of one culture's
shared beliefs and behavior onto a different geo-political context
amounts merely to the process of destruction and domination of
another culture.[7]

Similarly, their photographic series *Wall Street and Cuba* docu-
mented the fact that "the grand eloquent and ostentatious version
of neo-classicism" was the architectural form "the business and
bank buildings in Cuba . . . considered most adequate for their
mission and enterprise of control and domination."[8]

Still, in keeping with their basically optimistic outlook, the
social commentary in their photographs does not "necessarily
emerge from a melancholic contemplation and commemoration
of loss. Quite the opposite: the ruins of colonialism in Namibia
just as much as those of imperialism in Cuba can also be per-
ceived in a utopian perspective: as a promise of the possibility of
the departure of power and the actual potential for historical
change."[9]

Diller and Scofidio bring their work to public view through
numerous venues: galleries, museums, theaters, site-specific in-
stallations, public buildings, and other architectural structures.
All of their projects are "oriented around the present and taking
apart the conventions of the everyday." As described on a Web
page of the Dia Center for the Arts, they use "the built environ-
ment and the visual arts to reveal societal norms that operate in-
visibly to govern and inform daily relationships."[10]

Commenting on a work called *The WithDRAWING Room*,
Liz and Ric say the house itself is a means to "address the issue of
domesticity and the complicity of architecture in sustaining its
conventions." Their installation, put up within an existing house,
emphasized

how building design serves to construct our social and personal
experiences. Moving through "the WithDrawing Room," the

Travelogues by Diller and Scofidio. Corridor Perspective of Installation at JFK International Airport, Terminal 4, 2001. Courtesy of the artists.

audience experienced an eerie sensation of disequilibrium, which heightened appreciation for the power of architecture, and the particular kind of order it imposes on our lives.

By cutting a two-inch slit in the floor and exposing the home's archeological and legal histories, Diller + Scofidio forced the viewer to contemplate the meanings of "private property" and the home's relationship to the larger world. Moving next to the social circle of the dining table, the artists upset the notion of etiquette by suspending furniture from the ceiling. . . . Once the viewer left . . . he or she was likely to think twice about how, and perhaps why, architecture maintains a not-so-neutral relationship to conformity.[11]

<center>⌘</center>

The dramatically innovative creations of Christo and Jeanne-Claude are inscribed in the history of art. Yet they put up their installations with the aim of taking them down within a few weeks.

And they regard this transience as contributing to human liberation from the illusion of artistic immortality and the coils of material possessiveness.

With fabric as their preferred medium, they convey a sense of impermanence in even their most massive projects. "By using this vulnerable material, there is a greater urgency to be seen — because tomorrow it will be gone. . . . Nobody can buy these works, nobody can own them. . . . Even ourselves, we do not own these works. The work is about freedom, and freedom is the enemy of possession, and possession is the equal of permanence. That is why the work cannot stay."[12]

The pair has done their utmost to spread this philosophy to people around the globe. "Our projects are once-in-a-lifetime experiences. . . . Our bourgeois society has the notion of art as merchandise available only to limited audiences. With our art, you do not need tickets to see it."[13]

Christo and Jeanne-Claude deliberately bring their art into the context of daily life, where people can perceive it in the course of their normal activities. He has sketched out the multitude of dimensions embedded in the interplay between the construction and placement of their projects: "While our temporary works . . . all contain . . . elements of social, political, economic, and environmental concerns, they also have aspects of painting, sculpture, and urban planning. . . . *The Pont Neuf Wrapped* with its folds of drapery shows the image of a classical sculpture, but the bridge, while wrapped continued to be architecture, people were walking on [it], cars were rolling, boats were passing under the arches."[14]

In designing every project, the team gives careful consideration to its ecological impact. Their proposals include provisions for restoring the land to its original state and recycling all the materials employed. Finally, as pioneers in the field of environmental art, Christo and Jeanne-Claude try to release people from confinement to fantasies presented in completely enclosed spaces. "Our projects are not something out of fantasy. Fantasy is what we find in the cinema and the theatre, our imaginative notions of things. But when we feel the real wind, the real sun, the real river,

the mountains, the roads—this is reality, and we use it in our work. Our projects carry that reality."[15]

"The greatness of our projects is outside of us. They are not us. They are the things in themselves," Jeanne-Claude told us. "All the effort we do is so that these things will be exciting." She added that people come to see their work because they heard it is beautiful. "We'll never know the full meaning of it. It's outside our personal understanding. It's subject to so many kinds of interpretations. We cannot put together how it will affect people."

She recalled one of the most startling effects. The wrapping of the Reichstag in Berlin had been completed. Standing on a lofty perch high above the enormous crowd, the couple suddenly felt that they had "opened a Pandora's box." As he described it, "Four hundred thousand Germans were chanting in unison, 'Christo! Christo! Christo!' It was wonderful but very scary. This is how Hitler succeeded." Shuddering at the memory, Jeanne-Claude said softly, "And I'm Jewish. But," she went on with a smile, "at the same time, they were saying your baby is beautiful."

∽o∽

Most works by Jones and Ginzel are site-specific installations, both temporary and permanent, in the United States and abroad. In addition to the one they did for the 1996 Olympic Arts Festival in Atlanta, they have created major projects in Italy, Switzerland, and India. They have also collaborated with choreographers in conceptualizing dance performances for the avant-garde Next Wave Festival in the Brooklyn Academy of Music. They have, in addition, designed sets, lights, and costumes for such well-known groups as the Merce Cunningham Dance Company.

Although their art does not comment on the current sociopolitical scene, it expresses the couple's idealistic and universal values. Jones and Ginzel

create a visionary art which yearns for a perfect world. . . . [They] explore time and motion, pursue fusions of seeming opposites, and make use of simple materials to create meticulous new

worlds. A sense of wonder and meditative calm infuses their mysteriously cosmic work. In the broadest sense, theirs is an art about our environment—immediate and galactic.[16]

For the community in which they reside, Kristin and Andrew have created *Metronome* in Manhattan's Union Square, pieces for the subway station at the World Trade Center and an elementary school in the Bronx, and *Mnemonics,* for Stuyvesant High—a school for academically gifted children.

The Stuyvesant installation was commissioned by the New York City Department of Cultural Affairs and the Board of Education. Made of glass, stainless steel, mortar, and other materials, it has "four hundred glass blocks built into the walls of the school building. These blocks contain artifacts of symbolic value from around the world, such as water from the Nile and a fragment of the Great Wall of China, as well as relics tracing the history of Stuyvesant school." As an interactive component of the work, "other blocks have been left empty for future graduating classes to fill."[17]

For Bill and Mary Buchen, the *interactive* quality of their sonic sculptures is an integral feature of their democratic approach to art. Mary "loves making work that is out in life, not in elitist galleries—work that will be seen by all kinds of people." Indeed, the couple designs their creations with the intention of evoking everyone's innate capacity for creativity and desire to learn.

Bill and Mary have studied visual and acoustic phenomena through disciplines as varied as science, ecology, world cultures, and architecture. They travel extensively to do sonic research and make field recordings in far-off countries. Subsequently, they often incorporate these sounds into their work.

In a conversation on the Arts Wire Web site, the couple stressed their educational orientation: "We make artworks that can be used to aid the participant in creating music, discover perceptions about science and investigate the world around them. We like to design Science Playgrounds."[18] They have built several of these playgrounds for public schools in New York and other cities, as well as for children's museums like the

Andrew Ginzel and Kristin Jones in front of *Metronome*. Courtesy of the artists.

Wind Pavilion by Bill and Mary Buchen. At The WILDS, Cumberland, Ohio, 1996. Courtesy of the artists.

Liberty Science Center in New Jersey, where youngsters can interact with the sculpture for amusement and intellectual stimulation.

Occasionally, Bill and Mary even become educators in person. *Newsweek,* describing their installation at P.S. 23, "in New York's beleaguered South Bronx," went on to say, "Twice a year the Buchens offer workshops for teachers at the school, linking the playground to the curriculum in terms of art, physics and cultural diversity."[19] The students there can

> spend recess whispering into saucer-size metal dishes that throw their voices ten feet or speaking into a waist-high microphone that makes their words rise creepily out of every sewer opening on-site. They can also play nine bronze drums that produce tones based on the North African dumbek. . . . Or they can just relax and listen to the Burmese wind bells tinkling at the top of an otherwise menacing black chain-link fence.[20]

In addition to these public school projects, Bill and Mary are helping architectural firms to incorporate their sonic designs into the play areas of several renovated community centers in Brooklyn. And in keeping with her interest in community gardening, they created a 270-foot fence for a garden on the Lower East Side of New York. The fence is composed of laser cutouts of the community members' hands, a gesture of protection for the garden and a *Big Wave* (the name of the fence) to the neighborhood.

"We think this aspect of our work is political in its intent to inspire creativity in humans, making them creators rather than consumers."[21] Since Mary herself was not originally a musician, she is especially interested in involving others without formal training in playing music. The Buchens believe their art might lead people to make music that is personal to them instead of buying a product that a multinational company feels has the right beat or is trendy for a particular year.

Art and Political Activism

Some co-career couples go further in expressing their social and political values. They intertwine their artistry with direct political action, joining with community groups to support a particular cause or reinforce and publicize the efforts of some organization. Sometimes, they invite other members to participate in creating the art. The artists may then help to get the works displayed not only in galleries and museums, but also in government buildings, local union halls, prominent public places, and even on Web pages that permit viewers to register their personal reactions.

According to Eleanor Heartney, a prominent critic and curator, this blurring of the boundaries between art and activism has evolved from

> recent changes in the definition of public art. Having progressed beyond so-called "plop art," a derogatory term for the kind of large and often ungainly outdoor sculptures that adorn too many public plazas and lobbies, to the notion of "site-specific" art works that address the physical nature of the space around them,

discussions about public art have of late begun to center around a form of social or political site specificity. What links an art work to a place, according to this thinking, is not its physical presence but rather its interaction with the social, political, and economic forces that shape the life of any community.

> The definition [of public art] has been stretched to include community projects whose public aspect is the artists' interaction with community members; interventions in the mass media, which may take the form of artist designed billboards, radio or newspaper spots, or television commercials; or artists' participation in developmental planning boards or public works projects.[22]

❧

Carole Conde and Karl Beveridge, a Canadian couple who lived for many years in New York City, are leading exponents of art/activism. Writing on the Internet about their photography exhibit, *Political Landscapes,* a community-oriented theater and video artist said, "They had a vision of what was possible back in the seventies and have worked tirelessly to see it happen." This reviewer describes the series of pictures as intrinsically interesting, with its "bold colours, striking juxtapositions of real people and painted figures, the punchy text." The artists also make "a carefully crafted set of statements about contemporary social issues. Whether it be nuclear energy or the Days of Protest in Ontario . . . you can see what's happening in the unreported news from picket lines and protests." Along with this documentation, the work makes "a clear point: there is exploitation and corporate greed around us and we must resist that."[23]

Conde and Beveridge's projects require months of research and direct involvement with the groups they support. Relating to like-minded people is integral to their own intimate creativity. For them, the medium is definitely a basic part of the message.

Their art frequently includes direct quotations from workers they interview. Typically, they pass around sketches for a proposed series at union meetings to get feedback from the group.

"This commitment to a respectful representation of working people is what gives the work a real depth. It also marks the courage of the artists who are prepared to subject their work to close scrutiny by their subjects, in order that it speaks truthfully about those people's reality."[24]

Summing up the overall impact of their work, a Canadian curator and cultural critic writes:

> with one foot in the union hall and the other in the art world, Conde and Beveridge counterpose an aggressive corporate takeover of culture with a persuasive reminder of the importance of collectivized resistance and a collaborative cultural practice. . . . Taking the . . . social and economic effects of globalization as their subject, they not only record union history and culture, but become advocates of cultural opposition and consciousness-raising.[25]

Helen and Newton Harrison are militant artistic critics "of conventional thinking about environmental problems."[26] Their intimate collaboration

> began partially in response to Rachel Carson's *Silent Spring*, which pointed out that environmental destruction was integrally connected to post-war industrial agricultural practices and consumerism. . . . [T]heir work is often highly conceptual and ideally presents ways to challenge human intervention in the control of existing land and water usage. Many of the ecological projects [they] have worked on are long-term community projects.[27]

The Harrisons argue that changing the course of waterways to increase farming and allow for urban expansion is devastating not only to the land itself, but also to the people who live on it. "Their ecological projects," by contrast, "are based on building community partnerships that will sustain the healing of the bioregion even after they are no longer able to participate in the efforts of restoration." Helen and Newton Harrison were pioneers in proclaiming "the necessity of healing fragile places through collaborative efforts among disciplines. Their

cross-disciplinary work serves as an example for new genera-
tions of young artists."[28]

Their philosophy may seem to be idealistic, but in fact their
views are extremely practical: a plea for the intelligent use of nat-
ural resources—for people "to begin to encounter the planet
Earth in artful ways."[29] The Harrisons

> imply that [we] should treat the planet as a sculpture . . . humans
> are clearly modifying the ecosystem and changing the fragile
> biosphere. . . . The Earth . . . is already largely, an artificial
> construct. . . . There are virtually no untouched natural places
> remaining. . . .
>
> Human beings are the only species that has ever lived with
> the ability to ask whether or not our practices have good or ill
> effects. . . . We are the only species that has ever produced art . . .
> [the only organisms] capable of dealing with our natural envi-
> ronment with anything approaching artfulness. Limited as our
> control may be at the present, it portends a time when we will ei-
> ther deal with the environment artfully or die.[30]

Making Art/Making a Living

Regardless of their degree of political activism, all partners in love
and art have to earn a livelihood. Naturally, they would hate to see
their creative efforts ignored by the outside world. They are very
interested in having their work appreciated and financially sup-
ported. When they turn their attention from producing art to ob-
taining professional recognition and funding for it, they have no
choice but to confront the competitiveness and inequality of the
socioeconomic system head-on.

To achieve these *extrinsic* goals, partners have to participate in
the game society has laid down for success in any career. Paradox-
ically, while maintaining their cooperative and egalitarian rela-
tionship, the pair must assume a competitive stance with regard to
advancing the success of their own co-career over the careers of all
the other artists striving to further identical ambitions.

As in other professions, successful competition in the art

world is defined by the ability to gain the esteem of vocational experts and potential clients. By entering this competition, collaborative partners implicitly aim to surpass the myriad of people seeking the same goals. They are "two against the world"— determined to become a prominent constellation in a sky crowded with glittering talents.

Perhaps the partners' eagerness to succeed originates from a spontaneous impulse to communicate their visions to as many people as possible. After all, if they are inspired, uplifted, and enlightened by their own creations, they are likely to believe that others, on viewing their work, would experience similarly positive feelings and thoughts. But even if collaborative couples were motivated entirely by this generosity—with no concern for their economic well-being or standing in the art world—they would still have to compete unceasingly just to get their work noticed and displayed.

Before marching into this combat zone, both partners have to be convinced of the uniqueness of their combined creativity and their competitive toughness. Whether they enjoy the process of promoting their artistry or not, all of them feel that it is mandatory to compile an impressive resume of their accomplishments and to document their awards, grants, and commissions. They have to "toot their own horns" by providing information about their exhibits in galleries, museums, or other venues; presenting laudatory reviews of their work; and detailing its significance.

Katleen Sterck and Terry Rozo find collaboration to be a great advantage in this promotional struggle. "Since there's two of us and only one of them," Kat said, "we feel less intimidated when approaching a gallery owner. And we're more at ease."

<center>∽o∾</center>

To succeed in their artistic endeavors, all the partners automatically become self-employed entrepreneurs. Bill Buchen put it succinctly: "We're like a lot of other couples who work together. We run a business. We spend a lot of time doing business administration. But you don't want to dump that on a partner. You both have

to understand it and stay on top of it. If you don't make a profit, you don't eat. It's that simple."

Fortunately, none of the co-career couples are on the verge of starvation, but some feel unable to get by solely on the income derived from their art. So they do other things to earn more money; Sterck and Rozo, for example, supplement their income from grants and sales by doing lab work for other photographers.

This situation applies to most contemporary artists, according to a study released in 1998 by the Research Center for Arts and Culture at Columbia University. Surveying almost eight thousand artists in four cities, the research sought to discover the condition of American artists on such dimensions as income, education, professional status, community involvement, health coverage, and other legal and financial needs. The findings showed that "American artists are overwhelmingly and squarely in the middle class. . . . Even though they may not be making their living *from* their art so much as to *support* it."[31] It was also found that 37 percent of those surveyed "spent thirty-one or more hours a week on art or 'art related' activities, while fully 59 percent spent over twenty-one hours a week on 'other' employment." The majority "took home less than $30,000 a year. Tellingly, 45 percent of them derived less than $3000 of that income directly from their art."[32]

One male painter, who does building contracting and cabinetry to pay for his workspace, jests that he got a graduate degree to learn how to operate power tools. "Survivalists is what we are," a female painter said. "We'll do anything to support ourselves when our art doesn't. . . . It's been kind of hairy at times." But, she added, "Everything else I do besides making art is just some other side of me. It's just money."[33]

Only since the mid-1990s have Diller and Scofidio succeeded in making a profit from their artistic work. The projects they took on together as a new team were very "low-budget," financed from their own limited funds. Ric referred to this early work as "credit card art" because they had to charge all the expenses and pay the bills later. Since they were not willing to compromise their artistic standards, "all the money we lost came out of our collaboration," Liz said jokingly.

The couple started out with a basic income from Ric's professorship at Cooper Union and from their architectural practice. In due course, Liz added her salary from a faculty position at Princeton to their combined pot. Many people have told them that full-time teaching, in itself, is enough to constitute a complete career. But they could not teach separately, Liz and Ric said, without continuing to work together creatively. And they could not sustain their art—because it is so deviant and risky—without having the security of teaching as a back-up. So both of them do double-duty all the time.

The team is now approached by museums, theater groups, and public and private organizations. According to Ric, "Very delicious things are offered to us. It's like being in a candy store. It's hard to give up anything." But they can be very selective about which offers to accept, and their choices are not guided by market considerations. What interests them is the chance to express their own social values and esthetic talents and to develop new skills, like designing and directing theatrical or dance productions.

Aziz and Cucher also rely on teaching jobs to supplement the 30 to 40 percent of their livelihood that comes from art. In the past, Anthony simultaneously held several jobs—like waiting on tables—on an irregular and stressful schedule. The year before they moved to New York City, the pair taught a course together at the San Francisco Art Institute. Presently, Anthony has a faculty position at the Parsons School of Design. Sammy teaches part-time at New York University, the Parsons School of Design, and the Maryland Institute College of Art. Although their teaching jobs require them to spend a few days a week apart, both accept this separation, believing that the stability of predictable schedules and income will enhance their performance in every aspect of their lives.

Most of the couples now subsist entirely on income derived from their artistic collaboration. Having left their jobs to devote more time and energy to painting, Scherer and Ouporov have managed to support themselves through their art. This team does not have to solicit galleries and other venues; dealers and collectors come to them. Their paintings are exhibited in major shows

and sold quite readily. Convinced that it is important to retain a body of their work, however, they refrain from selling individual pictures too quickly.

Preserving the classical elements in their style, Suzanne and Pavel resist influence from the marketplace, which they characterize as extremely "fickle and trendy." They feel good about living in Brooklyn, away from Soho, Chelsea, and "all the hype." Once pigeonholed as Russian artists, they are glad such ethnic distinctions are dissolving. Boundaries are breaking down, and global standards are becoming more prevalent. Now people buy a particular painting because the image is speaking to them—regardless of the nationality of its creators or the fact that it is a collaborative work.

When LoCurto and Outcault were in graduate school at Southern Illinois, they were advised that an artist could survive only by teaching. Previously, Lilla had studied sculpture and drawing at the Accademia di Belle Arti in Rome, where her instructors emphasized the importance of forgetting about formal degrees and just doing your own art. When she and Bill finished their MFAs in 1978, they taught together for a short time, but their colleagues felt threatened by their collaboration as co-teachers. So they quit. For Lilla, this negative experience proved that her Italian instructors were right. Although she and Bill still had not teamed up as artists, giving up the role of teachers led them to take the risk of doing their own creative work and stop worrying about how they'd make a living.

Now, the pair concentrates on their joint creativity and does not give much attention to marketing. But they do apply for grants and enter competitions. Represented by galleries, they have also worked with an experimental lab at MIT and one at Johns Hopkins. These technical experts approached them, interested in supporting the couple's concepts and willing to pay for their participation in cutting-edge research.

Some of Lilla and Bill's pieces are owned by collectors, but, like Scherer and Ouporov, they prefer to have their work shown around the world and are reluctant to sell it before it has had sufficient "exposure." They put off concerns about their income "until it starts hurting."

Jones and Ginzel specialize in creating art in public settings for nonprofit organizations. Invited to make proposals, enter competitions, and fulfill specific commissions, this team also applies for grants. Galleries call on them to exhibit pieces that can fit into relatively small and enclosed spaces. In addition, they take on some corporate projects "to pay the rent." Although Andrew teaches, he does it primarily because he enjoys the process of communicating with students.

When Bill and Mary Buchen first came to New York to build their artistic career, they had to do a variety of jobs to support themselves. He played music for dance classes, but hated being subservient to the director of the school. Mary made shirts out of dishcloths, which she put on consignment in shops and sold at street fairs. By 1981 the couple had decided not to do any more distracting work, resolving to live—no matter how humbly—on whatever they could earn from their art. In 1985-1986 they received a fellowship from the National Endowment for the Arts and another from the New York Fellowship for the Arts.

Since then Bill and Mary have remained economically solvent on the strength of their artistry. They present themselves publicly as directors of their own not-for-profit enterprise: Sonic Architecture. In their newsletter the Buchens report on new commissions, projects, and ongoing exhibitions; the circular also advertises publications and videos about their work, offering those items for sale, and lists their e-mail and Web site addresses.

Regardless of how their art is financed, the Buchens maintain a definite set of standards for projects they are willing to consider: "It has to provide creative growth for us; opportunity to disseminate our work further; and we would learn new skills from it. It has to have one of these elements for us to regard it as fun and worthwhile. Money is secondary."

Motivated by their own inspirations, Robbins and Becher have never done any photography to order. Agreeing with Lo-Curto and Outcault, Andrea said, "You just have to jump into what you love. We get very excited about our subjects." Before becoming economically self-sustaining through their art, Andrea worked at a gallery and Max did computer-designed catalogues

for other artists. They have always been approached by galleries, and the people who buy or collect their photographs are enthusiastic about their work.

"It's a little bit scary or worrisome when there's a positive result from your work—some sign of success—because then you have to decide whether you want not to care about it or derive happiness from it," Max admitted. "And if you do that, there's the risk of becoming dependent on it and thinking about it as a goal." Convinced that the art market is unfair and problematic, he feels that "it would be cleaner for our psyches to have no success. Success always comes with a mixed feeling."

Sterck and Rozo expressed a similar ambivalence. Naturally, they would like to become better known, but being too successful brings pressure to keep repeating the same accepted formula that made you famous in the first place.

Andrea Robbins emphasized the capriciousness of success. "When you are a student, you base success on certain things. And then when those things happen, you realize that you're just as unstable as when you were a student, financially and in all other ways. Whether you're in this museum collection or in this or that show, you're still living on a month-to-month basis. We're always on the verge of wondering how we will support ourselves," she acknowledged, "and then luckily, something will come through for the time being, at least. It's surprising that you can reach a level of success and be on such delicate ground. Next year we could be at the opposite point and what would that mean?" Still, she and Max do not let these concerns prevent them from doing their own thing. Both agreed that they are "insanely optimistic."

Christo and Jeanne-Claude have followed a similar lifelong credo: "We never do commissions, never do other people's ideas," she said. "That's what's so fabulous about being an artist," Christo exclaimed, "because an artist is doing what he wants to do!"

The couple avoids applying for grants or accepting funds from foundations or businesses. Nor do they depend on galleries or

dealers to serve as their agents, since "the idea of accepting sponsorship is anathema to them. 'If we had sponsors, we'd lose our freedom,' Jeanne-Claude said."[34]

Early in their co-career, they raised money for their installations through the sale of original drawings and collages of a particular project and other works. Eventually, they evolved an ingenious version of corporate capitalism to secure their funds. Forming the Valley Curtain Corporation in 1970, they offered individuals, collectors, art dealers, and museums the opportunity to become "purchasing subscribers." By paying a minimum fee in advance to the corporation, subscribers gained the right to buy drawings and collages associated with the *Valley Curtain* project or any other work—up to the value of the amount paid *and at a discount*—before sales of those items were opened to the public at large.

Using the same system to finance *Running Fence*, they created a corporation with that name. And under the auspices of the C. V. J. (Christo Vladimirof Javacheff) Corporation, with Jeanne-Claude as president, they made similar offerings for subscribers to the *Surrounded Islands*.

After the completion of those three installations, they no longer needed to rely on the subscriber system. Now, people simply come to their studio to purchase any art work that is for sale. All the money is put into the C. V. J. Corporation, which dispenses funds for transforming the couple's proposals into actual installations. "Over the years they have managed to cover some hefty costs . . . wrapping the Reichstag was a $13 million project; placing the umbrellas in Japan and California cost $26 million."[35]

Following one's artistic inspirations can also lead to formidable frustrations, however. Even Christo and Jeanne-Claude have been unable to implement some of their projects. For them, the actual implementation of a design on its intended site is what constitutes a completed work of art. When they fail to secure the necessary permissions to construct an installation, they must live with the tension of creative incompletion.

It is all the more impressive to see how well they handle such disappointments; how resolutely they refuse to take "no" as an answer; and how tenaciously they cling to their plans, persisting for years in the struggle to get the key officials to change their minds. The couple "waited twenty-four years for the German government to allow them to wrap the Reichstag . . . ten years for permission from the French authorities to swathe the Pont Neuf . . . seven years to plant a forest of giant umbrellas in the rice paddies near Tokyo and along the open hillsides of Southern California."[36] They had to wait thirty-two years before getting clearance to wrap 178 trees in a park in Reichen, Switzerland.

Despite persistent campaigning for over nineteen years, the pair has not yet received permission to put up *The Gates* in New York City's Central Park. With projects installed in countries all over the world, it is particularly painful for them to be thwarted from placing a public work in their own community.

Over time, Jeanne-Claude told us, they have developed strength and stamina. Earlier in their co-career it was harder to tolerate rejection. Now they are not so vulnerable to refusal. "It's not patience," Christo has been quoted as saying; "it's passion."[37]

For a pair who can attract investments amounting to millions of dollars for an installation, they live very simply. As Christo revealed at the lecture where we first met them to have, the money earned from the sale of his drawings and other early pieces could permit them an opulent lifestyle—a magnificent home in the south of France, servants, expensive automobiles, and other luxuries. Instead, they reinvest the major part of their earnings in the ongoing process of planning and implementing new projects. They are content to remain in the same dilapidated building they have inhabited since settling in Manhattan over thirty-six years ago; they do not even have an elevator to ease their daily ups and downs on the steep five-floor staircase.

∽⚬∾

In our contacts with Christo and Jeanne-Claude, and with all the other collaborative partners, we were struck by their commitment

to the same set of humane values. Down-to-earth and access-ible in their direct interactions with other people, they live modestly and resist the materialistic consumerism so rampant in contemporary society. All of them have abiding faith in their own artistic vision and judgment. They are neither deterred from their goals by rejection nor inflated with false pride as a result of success.

Epilogue
The Composite Picture

Having chosen visual art as a lifelong vocation, artists are supposed to specialize in providing the rest of us with images and objects that captivate our imaginations and emotions. Some of their works may even shake us out of our habitual modes of thinking and perceiving—opening us up to fresh perspectives on ourselves and the world around us. But who expects artists to exemplify a uniquely fulfilling lifestyle for lovers?

Yet the couples we interviewed qualify as such models. We came away from our study feeling validated, inspired, and informed by them. Validated because they feel as good as we do about having combined love and creative work. Inspired by each partner's willingness to merge every bit of personal talent and skill in realizing a common dream. Informed because we learned so much about how they cooperate to confront and resolve whatever problems arise in the process of working and living together.

Despite their differences in background and artistic modality, the couples turned out to be strikingly similar in the techniques they employ to communicate and cooperate. Independently, they seem to have discovered and developed a set of interpersonal skills and attitudes that enable them to reap the benefits of intimate creativity while minimizing its costs. After summarizing the

highlights of our exploration, we will draw out its implications for co-career and dual-career couples.

Wholehearted Commitment to a Common Goal

Linked by an exceptionally deep and clear commitment to focus their loving relationships on the creation of art, the partners we studied have resolved the basic existential problem about what to do with their lives as a couple. Through the coalescence of their wills, they generate the motivation to learn whatever is necessary to enhance their union. The same motivation underlies their ability to endure difficulties and frustrations.

These partners have no counselors or manuals to guide them. Nor do they take the time to systematically analyze the ways in which they interact. Professionally engrossed in making their art, they simply do whatever has to be done in the interest of their projects.

In the art world, of course, they are judged by their products—not by the process through which they create. Still, everything they produce depends on their ability to relate as lovers and co-creators. While making the endless stream of agreements required to advance their artistic goals, they cultivate their relational and personal development.

The Simultaneity of Relational and Personal Growth

One of our most impressive findings is that partners in intimate creativity not only fulfill the promises inherent in their loving relationship but also grow as individuals. Contrary to the negative expectations of many people, their psychological and professional merger does not weaken or obliterate their personal autonomy. Instead, both of them actually strengthen their sense of individuality by working together. Essentially, they resolve their disputes through a dialectical process in which each retains his or her individual integrity until they make a synthesis of their

differences—or explicitly agree that one or the other's position is the way to proceed.

Unity

All the partners have evolved strategies for communicating and reaching consensus on every decision that must be made in the course of their joint endeavors. Each speaks candidly to the other; likewise, each listens attentively to what the other is saying. By questioning each other's opinions fully and nonjudgmentally, they consider the widest range of possibilities and maximize their chances of arriving at optimal solutions. Seeking to cooperate rather than compete, neither one is adamant about having his or her own way. Instead, they regard compromise as a win–win situation.

By maintaining these basic elements of communicative effectiveness, partners increase their relational unity. Yet they do not hesitate to disagree vociferously. During these spirited "debates," each one has the greatest possible incentive to articulate and justify his or her suggestions. They serve their collaboration best by putting forward all their personal thoughts and feelings and evaluating them in unison. Otherwise, they might be holding out on each other—to their common detriment.

To assert their own ideas and opinions, both partners need to tap into their personal capacities for self-validation. By daring to disclose their insights honestly and thoroughly, both bolster their sense of individuality while gaining greater access to the contents of each other's inner life. The mutual transparency resulting from these self-revelations increases the couple's intimacy. But each partner also develops psychological fortitude by not letting the other off the hook until both are satisfied with their joint decisions.

Interdependence

One might suppose that these endless confrontations are so wearing that partners would wish to flee from them. Yet just the

opposite is the case. In all their contentions, they "fight fair" and approach each other with mutual care and consideration. Not wishing to undermine each other's confidence, they use task-oriented criticism to improve their projects. Each trusts the other to strive to the utmost to resolve their artistic disagreements. The same mutuality of trust prevails in each one's willingness to take on projects that involve the acquisition of new knowledge and skills. Meanwhile, they discuss and accept their personal limitations, each depending on the other to do what he or she does best. Consequently, each remains receptive to the other's contributions throughout the entire creative process.

Partners avoid premature closure and wrestle patiently with a problem until they solve it. They count on each other for support in weathering painful periods of incubation or overcoming obstacles to implementing and marketing their work. By coming through in all these ways, the pair develops reliability as a team while each partner grows more trusting and dependable as an individual.

Equality

These partners could not communicate so honestly, confront their differences so openly, and support each other so unequivocally unless they respected each other as equals—emotionally, intellectually, and creatively. No matter how they divide the professional and household labor, neither one feels superior to or diminished by the other. Both are well aware of exercising the same degree of power in determining the course and conduct of their multifaceted relationship. And both get equal credit for the art they create together.

In sustaining their egalitarian relationships, the couples do not perceive themselves as exponents of an ideology. Rather, they enjoy the spontaneity and flexibility of freedom from stereotypical gender roles and the interpersonal rigidity of dominance and submission.

By treating each other as loved, respected, and admired equals, both partners gain self-esteem. As a result, they can

disregard whether their personalities and behavior conform to what is conventionally regarded as masculine or feminine. Validated in this fundamental way, each is empowered, becoming a genuine match for the other in coping with any problem they decide to tackle as a team. In addition, both carry that sense of empowerment into any situation in which they relate individually to other people.

Sexual Pleasure

As we have shown, partners fulfill three promises of love — unity, interdependence, and equality — by the ways in which they relate to each other while creating their work. To fulfill the promise of immersion in sexual pleasure, however, they have to withdraw from the process of making art and collaborate in making love.

Although unsparing in their quest for artistic excellence, all the couples devote some time to lovemaking. They vary, however, in the regularity and spontaneity of their indulgence — as well as in the connections they perceive between their sexual relations and their artistry.

Nevertheless, whenever partners give each other erotic gratification, they become involved in the most holistic form of expressing their mutual love and increasing their relational intimacy. Both also benefit individually from the incomparable pleasure and psychophysical release they experience.

When they work together, they are not interacting merely as friends or colleagues. As a result of sharing the sexual and affectionate wholeness of love, they bring a passionate intensity to their artistic creativity. This intensity heightens the synergy that comes from melding their talents. Free to express their individual thoughts and feelings in whatever they do, both partners are enlivened by the rush of energy from their inner depths. At the same time, they are recharged — like batteries — by the energy passing between them. They want to keep this synergy going and are inclined to escape from work only when their creative flow is blocked — such as during transient periods of incubation. Typically, on finishing one project, they itch to begin another.

Implications for All Couples

Contemplating a Co-career in Art or Other Fields

Co-career couples are still a rarity in the visual arts. But these partners are not exceptions that prove the rule; they have broken through it. Naturally, to achieve economic viability in art, the quality of any couple's creations must be approved by the gate-keepers. But curators, critics, collectors, and foundations now place as much value on the work of loving partners as they do on that of solitary creators. Having succeeded in the struggle to gain professional legitimacy, the couples we studied are an inspiration for other lovers who aspire to the same form of artistic collaboration.

These partners do not feel that collaboration diminishes the quality of their art. On the contrary, all of them said that everything they do together is different from and much better than whatever either one could do alone. Repeatedly, they emphasized the value of combining two sets of ideas and abilities—which are often complementary. By tapping into the special talents that one possesses and the other does not, both expand their personal repertoire of skill and sensibility. From this mutual influence, each partner becomes more proficient, and they produce work that is greater than the sum of their separate contributions.

Because they share responsibility for the outcome of their creativity, neither partner has to handle the entire burden. Together, they can take on more difficult projects than either of them could contemplate or do separately. Serving as audience and editor, each partner provides the other with feedback and constructive criticism that prevents both of them from going artistically astray or feeling overwhelmed by having to make so many decisions unilaterally.

Moreover, as all the couples confirmed, the process of intimate creativity eliminates the loneliness and isolation that many artists feel when working individually. Most of the partners spend virtually all of their time together, taking great pleasure in each other's company; they agree that collaboration is a lot of fun. Indeed, as

they show, there is no limit to how much intimacy a couple can share.

The partners also say they are more productive as a team than they would be individually. Sharing an indomitable perseverance, both enjoy hard work and artistic challenge. They stick to a project until they get it right enough to let it go. With mutual compassion, they ride out periods when both of them feel bereft of inspiration or are stymied by creative blocks. Giving each other unwavering support, they withstand failure or rejection of their artistic plans; they tolerate the stress of taking an unconventional or daring approach to their art.

∽∘∾

Many dual-career couples talk about starting a co-career in a field of shared interest and competence. Yet they worry about being engulfed in such a merger, losing their sense of self and their freedom of personal expression. They are also concerned that such a close collaboration might damage or undermine whatever relational harmony they have managed to achieve while pursuing separate careers.

Our study offers reassurance to these people. The co-career couples we interviewed are testimony to the positive impact intimate creativity can have on each partner's individual growth and on the development of their loving relationship. Thus, our findings are relevant not only to couples who wish to collaborate in visual art but also to those in other forms of symbolic creativity. In addition, our results should lend encouragement to couples who maintain—or contemplate—a co-career in any profession or business enterprise.

The Costs of Partnership in Love and Art

Certain psychological and financial pressures impinge on all lovers who want to sustain their intimacy and a successful career in our highly insecure society. As reported, the couples regularly endure the painful periods of doubt and uncertainty that always

accompany creative work, plus the stress of having to secure external approval for their artistic projects. And all of them are faced with the challenge of earning a decent living from their work in today's volatile art market. Yet they react to these frustrations and challenges by supporting each other in ways that help them to fulfill the promises of love.

In concentrating on the cultivation of their artistry, these couples tend to deprive themselves of other sources of growth and gratification. They rarely spend time in purely recreational activities or simply socializing with family and friends. Some partners complained about feeling deprived, saying that they would like to have more social contacts or do more traveling with no purpose other than to enjoy the trip.

As previously noted, few couples make love as often and spontaneously as might be expected, given the amount of time they spend together and the freedom they have to set their own schedules. Some said they would prefer greater indulgence in sexual pleasure.

By far the most troublesome deprivation voiced by any partner involved children. Only two couples in our sample are parents. Most of the others displayed some degree of ambivalence about procreation or adoption; a few have conclusively rejected the possibility of parenthood.

Nevertheless, none of the partners we interviewed expressed any regrets about having decided to combine their loving relationship with artistic collaboration. On the contrary: Despite the costs they incur, all of them feel that they have gained something immeasurably precious by giving up personal strivings in favor of a truly blended effort.

Dual-career Couples

Relatively few couples pursue a co-career in any occupation. But apart from the creative process involved in working together, every couple has the opportunity to approach their own loving relationship as the foremost creation in their lives. To do this, lovers do not have to possess artistic gifts or particular talents of any

kind. Whether aware of it or not, they began to collaborate as co-creators from the moment they decided to become a couple. By consciously seeing themselves in this light, lovers become empowered to cultivate their intimate relationship as their own life-long work of art. With this perspective, they automatically join forces as creative problem-solvers.

Like co-career couples in art, dual-career partners can fulfill the promises inherent in their loving relationship by collaborating on projects located "out there" in the world—outside the scope of their intangible interactions. By committing themselves to create something in material or social reality, lovers maximize their motivation to interact cooperatively.

Almost certainly they will encounter differences in their approaches toward their common goal. But if their wish to succeed is strong enough, they will find the means to communicate and resolve their conflicts with the same level of candor, patience, and respect that co-career partners extend to each other in overcoming their artistic disputes.

Naturally, dual-career couples cannot take on the kinds of professional projects that the partners in our study cope with routinely. Still, some spouses combine their energies in avocations that utilize their talents for symbolic creativity, such as playing musical instruments or doing a craft. Others collaborate to create benefits for their community, organizing groups to clean up and beautify the environment or operate a soup kitchen for the homeless. Every couple can decide to make a co-creative project out of anything they do to improve the quality of their day-to-day lives. In fact all couples get involved in pursuits that require problem solving and decision making: purchasing a new home, remodeling and redecorating an old one, making a vocational change. Viewing such an activity as an outlet for their creativity, partners can use it as a medium for growing personally and enriching their intimacy.

For example, a couple may decide to add an extension to their home. As they begin to exchange ideas about the basic design, each partner has the opportunity to let the other know exactly

what is closest to his or her heart. Perhaps one envisions an entirely open space for entertaining friends, while the other wants to wall off part of the room to house their computer and exercise equipment.

After a series of arguments about whose wishes should prevail, the couple sees that each one's insistence on having his or her own way is keeping their project from getting off the ground. Aware that they have to stop competing, they cooperate by altering their discrepant desires in the interest of reaching a mutually satisfying compromise. One gives up the notion of an undivided expanse; the other reduces the size of the work area to be set aside. By arriving at a collective plan, the pair solidifies their relational unity. And, having honestly aired their disagreements, both affirm their personal integrity.

Enthused about moving forward with the renovation, the couple starts to collect information about suitable architects and contractors. On weekends, they go around to building suppliers, examining windows, flooring, and siding. For about a month, they are very diligent in their quest. Then both begin to succumb to the fear of making the irrevocable decisions necessary to actualize their project. They silently shun their common responsibilities, pretending to be distracted by other claims on their time.

Privately, both partners sense that they are copping out and being untrustworthy. Oppressed by their negative feelings and the impasse in their progress, they have a big blow up. By confronting and admitting their mutual unreliability, they help each other to gather the courage to finalize all the decisions they had put on hold. In coming through for each other in this way, the couple increases their interdependence. Having restored their faith in each other and their own sense of trustworthiness, they feel more dependable as individuals and as a pair.

As the structure goes up, the couple discovers that their expenses are larger than they had estimated. To save money, they decide to do some of the indoor finishing work themselves. Volunteering to construct the bookshelves, the husband suggests that

his wife paint the walls. She immediately balks at his suggestion, since she likes doing carpentry and has already built a number of attractive birdhouses to decorate their back yard.

When she objects, the husband argues that he should build the shelves because the job involves lifting and sawing heavy boards. She counters by accusing him of male chauvinism. Besides, she yells, wielding a paint roller all day long is not exactly a piece of cake.

This confrontation puts the couple in touch with the stereotypical roles they have generally upheld in running their household. In the ensuing discussion, the husband discloses his accumulated resentment about being relegated to the "man's" chores of mowing the lawn, washing the windows, and getting their car serviced. She lets loose her previously unexpressed complaints about having to handle the "woman's" work of grocery shopping, cooking, and cleaning.

Eventually, realizing that they could run their household more efficiently and derive greater fulfillment from their relationship, the couple agrees to share these gender-typed tasks more equitably. They make a good start in that direction by deciding to work as a team of equals in building the bookshelves and painting.

Exhilarated by the synergy unleashed through the removal of psychological barriers to their intimacy, the couple feels turned on to each other. But since they are eager to finish their renovation, neither one makes a move to act on those feelings. They keep working every Saturday and Sunday until they literally droop with fatigue.

One morning, after a night of fitful sleep, both partners wake up tense and short-tempered. Seeing her husband splatter paint on the woodwork as he moves the roller down the wall, the wife grabs his arm, intending to make a critical remark. But touching him sets off an erotic current between them. Instead of expressing displeasure, she looks at him tenderly. He smiles back, acknowledging their common desire. Without saying a word, he puts down the roller and they head for their bedroom.

After this incident, the couple realizes that there is no pressing reason to deprive themselves of sexual pleasure. Deciding to take

a more balanced approach to their collaboration, they no longer feel compelled to spend every moment of their leisure time doing work—even on a cherished project.

~o~

By approaching any shared activity in this way, partners fulfill the promises of love. As a result, they enhance their relational and personal growth. They also carry the benefits of this form of intimate creativity into their daily interactions with children, relatives, friends, and colleagues. What it takes for lovers to be honest, cooperative, caring, reliable, and equal with each other is precisely what it takes to live as a mature and humane adult in society. Through the example of their loving relationship and the positive vibrations rippling out from their own well-being, a couple makes a distinctive contribution to the welfare of others.

Appendix

Notes

Index

Appendix
Interview Questionnaire

1. How old are each of you?
2. What is your educational background?
3. How long have you been together as a committed couple?
4. How did you meet?
5. What were your initial reactions to each other?
6. How did your relationship develop to the point of making a commitment to each other?
7. What hopes and dreams did you share for your future as a couple?
8. How and when did you start thinking about the possibility of doing art work together?
9. Why did you think it would be a good idea to blend your careers?
10. Have you had any qualms about working together? What are your concerns?
11. How and when did you present yourselves publicly as a collaborative team?
12. How much of your income is presently derived from your artistic collaboration? What other work do you do to earn money?
13. How have people in the art world reacted to your collaboration? Dealers? Collectors? Other artists?
14. How has working together affected your social relations with other people? Friends, family, etc.?
15. How do you decide on which project to start?
16. Do you ever disagree about what to begin working on?

17. Do you ever find yourselves competing over whose ideas to follow? How does this competition show up?

18. How do you resolve such conflicts and disagreements?

19. Once you get on the same wavelength about what you want to do, how do you feel?

20. After sharing your inspiration, how do you get started on a work? How do you actually divide the labor?

21. Do either or both of you ever get blocked or hung-up about how to proceed?

22. How does that blockage feel? How do you deal with it, if and when it happens?

23. Do you ever have trouble sharing what is on your minds? About your work? About other aspects of your relationship?

24. Since the time you first started, have you made any changes in the nature and method of your collaboration?

25. Are you both pleased with your current way of working, or would you like to make further changes?

26. Have you ever abandoned a project after having put in work on it? Why?

27. How do you decide when a work is finally finished?

28. Do you ever disagree on that point? If so, how do you deal with it?

29. What feelings do you experience once you agree a work is completed?

30. What do you think are the challenges involved in the actual process of working together? In what way do you think it differs from working alone?

31. What personal growth and satisfactions have you derived from working together?

32. Are there any satisfactions or opportunities for growth that you have felt deprived of or frustrated about?

33. How has working together affected your feelings about yourselves as artists? As a couple?

34. How do you go about exhibiting and marketing your work?

35. How do you feel about whatever degree of success you have had?

36. Do you think your collaboration has helped or hindered your acceptance by critics in the marketplace?

37. Do you have any children? What are their ages and sex?

38. If you have a child or children, how do you handle the responsibilities of parenting?

39. How has parenting affected your work?

40. Are you thinking of having any more children?

41. If presently child-free: Have you ever thought about the possibility of having or adopting a child/children?

42. Have you ever found yourselves disagreeing about the issue of having or adopting a child? How did you deal, or how are you dealing with the conflict?

43. How do you deal with household chores? Are both of you pleased with the way you have handled these arrangements, or would you like to change any of them?

44. How do you handle financial arrangements for your household, business, and personal expenditures? How do you cope with conflicts in this area?

45. Has the problem of jealousy regarding relationships with other people ever come up between you? If so, how did you resolve the problem?

46. Do you think your work reflects the fact that you create together as a man and a woman? (Or as two men, or two women.)

47. In what specific ways does that manifest itself in terms of style, content, or division of labor?

48. In what ways do you think your sexual relations affect your work?

49. On the other hand, in what ways do you think your artistic collaboration affects your sexual relations?

50. Does it make any difference when you feel your work is going well? Or when you experience problems with it?

51. Does your work ever get in the way of your lovemaking? How do you feel about that?

52. Does your work ever get in the way of fulfilling other aspects of your life?

53. What is there about working as an artistic team that has

encouraged you to keep on going — no matter what problems you may have encountered?

54. What advice would you give to other couples who are thinking about collaborating as artists? What pitfalls should they try to avoid?

55. What could they do to enhance the fulfillments of their joint creativity and their loving relationship?

Notes

Introduction. Exploring Intimate Creativity

1. Kirkham, P. (1995). *Charles and Ray Eames: Designers of the twentieth century.* Cambridge, MA: MIT Press, p. 1.

2. *Newsweek* (1997, April 21), p. 37.

3. Zorpette, G. (Summer, 1994). Dynamic duos. *ARTnews, p.* 165.

4. Yeats, W. B. (1973). The choice. In R. Ellman & R. O'Clair (Eds.), *The Norton anthology of modern poetry.* New York: Norton, pp. 147–148.

5. See: Rose, P. (1983). *Parallel lives.* New York: Knopf; and Chadwick, W., & deCourtivorn, I. (Eds.). (1996). *Significant others.* New York: Thames and Hudson.

6. Seligman, M. E. O., & Csikszentmihalyi, M. (2000). Positive psychology: An introduction. *American Psychologist, 55* (1), 5–14.

7. Sarnoff, I., & Sarnoff, S. (1989). *Love-centered marriage in a self-centered world.* New York: Hemisphere.

8. See Appendix for the exact wording of our questionnaire.

9. Fox, J. (1997, May). *Gilbert and George* [Videotape]. South Bank Show, London Weekend Television/Channel Four Productions.

Chapter 1. Relating and Creating

1. Numerous developmental damages stem from a child's lack of affectionate and tactile contact with a caregiver; see: Montagu, A. (1972). *Touching.* New York: Harper and Row. Likewise, the stressful effects of the deprivation of love may show up in a variety of psychosomatic ailments, as documented in: Walsh, A. (1991). *The science of love* (see: chap. 4, Love and physical illness). Buffalo: Prometheus.

2. Csikszentmihaly, M. (1996). *Creativity.* New York: HarperCollins, p. 11.

3. Ibid., pp. 1, 2, 10.

4. Lowen, A. (1967). *Love and orgasm.* New York: New American Library, p. 48.

5. Buber, M. (1970). *I and thou.* New York: Scribner's.

6. Parker, I. (1998, May 3). Born to be Wilde. *New York Times Magazine,* p. 41.

7. Berscheid, E. (1983). Emotion. In H. H. Kelly, E. Berscheid, A. Christensen, J. H. Harvey, T. L. Huston, G. Levinger (Eds.), *Close relationships.* New York: Freeman, p. 155.

8. Person, E. S. (1989). *Dreams of love and fateful encounters.* New York: Penguin, p. 331.

9. Brehm, S. S. (1992). *Intimate relationships.* New York: McGraw-Hill, p. 206.

10. Ejaife, J. (1994). Love and decay. *Art,* p.108.

11. Wertheimer, M. (1945). *Productive thinking.* New York: Harper, p. 218.

12. May, R. (1976). *The courage to create.* New York: Bantam.

13. John-Steiner, V. (2000). *Creative collaboration.* New York: Oxford University Press, p. 8.

14. Fox, J. (1997, May). *Gilbert and George* [Videotape]. South Bank Show, London Weekend Television/Channel Four Productions.

15. Glancey, J. (1995, Weekend, August 26). Well, that's Gilbert and George for you. *Independent,* unpaged.

16. Schwartz, S. (1990). *Artists and writers.* New York: Yarrow, p. 176.

Chapter 2. Transcending the Culture of Individualism

1. Sarton, G. (1962). The quest for truth: Scientific progress during the Renaissance. In E. Panofsky (Ed.), *The Renaissance.* New York: Harper and Row, pp. 80–81.

2. Rizzatti, M. L. (1967). *The life and times of Michelangelo.* New York: Curtis, p. 30.

3. Sollins, S., & Sundell, N. C. (1990). Team Spirit. In S. Sollins & N. C. Sundell (Eds.), *Team spirit* [Exhibition Catalogue]. New York: Independent Curators Inc., p. 7.

4. Hobbs, R. C. (1984). Rewriting history: Artistic collaboration since 1960. In C. J. McCabe (Ed.), *Artistic collaboration in the twentieth century.* Washington, DC: Smithsonian Institution Press, p. 68.

5. Arp, J. (1987). Introduction to an exhibition. In J. Hancock & S. Poley

(Eds.), *Arp: 1886–1966*. Cambridge, England: Cambridge University Press, p. 8.

6. McCabe, C. J. (1984). Introduction. In McCabe, *Artistic collaboration*, p. 17.

7. Arp, J. (1972). *Arp on Arp: Poems, essays, memories*. New York: Viking, p. 232.

8. Cooper, E. (1986). *The sexual perspective*. London: Routledge, p. 74.

9. Ibid., p. 76.

10. Gwynn, F. L. (1951). *Sturge Moore and the life of art*. Lawrence: University of Kansas Press, p. 19.

11. Cooper, *Sexual perspective*, p. 78.

12. Cohen, A. A. (1975). *Sonia Delaunay*. New York: Abrams, pp. 47–48.

13. Ibid., p. 57.

14. Chadwick, W. (1996). Living simultaneously: Sonia & Robert Delaunay. In W. Chadwick & I. deCourtivorn (Eds.), *Significant others*. New York: Thames and Hudson, pp. 31–32.

15. Cohen, *Sonia Delaunay*, pp. 29–30.

16. Ibid., p. 60.

17. Chadwick, Living simultaneously, p. 40.

18. Ibid., p. 34.

19. Read, H. (1968). *The art of Jean Arp*. New York: Abrams, p. 31.

20. Hubert, R. R. (1993). Sophie Taeuber and Jean Arp: A community of two. *Art Journal, 52*, 25.

21. Hancock, J. (1987). The philosophy in Arp's formal language: Toward an interpretation. In Hancock & Poley, *Arp: 1886–1966*, p. 61.

22. Mahn, G. (1987). Hans Arp with Sophie Taeuber. Ibid., p. 265.

23. Hubert, R. R. (1994). *Magnifying mirrors: Women, surrealism, and partnership*. Lincoln: University of Nebraska Press, p. 32.

24. Ibid., p. 46.

25. Baron, S. (1995). *Sonia Delaunay*. New York: Abrams, p. 145.

26. Katz, J. (1996). The art of code: Jasper Johns & Robert Rauschenberg. In Chadwick & deCourtivorn, *Significant others*, p. 193.

27. Hobbs, Rewriting history, p. 69.

28. Sollins & Sundell, Team spirit, p. 9.

29. Felshin, N. (1995). Introduction. In N. Felshin (Ed.), *But is it art?* Seattle: Bay Press, p. 24.

30. Ibid., pp. 24–25.

31. Hobbs, Rewriting history, p. 81.

32. Tuer, D. (1995). Is it still privileged art? The politics of class and collaboration in the art practice of Carole Conde and Karl Beveridge. In Felshin, *But is it art?* p. 210.

33. Turner, J. (Ed.). (1996). *The dictionary of art.* New York: Grove's Dictionaries, Vol. 3, p. 472.

34. Hagen, C. (1993, January 22). Making industrial buildings look like butterflies. *New York Times*, p. C15.

35. Tomkins, C. (2001, January 22). The big picture. *New Yorker*, p. 68.

36. Ibid., p. 65.

37. Ibid., pp. 65, 68.

38. Hobbs, Rewriting history, p. 75.

39. Baal-Teshava, J. (1995). *Christo and Jeanne-Claude.* Cologne, Germany: Taschen, p. 10.

40. Ibid., p. 15.

41. Mulholland, J. (1986). Christo's visions: The people who turn them into reality. In Christo (Ed.), *Christo: Surrounded Islands, Biscayne Bay, Greater Miami, Florida, 1980–83.* New York: Abrams, p. 393.

42. Fineberg, J. (1986). Meaning and being in Christo's *Surrounded Islands.* Ibid., p. 31.

Chapter 3. Embracing a Collective Identity

1. Levenson, H., & Harris, C. N. (1980). Love and the search for identity. In K. S. Pope & Associates (Eds.), *On love and loving.* San Francisco: Jossey-Bass, p. 268.

2. Ibid., p. 267.

3. Sarnoff, I., & Sarnoff, S. (1989). *Love-centered marriage in a self-centered world.* New York: Hemisphere, pp. 71–72.

4. Hubbard, S. (1995, September). Faecal fulminations. *New Statesman and Society*, p. 33.

5. Fox, J. (1997, May). *Gilbert and George* [Videotape]. South Bank Show, London Weekend Television/Channel Four Productions.

6. Unauthored. Anne & Patrick Poirier. Http://www.eyestorm .com/feature/ED2n_article.asp?article_id=60&artist_id=759 (July 18, 2001).

7. Zorpette, G. (Summer, 1994). Dynamic duos. *ARTnews*, p. 166.

8. Ibid.

9. Princenthal, N. (1989, November/December). Diller and Scofidio: Architecture's iconoclasts. *Sculpture*, p. 23.

10. Goldberger, P. (2000, May 22). The skyline: The Beaubourg grows up. *New Yorker*, p. 91.

11. Turner, J. (Ed.). (1996). *The dictionary of art.* New York: Grove's Dictionaries, Vol. 7, p. 236.

12. Weschler, L. (1996, May 3). Cars and carcasses: The last word on Ed Kienholz. *New Yorker*, p. 54.

13. Ibid.

14. Ibid.

15. Ibid.

16. Pincus, R. L. (1990). *On a scale that competes with the world: The art of Edward and Nancy Reddin Kienholz.* Berkeley: University of California Press, p. 78.

17. Ibid.

18. Ibid., p. 79.

19. Weschler, Cars and carcasses, p. 50.

20. Root-Bernstein, R. S., & Root-Bernstein, M. (1999). *Sparks of genius: The thirteen thinking tools of the world's most creative people.* Boston: Houghton Mifflin, p. vii.

21. Ibid., p. 252.

22. Ibid., p. vii.

23. Ibid., p. 7.

24. Hubert, R. R. (1994). *Magnifying mirrors: Women, surrealism, and partnership.* Lincoln: University of Nebraska Press, p. 47.

25. Mahn, G. (1987). Hans Arp with Sophie Taeuber. In J. Hancock & S. Poley (Eds.), *Arp: 1886–1966.* Cambridge, England: Cambridge University Press, p. 265.

26. Baron, S. (1995). *Sonia Delaunay.* New York: Abrams, p. 120.

27. Ibid., pp. 146, 151.

28. Ibid., p. 151.

29. Weschler, Cars and carcasses, p. 56.

30. Ibid., p. 57.

31. Kienholz, N. R. (1996). Chronology. In W. Hopps, *Kienholz: A retrospective* [Exhibition Catalogue]. New York: Whitney Museum, p. 275.

Chapter 4. The Unending Conversation

1. John-Steiner, V. (1997). *Notebooks of the mind: Explorations of thinking* (Rev. ed.). New York: Oxford University Press, p. xviii.

2. Brehm, S. S. (1985). *Intimate relationships.* New York: McGraw-Hill, p. 209.

3. Sabatelli, R. M., Buck, R., & Dreyer, A. (1982). Nonverbal communication accuracy in married couples: Relationship with marital complaints. *Journal of Personality and Social Psychology, 43,* 1088–1097.

4. Sarnoff, I., & Sarnoff, S. (1989). *Love-centered marriage in a self-centered world.* New York: Hemisphere, p. 66.

5. Csikszentmihalyi, M. (1996). *Creativity.* New York: HarperCollins, p. 188.

6. Strauss, E. S. (1974). *Couples in love.* Unpublished doctoral dissertation, University of Massachusetts, Amherst, p. 124.

7. For a summary of leading programs of this type, see: Brehm, S. S. (1992). *Intimate relationships* (2nd ed.). New York: McGraw-Hill, chap. 14.

8. Raven, A. (1991, April 9). Main stream. *Village Voice,* p. 88.

9. Solnit, R. (1990, July/August). Helen Mayer Harrison and Newton Harrison: Metaphor and habitat. *Artspace,* p. 49.

10. Zorpette, G. (Summer, 1994). Dynamic duos. *ARTnews,* p. 167.

11. Raven, A. (Spring, 1988). Two lines of sight and an unexpected connection. *High Performance,* p. 24.

12. Adcock, C. (Summer, 1992). Conversational drift. *Art Journal,* p. 41.

13. Ibid., p. 45.

14. Raven, Two lines of sight, p. 29.

15. Brady, L. (1994). Collaboration as conversation. In J. S. Leonard, C. E. Wharton, R. M. Davis, & J. Harris (Eds.), *Author-ity and textuality: Current views of collaborative writing.* West Cornwall, CT: Locust Hill Press, p. 150.

16. Ibid., p. 161.

17. Ibid., pp. 161–162.

18. Berkeley, M. (1986, August 15). PW interviews Louise Erdrich. *Publishers Weekly,* p. 59.

19. Ibid.

20. Brady, Collaboration as conversation, p. 151.

21. John-Steiner, *Notebooks of the mind,* p. 214.

22. Wolgamott, K., & Ochsner, D. How "Torn Notebook" was conceived, designed, & built. Http://net.unl.edu/swi/arts/tnprocess.html (September 13, 1999).

23. Ibid.

24. Root-Bernstein, R., & Root-Bernstein, M. (1999). *Sparks of genius: The thirteen thinking tools of the world's most creative people.* Boston: Houghton Mifflin, p. 276.

25. Wolgamott & Ochsner, How "Torn Notebook" was conceived.

26. Janovy, K. Torn Notebook by Claes Oldenburg and Coosje van Bruggen. Http://www.pbs.org/net/tornnotebook/1welcome/wel_2.htm (September 13, 1999).

27. Unauthored. Coosje van Bruggen. Http://www.pbs.org/net/tornnotebook/3people/peop_3b.htm (September 13, 1999).

28. Oldenburg, C., & van Bruggen, C. (1994). *Inverted Collar and Tie.* Ostfildern, Germany: Cantz Verlag, p. 45.

29. Ibid., p. 117.

30. Lauer, R. H., & Lauer, J. C. (1991). *Marriage and family: The quest for intimacy.* Dubuque, IA: Wm. C. Brown, p. 304.

31. Brehm, *Intimate relationships,* p. 230.

32. Bach, G. R., & Wyden, P. (1968). *The intimate enemy.* New York: Avon, p. 172.

33. Schwartz, P. (1994). *Love between equals.* New York: Free Press, p. 30.

34. Bach & Wyden, *The intimate enemy.*

35. Ibid.

36. Markman, H., Stanley, S., & Blumberg, S. L. (1994). *Fighting for your marriage.* San Francisco: Jossey-Bass, p. 87.

37. Ibid., pp. 79–80.

38. Gendlin, E. T. (1978). *Focusing.* New York: Everest House.

39. Davis, S. E. (1997, September/October). One + One = Three. *Step-by-Step Graphics, 13* (5), 33.

40. Ibid.

41. Ibid., p. 34.

42. Ibid.

43. Ibid., pp. 36, 34, 41.

Chapter 5. From Inspiration to Implementation

1. Csikszentmihalyi, M. (1996). *Creativity.* New York: HarperCollins, p. 80.

2. Ibid., pp. 80–81.

3. Maslow, A. H. (1967). The creative attitude. In R. L. Mooney & T. A. Razik (Eds.), *Explorations in creativity.* New York: Harper and Row, p. 47.

4. Danto, A. (1999, January 25). Pollack and the drip. *The Nation,* p. 40.

5. Csikszentmihalyi, *Creativity*, p. 74.

6. Gotham Writers' Workshop (Spring, 1999). *Schedule of classes*, p. 2; *Poetry Calendar* (1999, April), p. 25; Milner, M. (1979). *On not being able to paint*. New York: International Universities Press.

7. Caldwell, G. (1994). Writers and partners. In A. Chavkin & N. F. Chavkin (Eds.), *Conversations with Louise Erdrich and Michael Dorris*. Jackson: University of Mississippi Press, p. 66.

8. Kubie, L. S. Blocks to creativity. In Mooney and Razik, *Explorations in creativity*, p. 39.

9. Root-Bernstein, R. S., Bernstein, M., & Garnier, H. C. (1995). Correlations between avocations, scientific style, work habits, and professional impact of scientists. *Creativity Research Journal, 8*, 125.

10. Ibid.

11. Ibid., pp. 122, 125.

12. Spade, J. (1999, March–April). 15 Ideas That Could Shake the World. *Utne Reader*, p. 66.

13. Ibid.

14. Csikszentmihalyi, *Creativity*, p. 101, 102.

15. Ibid., p. 253.

16. Root-Bernstein et al., Correlations between avocations.

17. May, R. (1976). *The courage to create*. New York: Bantam, p. 147.

18. Root-Bernstein et al., Correlations between avocations, pp. 122–125.

19. Dacey, J. S., & Lennon, K. H. (1998). *Understanding creativity*. San Francisco: Jossey-Bass, p. 107.

20. Csikszentmihalyi, *Creativity*, p. 62.

21. Baal-Teshuva, J. (1995). *Christo & Jeanne-Claude*. Cologne, Germany: Taschen, pp. 68–72.

22. Kuspit, D. (1998). Mysticism of the self: Scherer & Ouporov's *Dream Ikons*. In S. Scherer & P. Ouporov, *Dream Icons* [Exhibition Catalogue]. New York: Mimi Ferzt Gallery, p. 2.

23. Scherer, S. & Ouporov, P. (1998). *Dream Ikons*, p. 25.

24. Cary, J. (1944). *The horse's mouth*. New York: Harper & Brothers.

25. Wong, H. D. (1994). An interview with Louise Erdrich and Michael Dorris. In Chavkin & Chavkin, *Conversations with Louise Erdrich and Michael Dorris*, pp. 35–36.

26. Baal-Teshuva, *Christo & Jeanne-Claude*, p. 52.

27. Ibid., p. 47.

Chapter 6. The Harmony of Equals

1. Silberstein, L. R. (1992). *Dual-career marriage.* Hillsdale, NJ: Erlbaum, p. 73.

2. Ibid., pp. 85–86.

3. Sarnoff I., & Sarnoff, S. (1989). *Love-centered marriage in a self-centered world.* New York: Hemisphere.

4. Silberstein, *Dual-career marriage,* p. 86.

5. Busa, C. (1997–1998). The equal other. *Provincetown ARTS, 13,* 90.

6. Mahn, G. (1987). Hans Arp with Sophie Taeuber. In J. Hancock & S. Poley (Eds.), *Arp: 1886–1966.* Cambridge, England: Cambridge University Press, p. 257.

7. Tomkins, C. (1998, February 2). Broken window. *New Yorker,* p. 54.

8. Guerrilla Girls. (1998). *The Guerrilla Girls' bedside companion to the history of western art.* New York: Penguin, p. 60.

9. Kirkham, P. (1995). *Charles and Ray Eames: Designers of the twentieth century.* Cambridge, MA: MIT Press, p. 83.

10. Ibid., p. 80.

11. Ibid., p. 82.

12. Ibid., pp. 80–81.

13. Ibid., p. 81.

14. Quoted in: Hubert, R. R. (1994). *Magnifying mirrors: Women, surrealism, and partnership.* Lincoln: University of Nebraska Press, p. 11.

15. Pycior, H. M., Slack, N. G., & Abir-Am, P. G. (Eds.). (1996). *Creative couples in the sciences.* New Brunswick, NJ: Rutgers University Press, p. ix.

16. Ibid., p. 75.

17. Weitz, S. (1977). *Sex roles.* New York: Oxford University Press, p. 246.

18. Guerrilla Girls, *Bedside companion,* p. 90.

19. Green, C. (2001). *The third hand.* Minneapolis: University of Minnesota Press, p. 107.

20. Ibid., p. 113.

21. Oldenburg, C., & van Bruggen, C. (1994). *Large-scale projects.* New York: Monacelli Press, pp. 376–377.

22. Ibid., p. 377.

23. Peplau, L. A., & Cochran, S. D. (1990). A relationship perspective on homosexuality. In D. P. McWhirter, S. A. Sanders, &

J. M. Reinisch (Eds.), *Homosexuality/heterosexuality.* New York: Oxford University Press, p. 342.

24. Ibid., p. 344.
25. Schwartz, P. (1994). *Love between equals.* New York: Free Press, p. 2.
26. Ibid.
27. Weingarten, K. (1978). Interdependence. In R. Rapoport & R. N. Rapoport (Eds.), *Working couples.* New York: Harper & Row, p. 157.
28. Weitz, *Sex roles,* p. 94.
29. Heartney, E. (1991). Imaginings. In *Noas* [Exhibition Catalogue]. Minneapolis: MCAD Gallery, unpaged.
30. Sollins, S., & Sundell, N. C. (Eds.). (1990*). Team spirit* [Exhibition Catalogue]. New York: Independent Curators Inc., p. 42.
31. Ibid., p. 13.
32. Ibid., p. 42.
33. Ash, E. (1996). *Contemporaneou.s.: New Work from New York* [Exhibition Catalogue]. Newlyn, Pezance, England: Newlyn Art Gallery, p. 11.
34. Ibid.
35. Guenther, B. (1993). *New California Art: Lilla LoCurto/William Outcault* [Exhibition Catalogue]. Newport Beach, CA: Newport Harbor Art Museum, unpaged.

Chapter 7. Making Art/Making Love

1. Fox, J. (1997, May). *Gilbert and George* [Videotape]. South Bank Show, London Weekend Television/Channel Four Productions.
2. Marcade, B., & Cameron, D. (Eds.). (1997). *Pierre et Gilles.* Cologne, Germany: Taschen, p. 248.
3. DeCaro, F. (2000, September 17). Two image doctors pay a house call on America. *New York Times,* Section 9, pp. 1–2.
4. Ibid., p. 2.
5. Cooper, E. (1986). *The sexual perspective.* London: Routledge, p. 258.
6. Ibid., pp. 258–259.
7. McDonald, P. (1995, August 28–September 3). Gilbert and George. *The Pulse,* p. 27.
8. Ejaife, J. (1994). Love and decay. *Art,* p. 108.
9. Buglione, N. (1995, September). Art in the raw. *Focus,* p. 8.
10. Ejaife, Love and decay.

11. May, R. (1974). *Love and will.* New York: Dell, p. 49.

12. Silberstein, L. R. (1992). *Dual-career marriage.* Hillsdale, NJ: Erlbaum, pp. 147–148.

13. Chadwick, W., & deCourtivron, I. (Eds.). (1996). *Significant others.* New York: Thames and Hudson, p. 20.

14. Reich, W. (1971). *The function of the orgasm.* New York: Farrar, Straus & Giroux.

15. Reich, W. (1972). *Reich speaks of Freud.* New York: Farrar, Straus & Giroux, p. 24.

16. Chadwick & deCourtivron, *Significant others,* p. 10.

17. Kimmelman, M. (1999, May 23). The happy-parents conspiracy. *New York Times Magazine,* p. 86.

18. Ibid.

19. Ibid.

20. Lauer, R. H., & Lauer, J. C. (1991). *The quest for intimacy.* Dubuque, IA: Brown, pp. 362, 363.

21. Ibid., p. 364.

22. Smith Brady, L. (1998, September 20). Marie Wilkinson, Cyril Christo. *New York Times,* Section 9, p. 11.

23. Ibid.

24. Unauthored. (1995). Andrea Robbins and Max Becher. *Blind Spot Photography, 6,* unpaged.

25. Since our interview with them and our meeting with Oscar, Andrea and Max have had a second child, Bruno.

Chapter 8. Couple and Community

1. Glasser, W. (1975). *Reality therapy: A new approach to psychiatry.* New York: Harper & Row, pp. 9–10.

2. Kynaston, N. (1995, September 16). Gilbert and George asked Nic Kynaston round for coffee. *Boyz People,* p. 13.

3. Ibid.

4. Sollins, S., & Sundell, N. C. (Eds.). (1990). *Team spirit* [Exhibition Catalogue]. New York: Independent Curators Inc., pp. 9–10.

5. Stewart, D. (1995, July). Gilbert and George talk to Dave Stewart about shit, artistic freedom and behaving like a gentleman. *GQ,* p. 28.

6. Unauthored. (1995). Andrea Robbins and Max Becher. *Blind Spot Photography, 6,* unpaged.

7. De Zegher, C. M. (Ed.). (1994). *Andrea Robbins and Max Becher.* Groeningestraat, Belgium: Kandall Art Foundation, p. 20.

8. Ibid., p. 21.

9. Ibid.

10. Tucker, S. Introduction to Diller + Scofidio's *Refresh*. Http://www
.diacenter.org/dillerscofidio/intro.html (August 20, 1999).

11. Unauthored. Diller + Scofidio, The WithDRAWING Room.
Http://tesla.csunayward.edu/cappstreet/installation/dillerscofidio.html
(August 20, 1999).

12. Baal-Teshava, J. (1995). *Christo and Jeanne-Claude*. Cologne,
Germany: Taschen, p. 86.

13. Ibid., p. 92.

14. Ibid.

15. Ibid., p. 93.

16. Sollins & Sundell, *Team spirit*, p. 12.

17. Unauthored. Kristin Jones & Andrew Ginzel: Mnemonics.
Http://www.batteryparkcity.org/jones_ginzel.htm (August 23, 1999).

18. Unauthored. (1996, April). A conversation with Bill and Mary
Buchen on the interactive art conference on Arts Wire. Http://
artswire.org/Artswire/interactive/www/buchen.html (August 13, 1999).

19. Seligmann, J., & Cohen, A. (1993, November 1). New grounds
for child's play. *Newsweek*, p. 68B.

20. Kahn, E. M. (1992, November 2). Sonic youth. *New York Maga-
zine*, p. 1.

21. Conversation with Bill and Mary Buchen on Arts Wire.

22. Heartney, E. (1995). Ecopolitics/ecopoetry: Helen and Newton
Harrison's environmental talking cure. In N. Felshin (Ed.), *But is it art?*
Seattle: Bay Press, pp. 162–163.

23. Bouzek, D. May Week events: Political landscapes.
Http://www.accessweb.com/mayday/artshow99.html (August 18, 1999).

24. Ibid.

25. Tuer, D. (1995). Is it still privileged art? The politics of class and
collaboration in the art practice of Carole Conde and Karl Beveridge.
In Felshin, *But is it art?* p. 220.

26. Heartney, Ecopolitics/ecopoetry, p. 159.

27. Krug, D. Ecological restoration: Helen and Newton Harri-
son, the Lagoon Cycle. Http://www.getty.edu/ArtsEdNet/Resources/
Ecology/Issues/harrisons.html (August 18, 1999).

28. Ibid.

29. Adcock, C. (Summer, 1992). Conversational drift. *Art Journal*,
p. 41.

30. Ibid., pp. 43, 45.

31. Trebay, G. (1998, October 27). Out of the garret. *Village Voice,* p. 38.

32. Ibid., p. 41.

33. Ibid.

34. Vogel, C. (1999, January 7). Stubbornly wrapped notion. *New York Times,* p. E1.

35. Ibid., p. E6.

36. Ibid.

37. Ibid.

Index